BIT BY BIT

ALSO BY ANDREW ERVIN

Burning Down George Orwell's House

Extraordinary Renditions

bit by bit

HOW VIDEO GAMES
TRANSFORMED OUR WORLD

ANDREW ERVIN

BASIC BOOKS
New York

Copyright © 2017 by Andrew Ervin

Published by Basic Books, an imprint of Perseus Books, LLC, a subsidiary of
Hachette Book Group, Inc.

Books published by Basic Books are available at special discounts for bulk
purchases in the United States by corporations, institutions, and other organi-
zations. For more information, please contact the Special Markets Department
at Perseus Books, 2300 Chestnut Street, Suite 200, Philadelphia, PA 19103, or
call (800) 810-4145, ext. 5000, or e-mail special.markets@perseusbooks.com.

A catalog record is available from the Library of Congress.
ISBN: 978-0-465-03970-8 (hardcover)
ISBN: 978-0-465-09658-9 (e-book)

10 9 8 7 6 5 4 3 2 1

TO ELIVI

CONTENTS

Midway upon the journey of our life
 I found myself within a forest dark,
 For the straightforward pathway had been lost.

Ah me! how hard a thing it is to say
 What was this forest savage, rough, and stern,
 Which in the very thought renews the fear.

So bitter is it, death is little more;
 But of the good to treat, which there I found,
 Speak will I of the other things I saw there.

—Dante Alighieri, *Inferno* (c. 1320)

Who gives a shit about these old video games? You
know, that's a question that some people might ask.

—Warren Robinett (2015)

the purpose of playing

The massive HDTV loomed in front of the windows and blocked the view of the beach. Two of my nephews, John and Logan, were watching cartoons at a volume that came to find me even after I retreated three rooms away. It was Christmas Day at my parents' house on the Jersey Shore. I heard sound effects but no dialogue to speak of. The background music seemed cheery at first, but the steady repetition of some sort of crunching noise called to mind a deranged celery-eating contest. The soundtrack was dominated by a Philip Glass-esque exercise in serialism: rapid crashes interrupted by bleating sheep that went on, full blast, for an hour. I was trying to read, but my noise-canceling headphones proved useless.

The headache kettle-drumming at my temples shot pin-pricks into the backs of my eyes. My face burned bright red because I was wearing a new cashmere sweater the color of reflective bibs worn by highway work crews, and I'm allergic to wool. In the kitchen, my father was loading his Crock-Pot

with the ingredients for his broccoli surprise, but it sounded like he was performing "Flight of the Bumblebee" using every metal pan and piece of flatware in the house. My wife Elivi, the smart one in the family, had gone out for a long run. Unfortunately, my sneakers were in the nephew-colonized living room. I closed the *Inferno* and then my eyes. The microwave started beeping and no one made it stop, so I took a breath and ventured out to the kitchen.

I found my running shoes buried in the living room amid the discarded wrapping paper and Legos and cardboard boxes. I planned to make a hasty exit and catch up with Elivi, but the TV grabbed my attention. The picture quality looked terrible, like a chunky 8-bit Atari game but in 3D. I sat on the rug between my nephews, who didn't notice my presence, and saw that John was tethered to the screen. In his hands was no simple joystick, but rather a plastic device shaped like a bat that had been squashed, taxidermied, and shellacked. The game was called *Minecraft* (2011) and I had never seen anything like it. I soon learned that it had sold over 100 million copies worldwide.

There existed no narrative structure—no story—to *Minecraft*, at least as far as I could tell. John toggled between pop-up boxes when he was not making his way among abstract trees and along poorly-rendered bodies of water. Block-like animals lumbered around. Though rudimentary, I found the action on screen enthralling. What I would have thought of as the camera didn't adhere to a stable or situated point of view. Instead, it flew around to capture the action from different angles. It was incomprehensible and yet I knew deep in my bones that it was a work of absolute genius, albeit one that I didn't understand.

Maybe every generation believes as much about their childhoods—or at least I hope they do—but the 1970s were the best imaginable time to grow up in America. We had the works of J. R. R. Tolkien, the first *Star Wars* movies, Dungeons & Dragons games, *Monty Python's Flying Circus*, and *I, Claudius* reruns on PBS—and emergent video game technology that every year matured and grew in sophistication right alongside us. I played my share of arcade and computer games growing up, and worked briefly as a video game designer in the 1990s for a Budapest-based startup. Later, I spent more hours of my life than might be reasonable playing *World of Warcraft* (2004). And yet, for some reason, I never thought of myself as a gamer.

I don't remember ever looking down on video games and the people who played them, but as a voracious reader, and eventually a graduate student in fiction writing, I naturally spent far more time with books than with video games. My interests leaned more toward the literary than the technological, but on that day down the shore I began to see how intertwined those two concerns could be. Although essential differences remain, and always will, literature and video games have more in common than I could have predicted.

Having been buried nose-first in books for so long, I had missed a fascinating cultural sea change. In my lifetime, video games have expanded from a small, geeky diversion to a mainstream phenomenon as popular in many regards as professional sports. I set out to write this book in order to learn what I had been missing. In doing so, I discovered that video games are not just *games*, but constitute a powerful storytelling medium, one that has provided startling new ways to think about my own life and the world in which I live.

The ways we interact with others have changed dramatically since Dr. William "Willy" A. Higinbotham first set up *Tennis for Two* on an oscilloscope in 1958. "Since 1959, we have come to live among flows of data more vast than anything the world has seen," Thomas Pynchon wrote in 1984, of all years, a full decade before Yahoo! and Geocities invited us online. Whereas computer scientists and video or computer gamers once constituted small subcultures of our society, relegated to government institutions and university labs, today a full 67% of American homes have video games of one sort or another. Many universities now offer MFA degrees in video game design, and the Museum of Modern Art has added games to its permanent collection. Instead of herding into noisy arcades or gluing ourselves to a single boxy TV in the den, we now hide our heads in mobile games like *Angry Birds* (2009), *Canabalt* (2009), and *Pokémon Go* (2016). The flows of data that Pynchon mentioned have indeed augmented our reality.

But who exactly is playing all these video games? Reliable statistics are tough to come by. As of 2010, the average gamer was thirty-four years old and spent eight hours each week gaming. That is equivalent, of course, to a full day of work. I find it particularly fascinating that at that time 40% of all gamers were women. A 2015 study revealed that 49% of American adults play video games; among those between the ages of 18 and 29, 77% of men and 57% of women played. It was also recently found that women over 35 made up half of the video-gaming demographic. Yet the gaming community is still widely—and unfortunately—perceived as a boys' club.

In many respects, video games have surpassed movies in terms of gross income and popularity. The *World of Warcraft*

franchise (1994–present) has reportedly earned in excess of $10 billion for its developer, Blizzard Entertainment. In 2014 in the United States alone, sales of video games on disc reached $5.47 billion. That does not include downloaded software, and that staggering sum was actually down 14% from the previous year; we're downloading more and therefore relying less on physical storage objects like CD-ROMs or DVDs. In that same timeframe, sales of downloaded digital games (such as from Apple's App Store and Valve's Steam service) increased by 11% and reached $1.2 billion. In 2015 alone, American consumers alone spent $23.5 billion on video gaming. More than half of those sales—56%—were digital downloads. Baseball might be America's national pastime, but video games have become a global obsession. To call games like *Call of Duty: Advanced Warfare* (2014) or *Madden NFL 16* (2015) big business would be the understatement of the millennium. Of course, video games are big business, but they are also more than that—or they can be.

Many more of us than ever before are now spending our commutes, our cubicle hours, and our free time enraptured by games, from the minor and mindless but irresistible (*Bubble Breaker* (2003) and *Peggle Blast* (2014)) to the magisterial and totalizing (*Fallout 4* (2015) and *No Man's Sky* (2016)). Whereas once we might have visited with friends, written a letter, or gone to the movies, now we find entertainment—and genuine human connection—through our TVs, our computers, and our phones. That reality alone shows the impact of video games on our lives and culture.

Less remarked upon are the benefits games can offer. Witness the documented effect *Minecraft* has on children's

problem-solving abilities. Or what in *Reality Is Broken* Jane McGonigal calls "stronger social connectivity." Or even the ability of *Pokémon Go* to prompt us to get outside and explore the natural (albeit digitally augmented) world around us. And yet it remains easy to think of video games as childish and the playing of them beneath the dignity of reasonable, mature adults, who should be spending their free hours on more socially acceptable leisure activities, like getting drunk on cheap beer and watching football. Many persistent prejudices about the medium derive from the—inaccurate, as it turns out—term "video game" itself. Yet even were video games only mere playthings, they would hold value. In his 1922 *Homo Ludens: A Study of the Play Element in Culture*, the Dutch historian Johan Huizinga likened play to sacred or religious rituals of the past: "Formally speaking, there is no distinction whatever between marking out a space for a sacred purpose and marking it out for purposes of sheer play," he wrote. "The turf, the tennis-court, the chessboard and pavement-hopscotch cannot formally be distinguished from the temple or the magic circle."

Playtime can serve a purpose beyond entertainment, distraction, and edification; it is a valuable and necessary element of being human. Or, as Huizinga put it, "culture arises in the form of play, ...it is played from the very beginning. Even those activities which aim at the immediate satisfaction of vital needs—hunting, for instance—tend, in archaic society, to take on the play-form." We are an innately play-oriented species. Play serves a valuable, ritualistic function. For us today, video games can provide a return to the rituals of that magic circle. The sociologist Roger Caillois's 1958 *Man, Play*

and Games spoke to a "pure space" that we enter during playtime. "In effect, play is essentially a separate occupation, carefully isolated from the rest of life, and generally is engaged in with precise limits of time and place." The truly great video games, the ones of interest to this book, evoke that pure space and help us return to the magic circle of our human past. As Drexel University digital media scholar Frank J. Lee told me, "text-based games and current games are part of the larger storytelling and play that people have been doing since the beginning of time."

Because video games are intended to be fun, it does not necessarily follow that they are frivolous. Every new style of art has inspired the previous generation to bellyache, perhaps in part because change reminds us of our mortality. I've heard many laments about the time children and adults waste on video games, but since that day sitting agog in front of the TV with my nephews, I have understood that new technologies always meet with resistance and games are an important subject for cultural and artistic analysis. After all, the early Sumerian poets who once recited their epics at great length and from memory likely bemoaned the new-fangled clay tablets upon which the stories of Gilgamesh were suddenly being preserved.

In preparation for a recent transatlantic flight, I chose two video games to add to my iPad. I confirmed my password to pay for the downloads, which transferred a series of 1s and 0s representing funds I had never seen from my bank account to Apple's App Store. I waited all of thirty seconds for the games to download over my lousy Comcast home Wi-Fi

network, and then there they were. One of my new apps—if it really belonged to me—allowed me to play Warren Robinett's *Adventure* (1979), or at least a version of it.

Not to be confused with the text-based *Colossal Cave Adventure*, Robinett's game was published by Atari, Inc. in 1979 for play on what we now think of as the Atari 2600 home console. It sold over one million copies, and remains one of the most important and iconic video games ever made. I was overjoyed to see it included in the Atari's Greatest Hits app and looked forward to mastering it 30,000 feet above Greenland. When the pilot finally announced that we were free to use electronic devices, I pulled out my iPad and discovered that the game looked great: the lines clean and straight, the colors bright, the movement responsive to the faintest swipe of my finger. Just seeing *Adventure* again after all those years—the geometric mazes and that pixel-dragon that looked a bit like a duck—brought back a flood of pleasant memories.

After five minutes I turned it off. By the time I arrived in Stockholm, I had deleted the app. Fortunately, the other game I had downloaded, *Monument Valley* (2014), turned out to be an incredible piece of digital storytelling and, as I discuss later in the book, one of the most affecting video games I have played. The re-developers of *Adventure* had created a lovely reproduction of the original, but the "aura," as Walter Benjamin would have put it, had vanished. It felt wrong to play such a brilliant game on such a mundane device, to see *Adventure* so polished and shiny but also sanitized and voided of personality.

That sense of being transported back to the 1970s lingered, however, so when I got home to Philadelphia a few

weeks later I dusted off my fake wood-grained Atari 2600 and purchased a copy of *Adventure* on eBay so I could play the game as it was meant to be played. Instead of waiting thirty seconds, I had an entire week to contemplate the extent to which I've come to expect instant gratification. Then the game showed up, a strip of old circuitry embedded in a casement of mass-produced, molded plastic: a perfect combination of digital and analog technologies. I powered up the console, popped in the cartridge, and the game looked awful—which was exactly what I had hoped for.

The original version of *Adventure*—as it appeared on my old Dell-manufactured flat screen TV, after extensive finagling with different adaptors and wires—was blurry and clunky and not remotely as polished as the app. The resolution was hideous yet beautiful, in much the same way that hearing the pops and cracks of an old LP is beautiful. I loved playing *Adventure* that way like I love hearing Ben Webster on a scratchy old record instead of on remastered and lifeless CDs. The scratches and crackle, or in this case the pixelated blurs and wonky motion, are essential to my enjoyment.

In writing this book, I have whenever feasible played the original incarnation of each game under discussion. I dropped quarters into arcade cabinets, loaded 5 1/2" floppy diskettes into buzzing C=64 drives, and spun tiny 3" CDs in a Nintendo GameCube. Without a single peep of complaint from Elivi, I installed a full-sized and obscenely loud *Donkey Kong* (1981) machine in our basement. However, with video games, and digital media in general, locating an original of a program can be futile. Newer games in particular are infinitely reproducible. It makes little sense to adhere to some false

notions, rooted in nostalgia, for an authenticity that never existed. For that reason, I did not lose sleep over my inability to play *Spacewar!* (1962) on a PDP-1 computer or *Pong* (1972) on an original arcade cabinet. I tried to be respectful of Benjamin's aura without being inexorably tied to it.

I have also focused my attention on the games that advanced the medium in creative ways. No work of history can be truly comprehensive, and this one is not. What you hold in your hands consists of a selective and ultimately subjective— and hopefully still corrective—survey. The contributions of women to video game history have been overlooked for too long, for instance. Margaret Atwood has written that, "In most conventional histories, women simply aren't there. Or they're there as footnotes. Their absence is like the shadowy corner in a painting where there's something going on that you can't quite see." Make no mistake: this is no conventional history. I have tried to celebrate some of the many brilliant contributions, otherwise often ignored, that women programmers and designers have made to the field of video games.

When I set off to write the book, I quickly and unexpectedly found myself learning about the origins of video games in the time of World War II and their parallel growth alongside and within the military-industrial complex. My research took me to a government laboratory and dusty junk shops, to design studios and arcades, to universities, and to museums that had recently added games to their collections. I met professors and professional gamers, scientists and hobbyists, critics and game makers themselves. I designed a university course about video games and taught it online, holding virtual student conferences inside *World of Warcraft*. And, yes, with

the help of my nephews I even learned how to play *Minecraft*. In fact, I played enough to suffer from Minecraft Syndrome, the effect of seeing the objects around me in real life as constituted of component blocks.

As Warren Robinett, the mind behind *Adventure*, has put it, "If you accept the idea that a new artform is emerging, then interviewing the genre-creators is equivalent, for a Classicist, to interviewing Homer; for an English professor, to interviewing Shakespeare." Self-aggrandizement aside, I could not agree more. I was fortunate, in a way, that many of the most important people behind games are still alive; my conversations with Robinett and Tim Schafer and other video game designers enlivened and complicated this book. Few of the people I met would agree on what makes video games important, or if they are art or not, but every last one shared an abiding—and contagious—passion for playing games.

And what is it exactly that I came to love about video games? The works of art I value the most—*Inferno* and *Moby-Dick*, Magritte's "The Treachery of Images" and Bartók's *Concerto for Orchestra*—always and necessarily resist definition; they allow me to question my own tastes and beliefs and values. Art cannot be pinned down like a butterfly to a taxonomist's board. Art helps me enter Huizinga's magic circle of ritual, where cordoned off from the workaday world I can find the mental and emotional bandwidth to better mediate my relationship between the real and the mystical or extra-real. My favorite video games do precisely that.

Before we hit START, I would like to thank you, the reader who has put down the controller long enough to pick up this book. You might find that I have ignored some popular games

that you're excited about and that I've devoted what may feel like excessive attention to lesser-known games that I love. Please bear with me. Fortunately, as I discovered, there are enough video games, and enough *kinds* of video games, for everyone. The diversity of video games—and of video gamers—can be the medium's greatest strength. The gaming community we build together is entirely up to us. Let's play, shall we?

CHAPTER 1

epic origins

Every existent ounce of the glassine substance known as Trinitite originated at one moment and at one place on our planet. On July 16, 1945, as part of the Manhattan Project, scientists at Los Alamos National Laboratory in New Mexico successfully detonated the first nuclear bomb. The heat of the blast melted some of the desert's quartz sand and feldspar into glassy green chunks. Currently illegal to gather, a small amount made its way to collectors and curiosity seekers in the years immediately following World War II. I keep a sample of Trinitite on a bookshelf in my Philadelphia row house. It was a gift from my friend Hans and I understand that it retains some amount of radioactivity.

Hans wrote, on the inside of the box in which it sits: "fused sand ('glass') from the first man-made atomic bomb." I have held in my hand one of the rarest and most obscenely frightening substances known to humankind. The nickel-sized object is smooth and ever so slightly pockmarked on one side

and as abrasive as sidewalk cement on the other. It is lustrous and beautiful. When I attempted to chip off a small piece it scratched my thumbnail, but it did eventually crack. It possessed no noticeable smell or taste.

The name of the substance is derived from the codename for that first atomic detonation: Trinity. The physicist J. Robert Oppenheimer, head of Los Alamos, famously said that the test brought to mind the apocalyptic line from the *Bhagavad Gita*: "Now I am become Death, the destroyer of worlds." Another witness to the detonation was the physicist William A. "Willy" Higinbotham. As group leader of the electronics division at Los Alamos, Higinbotham was responsible for creating the timing circuits for the Manhattan Project. A little over a decade later, he invented the first video game.

The famous lines that Orson Welles added to Graham Greene's screenplay for *The Third Man*, released in 1949, addressed the historical correlation of art to war: "In Italy, for thirty years under the Borgias, they had warfare, terror, murder, and bloodshed, but they produced Michelangelo, Leonardo da Vinci, and the Renaissance. In Switzerland they had brotherly love, they had five hundred years of democracy and peace. And what did that produce? The cuckoo clock." For all its ravages, warfare has inspired innumerable artistic triumphs. So perhaps I should not have been surprised to learn that the invention of video games can be traced directly to World War II.

Higinbotham was born on October 25, 1910 in Bridgeport, Connecticut. His father, a Presbyterian minister, encouraged his interest in the sciences, and at age fourteen Willy began tinkering with radios. He graduated from Williams

College in 1928 with a degree in physics and, unable to find a job at the beginning of the Great Depression, he pursued his graduate studies at Cornell University. In 1941, as the United States appeared likely to enter the war, he went to work with the experimental physicist Robert Fox Bacher at the Massachusetts Institute of Technology, where he helped adapt early, analog computing technology for military use, including a high-altitude bombing system. A few years later, it was Bacher who recruited Higinbotham to Los Alamos.

One of the figures responsible for initiating the Manhattan Project was the engineer Vannevar Bush, who helmed the US Office of Scientific Research and Development. In July 1945, *The Atlantic* published Bush's essay "As We May Think," in which he attempted to plot a new, peacetime course for scientific discovery. "Machines with interchangeable parts can now be constructed with great economy of effort," he wrote. "The world has arrived at an age of cheap complex devices of great reliability; and something is bound to come of it." Several weeks after the publication date of that essay, the United States unleashed atomic devastation on Hiroshima and Nagasaki.

Higinbotham was one of the physicists who, as Bush wrote, was "thrown most violently off stride, who [had] left academic pursuits for the making of destructive gadgets, who [had] had to devise new methods for their unanticipated assignments." Higinbotham lost his brothers Philip and Frederick in the war and suffered terrible pangs of conscience about his role in the Manhattan Project. For the rest of his career, in fact, he consistently threw himself into numerous anti-nuclear proliferation efforts. He moved to Washington, D.C. to become the first executive director of the Federation of American Scientists, which

sought to call attention to the humanitarian consequences of scientific research. Soon thereafter, he accepted a position at Brookhaven National Laboratory, founded by the Atomic Energy Commission in 1947 on the grounds of a former US Army base in east-central Long Island. Higinbotham took the job, he said, because he "wanted to be involved in instruments and also be at an institution that wouldn't complain if [he] continued to be active in arms control."

Beginning in 1958, at the height of the Cold War, Brookhaven instituted annual visitors' day celebrations so the public could learn more about the scientific discoveries their tax dollars were funding. By that time, Higinbotham had become head of the Instrumentation Division, the official purpose of which was to "develop state-of-the-art electronic instruments to help scientists collect and analyze data that would come from the big machines built for smashing the atom." For Visitors Day, he created an interactive exhibition, one that would demonstrate the application of the government's technological innovations in a way that the general public could understand. Using a Donner Model 30 analog computer—and basing his work upon the calculation of ballistic-missile trajectories—Higinbotham created a two-player tennis simulation. Today we would immediately recognize what he called *Tennis for Two* as a precursor to *Pong*.

The era's analog computers differed from our current digital machines in many ways, and the distinctions would be the cause of debate among video game historians for decades to come. In a digital computer, such as the ones eventually used to program and play *Spacewar!* and every subsequent video game, a central processing unit (CPU) converts numbers to

graphic representations on a display monitor. An analog computer, by contrast, does not get programmed so much as assembled: the organization and arrangement of the physical components themselves create the gameplay. Some gamers continue to believe, for that reason, that *Tennis for Two* was not a video game at all.

Higinbotham's blueprint-sized diagram for *Tennis for Two* depicted how a complicated network of physical circuits and relays would employ electrical and mechanical processes to simulate the flight of a tennis ball back and forth over a simulated net. With the schematic in hand, Higinbotham enlisted the engineer Bob Dvorak to assemble the computer and connect it to an oscilloscope, the globular screen of which was more commonly used to display the jagged lines of signal voltages. "By all accounts," according to a pamphlet published by the Instrumentation Division, "the game was a huge success. Willy Higinbotham was amazed that people were lined up completely around the gym to wait their turn to play." To appreciate the technological marvel of *Tennis for Two*, imagine trying today to create a playable version of *Minecraft* on a contraption made out of Lincoln Logs, wires, and a few 9-volt batteries hooked up to an Etch A Sketch.

In 1997, for the fiftieth anniversary of Brookhaven's founding, the human resources department organized a celebration for the lab's staff and their families. Like those early Visitors' Days in Higinbotham's time, it was also open to the public. To commemorate the occasion, Dr. Peter Z. Takacs, director of the Optical Metrology Lab in the Instrumentation

Division, agreed to recreate *Tennis for Two* using vintage technology and computing equipment. "I've always been interested in historical stuff," he told me. "We've got to preserve our history. When the call came around, knowing what Willy Higinbotham had done here, I said, let's see if we can recreate history." The task was actually more daunting than it had been in Higinbotham's time, since many of the components were harder to find. Unable to locate a Donner Model 30, Takacs and his team relied on old photographs and 1950s-era technology journals to make a version of *Tennis for Two* for modern, solid-state components.

Locating and restoring the vintage equipment were not the only challenges. The schematics at his disposal were wrong. Higinbotham's original plans contained any number of errors, which Dvorak had corrected while assembling *Tennis for Two*, but never recorded. Further confounding any attempt at authenticity, Higinbotham's original, hand-drawn schematic for *Tennis for Two* has mysteriously disappeared. Takacs was forced to work from a photocopy. Then there was the fact that there was no information at all about the controllers that allowed the players to serve the ball and control the angle of a return volley. Nevertheless, Takacs succeeded in recreating a playable version. A photograph from that event shows a wooden table on which a newer model Techtronic oscilloscope had been wired to a circuit board that simulated an analog computer. Next to the table, a bulky DC voltage power supply stood at the ready. Behind the gaming equipment, Higinbotham looked down in approval from a display board.

Takacs dusted off the recreation again in 2008 for the game's semicentennial, by which time he had found a vintage

DuMont type 304 cathode-ray oscilloscope. With an audience of 200 watching a simulcast on a larger screen, the game failed to function correctly and sparks flew in the exposed wiring. Takacs and his team managed to re-solder the board and make the game operational again within forty minutes. Since then, they have continued to find more vintage equipment to replace the newer parts. Every year that goes by, Takacs's wondrous recreation steps further into the past.

I recognized that Takacs's name was Hungarian and I assumed he or his family had emigrated to the United States, perhaps as part of the so-called "Class of 1956," when many scientists and artists fled Budapest during the Hungarian Revolution and subsequent crackdown by the Soviet regime. As it turned out, that was not the case. When I reached out to him via e-mail, he responded promptly to inform me, "The game is currently non-operational, as we had some problems connecting it to the Donner analog computer and have not solved them all." He had found the old computer on eBay. Nevertheless, I accepted his generous invitation to visit Brookhaven and after making the appropriate arrangements with the Public Affairs office I jumped in my old Toyota Echo and drove 180 miles to see what I regard as the birthplace of video gaming.

The sprawling Brookhaven National Laboratory sits in an otherwise rural pocket of Long Island, due south across the sound from New Haven. A narrow, tree-lined road leads to a security station, where I showed my photo ID and received a clip-on nametag, a map of the 5,265-acre campus, and a bright yellow VEHICLE AUTHORIZATION CARD for my dashboard. I had never been to a government laboratory. Unlike a typical

university campus, which must keep up outward appearances to attract students and their parents' money, Brookhaven's buildings were purely functional. Driving toward the Instrumentation Division, located next door to the National Synchrotron Light Source on the aptly named Technology St., felt a bit like going back in time. I could not envision a better place to witness a marvel of vintage technology.

Brookhaven reminded me of those black and white science fiction movies from the 1950s in which an experiment at the lab would go terribly, terribly wrong and the beatnik boyfriend of the scientist's daughter, allied temporarily with a Jeep full of soldiers, must save everybody living within twenty miles from the giant radioactive iguana. In reality, Brookhaven is thoroughly modern, operating under the aegis of the United States Department of Energy, a direct descendent of the Atomic Energy Commission. In addition to 3,000 or so in-house scientists, technicians, and support staff, other physicists and chemists travel from around the world to use the facilities, which include the New York Blue Gene, the world's fifth-fastest supercomputer.

I arrived a few minutes early, parked the car, and looked over my notes one more time. I knew that Takacs focused on optical metrology, but previously had no idea what that meant. Fortunately, one of the players in my regular Dungeons & Dragons game, Jim, is a physicist who at the time worked for DuPont. He was excited to provide some background information. As Jim explained it, optical metrology deals with the precise measurements of lenses, such as in satellite-imaging technology. I also learned that Takacs had developed a potentially revolutionary machine called the Long

Trace Profiler, which could detect the most miniscule errors in the surface of a mirror. And yet he still found the time to re-make *Tennis for Two*.

Takacs met me in the lobby of the Instrumentation Division. In his early sixties, I guessed, he wore glasses and had a trimmed, white beard. Having grown up in New Jersey, he did not speak a lick of Hungarian and gently corrected my pronunciation of his name: it was "Tack-axe" and not the mag-yarul-sounding "Tock-ahtch." Then he showed me around.

Laminated posters celebrating the Instrumentation Division's many achievements decorated the long hallway. On one side, I spotted a photograph of Willy Higginbotham's original *Tennis for Two* display. It depicted an entire row of complex machines—with wires, knobs, dials—occupying a long banquet table. Takacs pointed out the second machine from the left, a tiny oscilloscope in front of which were two small controllers and a strange object I could not make out. In the building, there were any number of labs and offices in which some of the nation's brightest minds conducted cutting-edge experiments and contributed, on a daily basis, to the scientific progress of our species—and I was there to see the non-functional recreation of a video game.

Takacs led me to his basement office. He worked in what had once been a Cold War-era Emergency Relocation Center bomb shelter. The concrete walls were two feet thick. The shelter had once boasted its own generators, ventilation system, and a communications room separated from the rest of the facility by an automated blast door so that those hiding from a Trinity-like mushroom cloud could remain in radio contact with whatever government agencies had not yet been

annihilated. While the rest of the world burned, Higinbotham could have still enjoyed a pleasant game of video tennis.

The 300-pound *Tennis for Two* contraption sat on an old A/V cart, the kind on which a high school teacher might wheel in a TV and VHS player. On the uppermost of the cart's two shelves sat a Donner 3230 "Problem Board," with an unruly braid of wires connected to the network of circuits on the lower shelf. A smaller combination of wiring led from those circuits up to the HAL 9000-like Dumont oscilloscope that had been placed above a Donner Analog Computer Model 3400, which resembled an old-fashioned telephone switchboard. Takacs plugged in the power supply and the machines hummed to life. On the oscilloscope, we could discern the vertical line of the tennis net and the white ball that the shiny, fabricated-metal controllers should have allowed us to hit back and forth. I asked about the item I could not identify in the original 1958 photograph upstairs. That had been an ashtray—one artifact Takacs had not yet managed to find.

Clicking the controller button created a mechanical snapping noise that originated from the circuit boards on the bottom. "The interesting thing is the sound," Takacs said. "That's the unintended consequence." Once the machine warmed up, we got a bit more of a vertical lift on the ball, but it would not go far enough to reach the net. All the same, we spent a few minutes hitting the listless ball back and forth.

Today we take the supposed fealty of sports-simulation games like the *Madden* and *NBA 2K* series for granted, but seeing a tennis match represented on an oscilloscope made me reconsider the entire genre. *Tennis for Two* reminded me of René Magritte's "The Treachery of Images." An illustration of a

tobacco pipe fills most of the 25"x37" canvas. At the bottom of the picture, Magritte painted the words "Ceci n'est pas une pipe." This is not a pipe. Of course it's not a pipe, not any more than a green sewer pipe in *Super Mario Bros.* (1985) is a pipe: it is a representation of a pipe made with oil paint or pixels. The distinction that Magritte illustrated—between a thing and a representation of that thing—points to the ways in which the video game medium can provide more than mere distraction and entertainment. No one would mistake *Tennis for Two* for a real game of tennis. Mimesis is not the point; realism is secondary to a representation's ability to pose questions about reality itself.

A representation is often a depiction of a thing's essential components or features. Some years ago, I spent a few hours birding with David Allen Sibley, author and illustrator of our era's definitive manual for birdwatching. He told me that he doesn't paint portraits of specific birds he sees, but instead combines elements of many examples in order to form something like an idealized version of each species. A similar idea is at work in "The Treachery of Images" and *Tennis for Two*. Seeing an object broken down to its basic parts—racket, ball, net—can provide a sort of perspicuity, and a healthy reminder that the world might be simpler in some regards than we frequently make it out to be. Video games, even crude ones, can provide the necessary distance from which we can more clearly see the world, and ourselves.

Takacs and I pored over some archival documents and photographs, then returned upstairs to a conference room. I looked out the window to make certain no mushroom clouds had appeared on the horizon. His career had begun at an important moment for his and every related field, not to

mention for the rest of the world. "I was around for the transition from analog to digital," he said. I asked him to expand on the technological changes he had experienced firsthand:

> When I was a kid, all the TVs were vacuum tubes. If you had a problem you took the tubes out and took them to the tube tester at the super market. When I got to graduate school at Johns Hopkins, all the students were required to take advanced lab. One of the things in advanced lab was electronics. My advisor was in charge of the lab and he was making the transition from analog to digital. He was getting rid of all the analog stuff and we were learning TTL [transistor-transistor logic] circuits and stuff like that. That was the transition period. I started graduate school in '69, so that would have been the early '70s. By the time I finished grad school, it was pretty much all digital, everything.

According to Takacs, the transition helped popularize video games, because all of a sudden, a program became infinitely reproducible.

Since we now play video games on so many different platforms and devices, I have always tended to use the terms "video game" and "computer game" interchangeably. Takacs, however, pointed out a possible discrepancy. To him, whereas a digital "video game" could be reproduced and made playable on multiple machines, an analog "computer game," like *Tennis for Two*, had only one iteration. Beyond that, he said, "you could make the distinction that a computer game is something that requires a processor with logic, some kind of logic circuits."

Takacs had discussed this distinction with Ralph Baer, the man many consider to be the father of video games. "You have to be careful," Takacs told me. "His position is that Willy Higinbotham's isn't really a video game—and it's true. It's not a video game. It's a quasi-computer game. The computer happens to be an analog computer. It's not something that you can plug into your TV or computer screen now and run."

By my thinking, digital games also often have many hardware-specific operations. And even *Tennis for Two* could be—and has been—simulated. I have trouble drawing a clear distinction between video games and computer games and, for that reason, I continue to think of *Tennis for Two* as the first video game. That said, I do understand why Baer, attending to his own immortal place in history, wanted to believe otherwise. Takacs appreciated that these distinctions are difficult to pin down. "How would you classify *World of Warcraft* now?" he asked me. "Would you classify it as a computer game or a video game? There's a blurring now of what is computer versus what is a purely video display."

When our conversation ended, Takacs escorted me back to the lobby. Whether it was because he didn't want to go back to work just yet or because I didn't want to face Long Island traffic again so soon, we kept chatting. He told me about growing up in what was once a Hungarian enclave in the New World. "My grandfather," Takacs explained, "ran a bar in New Brunswick, where I grew up. My father worked there for a number of years when I was a little kid. He would take me in there. They had the pinball machines—it was the sound I remember most." To him, the analog noises of *Tennis for Two* were redolent of the mechanical tavern games of his

childhood. Those otherwise lost sounds, like Proust's petites madeleines, recalled a bygone era. Takacs had succeeded, despite the odds and immeasurable difficulty, in creating a new aura for Higinbotham's old game. I taught him some curse words in Hungarian and got back in the car for the return drive to Philadelphia.

Playing *Tennis for Two*—or almost playing it—in an atomic-bomb relocation shelter, of all places, felt perfectly natural: one of Willy Higinbotham's inventions offered unlimited destructive capability and the other unbound creative promise. I wondered, if only for a moment, which will ultimately have a more profound effect on humankind.

CHAPTER 2

era of innovation

For one Russian man, permanently changing the course of human history took only an hour and forty-eight minutes. On April 12, 1961, Yuri Alekseyevich Gagarin crammed himself into an eight-foot-wide capsule atop a twenty-story-tall rocket and soon became the first earthling to break through our atmosphere and reach space. Back on the ground, the officials at the Tyuratam Missile Range launch site on Kazakhstan's desert steppe had prepared three press releases, and it was not until twenty-five minutes after liftoff that they could shred the two announcing Gagarin's disintegration.

The short and slightly built cosmonaut orbited the earth once, with the automated controls of the vessel locked to prevent a costly human error, and then reentered the planet's gravitational pull. At 23,000 feet he ejected from the capsule. By the time the parachute landed Gagarin near the Volga River, some five hundred miles southeast of Red Square, he had already rebooted humankind's relationship to our planet and the

cosmos. He was twenty-seven years old. Decades later, the computer programmer Steve "Slug" Russell would cite Gagarin's achievement as inspiration for one of the most influential video games ever made: *Spacewar!* "In 1961, something happened," Russell once told another famed video game designer, John Romero, co-creator of *DOOM* (1993). "The space race was on."

The Russians had put a man into orbit and the following month the United States launched its first astronaut in what would turn out to be a suborbital flight. The consolidation of scientific research necessitated by World War II had led to the age of computers as well as new tensions between the United States and the U.S.S.R. Russell's pioneering video game addressed those current events head-on. For the first time, the medium proved topical and reflective of the evening news.

If *Tennis for Two* was in a sense born of World War II, then *Spacewar!* was a child of the Cold War. The connections between scientific work for the military on the one hand, and for video games on the other, persisted throughout the early postwar period. The mathematician Norbert Wiener, for instance, developed new automated technologies for anti-aircraft guns during World War II. Later, after the atomic bombing of Japan, he refused to accept government funding for his research and instead took an academic position at Higinbotham's former place of employment, the Massachusetts Institute of Technology. In 1948, Wiener published a landmark book, *Cybernetics: Or Control and Communication in the Animal and the Machine*. Not long after Higinbotham introduced *Tennis for Two* to the world, Wiener revised *Cybernetics* and updated it, adding new chapters including one titled "On Learning and

Self-Replicating Machines." In it, he proposed a radical idea: "In engineering, devices of similar character can be used not only to play games and perform other purposive acts but to do so with a continual improvement of performance on the basis of past experience." That is, Wiener sought to quicken the advent of "learning machines" capable of playing "a competitive game like checkers" and even improving in skill with each subsequent game.

As a student at MIT, Steve Russell was among the first to accept the implied challenge. I would like to imagine that he and his fellow proto-hackers of the Tech Model Railroad Club (TMRC) student club sought out Weiner for advice and inspiration as they began work on a game that allowed players to control rocket ships and battle in outer space. Housed in the basement of the building where radar was invented, the TMRC geek collective collaborated on the ultimate hack. While today we think of hackers as vandals—and sometimes anonymous do-gooders—who gain illegal access to computer systems, back then the word "hack" referred to a clever modification to an existing program or system. Russell apparently fit right in among those brilliant misfits.

Born in 1937 in Hartford, Connecticut, Russell's interest in computer science began early when his uncle, a professor at Harvard, got him a tour of the university's IBM-made Automatic Sequence Controlled Calculator, also known as the Mark I computer. He earned a degree in mathematics from Dartmouth College in 1958 and then joined the Artificial Intelligence Project at MIT, where he received an advanced degree in Electrical Engineering and Computer Science. In addition to inventing *Spacewar!*, he is also known for writing

the first implementation of the previously theoretical Lisp programming language. He has claimed that he doesn't know how he earned the nickname "Slug."

When Russell arrived at MIT, as he put it, "the biggest computer available was an IBM 704. That machine was a vacuum tube computer that needed about 2,000 square feet of false floor and an extremely enthusiastic air conditioning system to work." The lab work was funded by the Pentagon. In September 1961, the Digital Equipment Company donated the prototype of its revolutionary PDP-1 computer to the university. Instead of vacuum tubes, the PDP-1 employed transistors. The manufacturers had succeeded in substituting analog parts— such as those Higinbotham had assembled—with solid-state transistors.

The broader transition from analog to digital, promised by the invention of the transistor in 1947, had begun in earnest with that delivery of the PDP-1. Every subsequent computer has relied on variations of the same technology. Those transistors brought an end to the age of vacuum tube machines, like those in Peter Z. Takacs's childhood television set. Whereas vacuum tubes once controlled the flow of electric currents in a machine, starting with the PDP-1, digital electronics performed the same task. The hackers at MIT could not wait to get their hands on the computer.

Today, most user-interface experiences have become so intuitive that we no longer notice them, but the PDP-1 represented the first time a computer had been built with ease of use in mind. The space-age design included a built-in display, which was a major improvement over Higinbotham's purloined oscilloscope. That might not sound like a big deal to

those of us with televisions in every room and electronic devices in every pocket, but throughout the 1960s only three universities in the United States—MIT, Stanford, and the University of Utah—owned computers with monitors.

According to Russell, the PDP-1 "was only the size of three or four refrigerators" and came with a staggering 4K of memory. The new computer needed a program that could demonstrate its powers, and Russell proved to be the person for the job. During the 1961 Christmas break, he began work on the first interactive game for a digital computer and spent six months developing the first iteration, which he launched in 1962 in collaboration with the TMRC.

Spacewar! featured a duel between two rival spaceships, presumably representing the United States and the USSR. Given the graphical limitations of the time, one is a needle, the other a wedge. I found a recreation online. In this version, I used the keyboard of my iMac to rotate clockwise and counterclockwise, fire the thrust to accelerate, and fire torpedoes to blow my commie enemy to bits. Players on the PDP needed to flip switches on the console itself and, as Russell put it, their "elbows got very tired." In keeping with the hacker ethos of the TMRC, *Spacewar!* was an open-source game that was preloaded onto future PDP models, and which programmers across the globe modified on their own. *Spacewar!* rapidly spread to other universities and labs with mainframe computers, and then really took off when display monitors became more widely used in the second half of the 1960s. Russell never copyrighted his game nor attempted to collect royalties from it or from future hacks like *Asteroids* (1979).

Now a central part of the gaming pantheon, *Spacewar!* is, naturally, a fixture at the Computer History Museum in Silicon Valley, where visitors can witness a forty-five-minute demonstration on a fully restored PDP-1. Because Russell's contemporaries and so many subsequent programmers hacked their own versions, *Spacewar!* is, however, probably better experienced from the comfort of one's home computer than on the more authentic original incarnation. On one site, players can choose between eleven different variations of *Spacewar!* The ability to cycle through so many hacks can provide its own history lesson. The early versions include Russell's 3.1, 24 Sep 62 [bin] and 2b, 2 Apr 62 (Minskytron hypersp.) [bin], named after the MIT Artificial Intelligence Group professor Marvin Minsky; that one offered a hyperspace escape that could, if I was unlucky, smash my spaceship into the sun or directly into an opponent's targeting range, in either case with disastrous consequences. A 2015 kitchen-sink hack even boasted a number of features combined into one game, such as the Minskytron Hyperspace, a score display, and a "Ptolemaic ego view."

My preferred version was called 3.1 "Winds of Space" [hack], in which unseen interplanetary weather warped the trajectories of the rockets and flight patterns, introducing another wrinkle of difficulty. A pulsating star in the middle of the screen exerted a gravitational pull that I learned to utilize for greater flight speed. A nebula of pixel-sized stars twinkled in the background; each star resembled, as Rainer Maria Rilke wrote in a slightly different context, a "tiny dot whose quick contrast is enough to awaken the eye even more to the thousand vicissitudes of grey."

Soon after the wide dissemination of *Spacewar!*, IBM made home computing feasible for the first time. The compa-

ny's release of the hugely successful System/360 line of computers in 1965 meant that people at home or in a lab could customize a computer to fit their specific needs; the 360 offered five different processors and nineteen possible combinations of speed, memory, and power. Unlike the PDPs and other hulking mainframe behemoths, the 360s utilized interchangeable peripherals and software. IBM's proprietary programs could run on every model in the line. Toward the end of the decade, one of IBM's marketing innovations had an even greater effect on the burgeoning video game market.

In 1969, the company adopted a new unbundling policy in which consumers would pay separately for the company's services, education courses, and future, updated iterations of its computer programs—including system software and eventually games. The software had become separate from the hardware on which it ran, creating another source of revenue for the company and allowing third-party programmers to create games for IBM hardware. It was an ingenious decision that ushered in the software industry, opening up new opportunities for would-be programmers and video game makers. Home computing—and home video gaming—would soon become a reality. The research done by the defense contractor Sanders Associates (where a young engineer named Ralph Baer found gainful employment) and several other companies would soon lead to the proliferation of home video game consoles we have today.

We attribute the word "eureka"—and the sense of an exciting, sudden discovery—to the ancient Greek polymath Archimedes, who supposedly shouted it when he stepped into the bathtub

and noticed the way the water rose around him, thus realizing that the volume of a submerged object equals that of the water displaced by it. The story sounds plausible enough to any of us who get our best ideas while in the shower, but the tale is almost certainly apocryphal; the first extant record of Archimedes's discovery did not appear until two hundred years later, in the ninth volume of *Architectura* by the Roman author and military engineer Marcus Vitruvius Pollio. Archimedes, according to Vitruvius, "leapt out of the vessel in joy, and, returning home naked, cried out with a loud voice that he had found that of which he was in search, for he continued exclaiming, in Greek, εὑρηκα." Ralph Baer, who is widely—and perhaps imprecisely—considered the Father of Video Games, had his own eureka moment in 1966 at Manhattan's Port Authority Bus Terminal.

Born into a Jewish family in Germany in 1922, in the next decade Baer, like so many others, was forced to flee the Nazi regime. In 1938, a mere three months before Kristallnacht, his family settled in the Bronx. "I was damn lucky to get out just in time," he later said. During World War II, he served as an intelligence officer in Europe, where he figured out how to adapt discarded mine detectors into radios so he could listen to music. After the war, he earned a degree in television engineering and in 1956 landed at Sanders Associates, a New Hampshire defense contractor. Baer spent his first fifteen years at Sanders working on military projects and, like most of his contemporaries, soon enough transitioned from working with vacuum tubes to digital technology and the first generations of microprocessors.

On one late-summer day, while waiting for a colleague's bus to arrive in Manhattan, Baer hit upon an idea that would

simultaneously launch a multi-billion-dollar industry and establish the foundation for the most important creative medium of our time. "I'm sitting on a curb or some steps outside of a bus terminal," Baer told an interviewer later in life, "waiting for this guy to come in, and the idea of playing games with a television set resurfaced. It had been there once before." He used a No. 2 pencil to scribble his ideas on a yellow legal pad. That four-page outline would become a reality in the form of the first video game console that people could plug into television sets in their homes: the Magnavox Odyssey.

When he returned to work, legal pad in hand, Baer began to assemble his machine:

> A few days later I put a technician on a bench and had him build television Game #1. We didn't call it that then, but that's what it was. It was basically a demonstration of how to put a spot on a screen, how to move it laterally, horizontally, and vertically, and how to color it, how to color the background.

Soon the research and development department at Sanders Associates got on board and began to experiment with the technology. "So, we put two spots on the screen, so they could chase each other and wipe one spot out upon contact," Baer said. "The very first thing I had him do was go out into a store and buy a plastic gun, and made a light gun out of a plastic gun, and shot at spots on the screen." Due to the amount of masking tape holding together the prototype, the first version was known as the Brown Box.

In March 1971, the month I was born, Sanders Associates filed for the first video game patent, something that neither

Higinbotham nor Russell had attempted to do. Sanders would soon sell the Odyssey license to the American electronics company Magnavox, which in the summer of 1972 released it to the public. That first commercial system included the console itself along with two controllers with which customers could play games with names like *Wipeout* and *Handball* and *Fun Zoo*. Each game came on a program card that depressed different dipswitches on the main board inside the console to change the game features. They were not electronic. Oddly, the Odyssey also came with playing cards, dice, and poker chips—as well as colorful, translucent plastic sheets players were supposed to hang over the television screen. While the available peripherals included the first video game gun accessory, the Odyssey had no sound capabilities whatsoever.

Ralph Baer's great contribution to video games came not as much from the design of the Odyssey, which was quickly superseded, but from his business savvy. Because he filed that first copyright, it would seem sensible to consider Baer, at the very least, the father of the video game *industry*—a subtle but important distinction. With the advent of the Odyssey, video games gained enough velocity to escape the governmental and academic atmospheres and make their way into living rooms, as a welcome distraction from the carnage being broadcast from Southeast Asia. In the first year alone, Magnavox sold 130,000 units of the Odyssey and moved Johan Huizinga's "magic circle" into the living room.

A kind of creative schism soon appeared in the nascent video gaming industry, however. While Baer and his associates attempted to corner the home-gaming market, another group of pioneers wanted to introduce stand-alone video gaming

cabinets into taverns and eventually arcades full of people, young and old, eager to drop their hard-earned quarters into the strange and alluring new machines.

In September 1971, two *Spacewar!* addicts in California, Bill Pitts and Hugh Tuck, debuted the first public video game. At a time when many people were protesting an American war overseas, they chose a less violent sounding name for it, *Galaxy Game*. They made the game for a PDP-11/20 mini-computer connected to the console by long wires and hidden, like the Wizard of Oz, behind a curtain. The $14,000 price tag did not include the $3,000 for the Hewlett Packard 1300A Electrostatic Display, the coin acceptors, or even the veneered walnut enclosure. By way of comparison, a stylish 1971 AMC Gremlin had a starting price of just $2,299. Players at the Stanford University student union sometimes waited over an hour for a single game that cost a dime; a quarter was good for three turns. The equipment was simply too expensive to make the endeavor profitable, and yet the era of arcade gaming had begun.

Meanwhile, a few miles away in Menlo Park, another *Spacewar!* fan was busy working on his own equally derivative game, *Computer Space. Spacewar!* had been "seminal to anyone who loved computers," Nolan Bushnell would say, "and for me it was transforming." As he put it, "Steve Russell was like a god to me." Bushnell built a prototype on a custom computer designed for the sole purpose of playing his game. For the display, he used a black and white TV purchased from the local Goodwill shop.

With the help of the engineer Bill Nutting, Bushnell produced 1,500 fiberglass *Computer Space* machines, but the

instructions were too complex and their slapdash marketing efforts had little effect. Even a simplified and far less expensive rendition, which a bitter Pitts called a "totally bastardized version," crashed and burned as badly as its poorly rendered spaceships. After the failure of *Computer Space*, Bushnell started his own company, drawing creative and technical inspiration from *Spacewar!*—and also on Ralph Baer's business acumen. In doing so, he succeeded in marrying the creative promise of video games to their enormous commercial potential. His upstart company—Atari—would soon become synonymous with video games.

Even now, the Atari 2600 home console can send pangs of nostalgia surging through the cholesterol-choked veins of aging gamers like myself. Whether video games today embody the ideals of art or the reach of American commercial power, or some combination of the two, depends on the specific game in question. But in its first decade, when it established many of the gaming genres and conventions that we now take for granted, Atari successfully rendered those concerns all but indistinguishable.

CHAPTER 3

atari

One recent, global-warmed winter afternoon, I dug out my Atari 2600 from the basement and carried it upstairs to our guest bedroom, which also served as my gaming cave. I had amassed a small collection of consoles as well as a Commodore 64 on which I hoped to test my limited BASIC programming chops. Mounted on the wall was a hand-me-down Dell flat screen TV from my parents which I had wired to a vintage Technics receiver and some bookshelf speakers. I eventually got the Atari working with an RCA/coax adaptor, but the picture looked lousy, showing static or some sort of interference. The console was almost as old as me, sure, but the picture quality appeared far worse than I had anticipated.

One element of vintage technological components for which I remain hopelessly nostalgic is the screws that hold them together. We cannot take apart most new electronics, not without complicated and often proprietary tools. Older devices are more obliging. With the Atari 2600 safely unplugged, I opened

it up. It snapped apart into two big pieces to expose the circuit entrails and an unfathomable amount of dust for what had been a sealed case. One wire had wiggled loose over the years, but I tightened it and hooked up the console again to find that the dense mushroom field of *Centipede* (1980) on the TV looked inviting. I searched through my small collection of game cartridges. Sadly, *Adventure*—the game I was most eager to play—was not among them. Using a more modern machine, I ordered a copy. While waiting for it to arrive, I delved into the history of Atari.

Nolan Bushnell and his business partner Ted Dabney incorporated the company in June 1972, with initial investments of $250 each. The name they chose derived from the ancient Chinese strategy game Go, in which "atari" meant something akin to "check" in chess. For their first office, they found a location in a Santa Clara industrial complex. The company scraped by on the paltry *Computer Space* royalties, a small contract with the pinball table manufacturer Bally, and the pinball machines they had installed in a bar, some coffee shops, and the Stanford University student union.

Atari's first hourly employee was seventeen-year-old Cynthia Villanueva. In addition to building components and making game cabinets, her responsibilities included making callers wait on the phone in order to give the impression that she was the point of access to a very large organization. She remained with Atari for over a decade, even after Bushnell and Dabney moved on, and watched it grow into a $2 billion a year business.

The second employee hired, Allan Alcorn, had played high school football with O. J. Simpson and graduated with an

engineering degree from Cal-Berkeley. "I had no aspiration of being a capitalist pig or anything," he would later say, "but this was a fun thing to do." His first task involved making an electronic ping-pong game supposedly contracted to General Electric. It was only meant to be an exercise and, at first, was not intended for a public audience. The project had been intended as an exercise to acclimate Alcorn to the business of making games. It certainly worked: he called his experimental game *Pong*.

Pong occupies a unique place in the American cultural imagination. The arcade-cabinet game was an obvious hack or remake of an Odyssey game, which itself was an obvious remake of *Tennis for Two*, and yet the series of lawsuits that ensued made no mention of Willy Higinbotham. Many other people—starting with Ralph Baer and Nolan Bushnell—would make a great deal of money from the game.

For all Baer and Bushnell's success in launching the video game industry, however, as a final answer to the question of who invented video games, I'd say Willy Higinbotham and Steve Russell. They are the true creative pioneers. While the entire debate of who fathered this or founded that strikes me as misguided, I do feel quite comfortable with the fact that video games have two dads.

While the gameplay of *Pong* closely resembled previous tennis or ping-pong simulations, Alcorn's decision to add angles and variable velocities to the simulated ball's trajectory off the paddles made for a more sophisticated experience than anything that had come before it. As with *Tennis for Two*, players used rotating dials to move narrow rectangles (or paddles) up and down the sides of the screen. A ball bounced back and

forth between them; the objective, simple enough, was to hit it past the paddle of the opponent. Moving the paddle upward or downward while striking the ball volleyed it back at a sometimes tricky angle. That was about the extent of the strategy.

For all of Alcorn's innovations, however, it was the digital noises that made *Pong* the touchstone that it is. He described how the combination of a lucky accident, a tight budget, and limited technical resources led to those iconic sounds:

> I just tried to make the game better and better, and at the end of the thing [Bushnell] said 'you've got to have sound.' Oh okay, well I'm over budget and three months into this thing and Nolan said 'I want the roar of a crowd of thousands.' Cheers, applause. How do you do that with digital circuits? Ones and zeroes? I had no idea, so I went in there that afternoon and in less than an hour poked around and found different tones that already existed in the sync generator, and gated them out and it took half a chip to do that. And I said 'there's the sound—if you don't like it you do it!' That's the way it was left, so I love it when people talk about how wonderful and well thought out the sounds are.

Alcorn programmed the game to make different noises when the ball hit the wall, when the ball hit the paddle, or when one player scored a point. The frequencies were, respectively, 226 Hz, 459 Hz, and 490 Hz. In musical terms, the interval between the wall and paddle amounted to an octave, which made the combined effect of those two *bop* and *beep* sounds during gameplay pleasing to the ear. The longer,

screeching sound when a point was scored, however, used a disharmonious and scolding tone, as if to punish the player who allowed the point rather than to celebrate the one who scored it. Even now, those three sound effects have a pseudo-religious status among video game aficionados and even some non-gamers, who might not know where they come from.

Subsequent game makers would build upon those three short tones for decades, employing harmony and disharmony in effective ways. Perhaps Alcorn was merely being modest when he described choosing *Pong*'s sound effects—or maybe we should consider them to be among the many great strokes of luck in video game history. The expansive musical landscape of a current game like *Journey* (2012) or *Gravity Ghost* (2015) might seem like an entirely different beast, but just as the ape has evolved from a single protein so too can we hear the origins of today's lush and beautiful video game soundtracks in *Pong*. Like the early moving pictures, the first video games had been silent. *Pong* changed that, permanently.

The prototype took Alcorn three months to build. He housed it, along with a black and white Hitachi TV, inside a four-foot-tall wooden box. Two knobs controlled the action and, of course, a coin slot accepted the players' spare change. The terse instructions read simply: "Avoid missing ball for high score." Again, I find the baseline negativity interesting. The point of *Pong* was not to score points, but to prevent one's opponent from doing so.

To test the game, Bushnell and Dabney installed it at Andy Capp's Tavern in Sunnyvale, California, where its immediate popularity caused them to rethink their limited plans. Because they had not initially anticipated making a commercial

version of *Pong*, they had neglected to take Ralph Baer's patents (since licensed to Magnavox) into account, and he promptly sued them. Atari reached an out-of-court deal with Magnavox that involved a small financial settlement. At the time, no one expected Atari to become the fastest-growing company in America. The agreement also made Atari the exclusive license holder for Baer's patent; other companies that wanted to market video tennis would be on the hook for royalty payments to Magnavox. That discouraged much of the competition.

Atari distributed *Pong* games in stand-up cabinets 26" wide and 50" tall with a shipping weight of 150 lbs. The fake wood grain gave it the appearance of a piece of furniture, though it had a screen placed inside the trapezoidal hole cut from the yellow facing. An early advertisement boasts the "Realistic Sounds of Ball Bouncing, Striking Paddle" and "Simple to Operate Controls." At the top of the machine, the four letters P O N G were rendered in a variation of Herbert Bayer's experimental 1925 Bauhaus typeface. The O appears perfectly round and the lower-case N resembles a horseshoe-shaped magnet. Later, Nintendo would revive that font again for the title screen of another iconic game, *Super Mario Bros.*

By the end of 1973, Atari had sold 2,500 *Pong* cabinets. A year later, they had moved upward of 8,000. The rapid growth in orders led Bushnell and Dabney to expand their operations; the company soon moved to successively bigger facilities and hired more and more employees, few of whom had experience with engineering or assembling electronics. They brought in untrained workers, including members of motorcycle gangs,

from the unemployment office. Some of them reportedly stole the televisions and sold them in order to buy heroin. The corporate culture included plenty of beer drinking and recreational drug use. During the winter of 1977, a new designer nearly stepped on dirty syringes littering the bathroom floor. Dabney grew uncomfortable with the new developments and left Atari, but kept enough shares to become wealthy.

As with most successful companies, copycat businesses eventually came out of the woodwork. Rather than taking on the time-consuming chore of filing for patents, Atari continued to innovate and expand upon its line of arcade-cabinet games, many of which have been entirely forgotten. In *Gotcha* (1973), one player acted as the square-shaped Pursuer and chased the other player, the plus-sign Pursued, through a maze. Early versions featured round, pink orbs that players squeezed to control the action; it was an attempt to make a female-oriented game, which many Atari employees came to call the "boob game." They eventually removed the orbs in favor of a joystick. Advertisements for *Gotcha* included a photograph of a man grabbing a scantily clad blonde woman from behind. Bushnell was also known to wear a t-shirt that read "I love to screw" to the office. The poor taste aside, *Gotcha* no doubt inspired *Pac-Man* (1980), among countless other maze games.

Atari's *Gran Trak 10* (1974) was among the earliest racing video games and thus serves as a precursor, of sorts, to the *Mario Kart* series. Two budding programmers hanging around the Atari offices, Steve Jobs and Steve Wozniak, adapted *Pong* into the aptly titled *Breakout* (1976), in which players sent the ball careering towards the top of the screen in an attempt

to chip away at colorful blocks suspended there. With the advantage of hindsight, it is easy to imagine those shapes falling downward and maybe twisting and turning along the way: the original incarnation of *Tetris* (1984) appeared less than a decade later.

Atari also began development of a home version of *Pong* that, like the Odyssey, consumers could hook up to their TVs. It went on to sell 150,000 units at Sears Roebuck and invigorate the home video game market on a scale not even Ralph Baer could have imagined. Later systems from other companies, including the Fairchild Channel F, which employed interchangeable cartridges, exposed the banality of *Pong* and threatened to take over the market. In October 1977, Atari responded by placing an 8-bit 6507 microprocessor inside its new and poorly named Video Computer System or VCS—later rechristened the Atari 2600.

The VCS offered startling new imagery, and it arrived with the paddles needed for *Pong* and other games, as well as with a new user-interface device that had been invented by German rocket scientists and used to steer guided missiles during World War II: the joystick. That proved to be perfect for shooting at bugs and running from dragons. The VCS made such great use of the cartridge technology that it soon dominated the marketplace and the public imagination.

I was six years old when the VCS debuted, but didn't own one because my parents believed video games were frivolous. They didn't forbid me from playing them, but they didn't encourage me either. Now, finally, I understand why. And they were

generous enough to buy my siblings and me a Commodore 64, which they thought would be more edifying, as with it we could learn how to program computers instead of, by their thinking, waste time with mere games. Watching others play Atari at the homes of friends and neighbors became one of my great pleasures. I vividly remember being dazzled by the dexterity one classmate demonstrated in navigating the mazes in *Adventure*. That game transfixed me for hours, even though I was a mere spectator. Contemporary e-sports fans tend to understand this kind of passive enjoyment. And I never did learn how to program a computer, beyond a few simple commands like `10 PRINT CHR$ (205.5+RND(1)); : GOTO 10`.

In 1999, Elivi and I moved back to the United States after nearly five years in Budapest. I was twenty-eight years old. While abroad, I gained a new and nostalgic appreciation for Americana and for distinctly American forms of art. Once we settled down in a tiny Philadelphia apartment—temporarily, as it turned out—I acquired an Atari 2600 from one of my newly married friends. The adoption papers had pictures of US presidents on them. At that time, the Nintendo 64 and the original PlayStation ruled the console market, and the 2600 had not yet gained the cult following it has today.

The Atari 2600 wasn't the first home console, nor the most sophisticated, and every subsequent generation of consoles makes the older ones appear ever cruder by comparison. The only reasonable explanation I can think of for my revived interest in the 2600 and for its enduring popularity today is the way in which nostalgia can file down the rougher edges of our memories. The reality of the late 1970s for most Americans was not all video games and Pop Rocks, and yet we

cannot resist imagining the past—even the recent past—as a simpler and much more fun time.

Nostalgia for the Atari 2600 also stems, I would hazard, from the widespread tendency to think of the history of video games in what are literally epic terms. Long before there was epic loot, there was epic storytelling that explained the origins of a country or, nowadays, an industry. According to the Russian formalist thinker M. M. Bakhtin, "the world of the epic is a world of 'beginnings' and 'peak times' in the national history, a world of fathers and of founders of families, a world of 'firsts' and 'bests'." To declare Baer or Russell or Higinbotham the father or founder of video games is to sequester and valorize their eras, establishing a false historical moment that is "walled off absolutely from all subsequent times." The reality is always more fluid and subtle.

Beginning in 2002, Elivi and I moved numerous times around the country for graduate school and careers: from Philly to the Midwest, the Midwest to Louisiana, Louisiana back to Philly. Each time we loaded up the car, be it the old Camry sporting its third transmission or new 2003 Echo that we towed 780 miles behind a moving truck down I-55, we brought along the Atari 2600 and a dozen cartridges. When I hooked it up again recently in my gaming cave, I was curious to learn if the games might provide pleasures beyond the mere historical or nostalgic. Could they possibly be artful? Luckily, a copy of *Centipede* was among them. Even the most casual gamers are likely familiar with *Centipede*, but few recognize that it represented one of the earliest contributions of a female game designer. Dona Bailey, co-creator of the game, was the only woman programmer in the arcade division at Atari

during her two-year stint there. "I wasn't really interested in war, or lasering anything, or violence," she once recalled. However, "it didn't seem that bad to shoot a bug."

I was struck by how contemporary *Centipede* felt in many regards, perhaps because of the game's unusual vertical orientation on my letterbox-shaped TV. It's a fixed-shooter in which I controlled a cannon on the bottom of the screen. My goal was to repel the snaking and segmented insects that dropped down amid the mushrooms that may have inspired Shigeru Miyamoto's fungus imagery a few years later in the *Mario Bros.* games. *Centipede* remains a kinetic game that generates enough stakes-free panic to get my heart pumping.

I also became absorbed by another shooter, this one horizontal, called *Yar's Revenge* (1982). It was the first game made by the talented designer Scott Warshaw and also his most creatively and commercially successful. In it, I controlled a spaceship in its effort to destroy the defenses of an enemy called Qotile. The strange visual design included an ugly, static-like vertical bar of multicolored pixels down the center of the screen. On my TV, it looked like a flaw in the hardware. The first time I played the game, I assumed that the cartridge had deteriorated over the years, but that was not the case.

Incorporating pure code into the field of play was an unconventional decision, one that allowed *Yar's Revenge* to revel in the 128 bytes of RAM and 4K bytes of ROM instead of hide from them. "As an Atari 2600 designer you were hemmed in by all the things you couldn't do," Warren Robinett, creator of *Adventure*, told me, "so it did make some decisions for you. It was a little bit easier in a way. The things you struggled with were just how to implement anything in a tiny little

memory." Warshaw would also have success with 1982's *Raiders of the Lost Ark* game, but his adaptation of another Steven Spielberg movie did not fare as well. *E.T.: The Extra-Terrestrial* cartridge (also 1982) is often deemed the worst Atari game of all time. It was said to be so terrible that hundreds of thousands of copies were buried in a New Mexico desert—not far, incidentally, from Los Alamos. A spring 2014 expedition undertaken by an intrepid documentary crew managed to unearth some intact copies, verifying the story, at least in part. Like the Ark of the Covenant, perhaps the game should have remained buried.

Carol Shaw's *River Raid* (1982) was, like *Centipede*, another vertically-oriented shooter. Instead of seeing the entire playable area all at once, however, I controlled a jet that flew upward over a scrolling landscape. The objective was to shoot helicopters and other planes out of the sky, knock out bridges, and steal fuel to remain airborne. The action reminded me of disturbing footage from the Vietnam War in which fighter jets indiscriminately carpet-bombed a Southeast Asian delta. *River Raid* earned rave reviews from several American publications. The nascent video game press called it "one of the most playable and entertaining of all war games." The government of West Germany, by contrast, banned its sale to minors.

Despite the violent gameplay, *River Raid* and *Yar's Revenge* both at least *sounded* great, like so many other early games. The combination of herky-jerky motion, more colors, and minimalistic sounds made for a distinctive experience. Those games hinted at the medium's artistic potential. The 1982 cartridge *Berserk* (adapted from a 1980 arcade-cabinet game) included an even more sophisticated use of sound. In

that game, the player controlled a human-like avatar apparently trapped in some sort of complex with a series of murderous, ray-gun toting robots and a bouncing smiley face named Evil Otto who wiped out everything in his path.

Each shot I fired produced a tone that lasted as long as the projectile stayed in motion, which meant that the rhythm of the soundscape sped up and slowed down depending upon the number of killer robots remaining and their proximities to the walls separating the rooms on the screen. I discovered that the robots would continually attempt to fire back at my avatar even through those same walls, which blocked their blasts. I could put down the joystick and go downstairs for a glass of water, maybe take a walk around the block, and upstairs a digital beat circa 1982 continued to throb.

The entire point of *Berserk*, like so many video games, is to stay alive as long as possible. Like existence itself, in *Berserk* there are no levels to attain, no loot, and no real point other than inevitable death. "What we call death is the total non-functioning of the physical body," the Buddhist monk and scholar Walpola Rahula has written. "Do all these forces and energies stop altogether with the non-functioning of the body?" Alone in my cave, seeking answers, I flipped the reset switch on the 2600 again and again.

CHAPTER 4

call to adventure

I plugged the plastic cartridge containing what I believe to be the greatest video game of all time into my Atari 2600. Warren Robinett's *Adventure* came to life. It depicted a room that felt deeply familiar, in part because it had the same general dimensions as those in *Berserk* and several other titles of the era. The numeral 1 appeared dead center in the screen. A thick, bright pink border surrounded the playable area—except at the bottom of the screen, where there was a gap representing a door. That seemingly unremarkable segment devoid of pixels represented a gigantic innovation in video game history. It would open up creative possibilities for every future video game designer.

Toward the end of his long and vibrant career, the British art historian Kenneth Clark described a masterpiece as a "work of an artist of genius who has been absorbed by the spirit of the time in a way that has made his individual experiences universal." That strikes me as the perfect definition,

one that is both generous and sensible. In his book *What Is a Masterpiece?*, Sir Kenneth is concerned primarily, but not exclusively, with paintings, citing such luminous artists as Rembrandt, Breughel, and Caravaggio.

Conservative-minded critics have always dismissed new and radical artworks that later generations grew to revere. The critic Henry F. Chorley, writing in the *London Athenaeum* in 1851, famously said of *Moby-Dick*: "Mr. Melville has to thank himself only if his horrors and his heroics are flung aside by the general reader, as so much trash belonging to the worst school of Bedlam literature—since he seems not so much unable to learn as disdainful of learning the craft of an artist." That final clause remains a sick burn for the ages. Contrary to popular legend, Vincent van Gogh did not sell only one painting during his lifetime. Recent evidence indicates that he sold two.

Likewise, in the last century, it took museumgoers and critics decades to warm up to emerging styles like Cubism, Abstract Expressionism, and Pop Art, all of which are now woven into the musty fabric of art history. "Can we say that the great cubist pictures of Picasso are masterpieces?" Sir Kenneth asked as recently as 1979, the same year Atari released *Adventure*. "I think we can. A picture like the *Woman with a Guitar*, which seemed so esoteric when it was painted in 1911, now offers no difficulties to anyone with a sense of animated design."

Considering the number of copies sold, *Adventure* was not exactly esoteric. It attained mass popularity almost immediately, but only in later decades has the game's true significance become apparent. Clark wrote that "a masterpiece must use the language of the day, however degraded it may seem" and

Adventure does precisely that. Yet the game's internal logic was at the same time revolutionary; it introduced features that have become not merely commonplace, but that even non-gamers find intuitive. Robinett's doors opened up an entirely new way of existing in digital space.

Though indicative of their times, according to Clark, masterpieces have their antecedents. Or as Borges put it, in writing about Kafka: "The fact is that each writer *creates* his precursors. His work modifies our conception of the past, as it will modify the future." So it would be impossible to fully appreciate the genius of Robinett's *Adventure* without first understanding the text-based game that inspired it.

Colossal Cave Adventure (1976) has a long and complicated history. It has gone by several different names, including *ADVENT* and, confusingly, *Adventure*. It persists in the public imagination in part because of its invention of the magic word "Xyzzy," which many subsequent programmers have adopted and utilized. It has been tinkered with, hacked, remade, and ported to countless different computer systems over the years.

Will Crowther was an active spelunker, mapmaker, and role-playing gamer. In the early 1970s, he had worked for the Boston defense contractor Bolt, Beranek and Newman, which, with funding from the Department of Defense, developed the Advanced Research Projects Agency Network (ARPAnet). ARPAnet was the first system to utilize packet switching (in which data is divided into small blocks or "packets"), and was thus a foundational technology behind our current internet. Crowther once described his inspiration for what became *Colossal Cave Adventure*:

Suddenly, I got involved in a divorce, and that left me a bit pulled apart in various ways. In particular I was missing my kids. Also the caving had stopped, because that had become awkward, so I decided I would fool around and write a program that was a re-creation in fantasy of my caving, and also would be a game for the kids, and perhaps some aspects of the Dungeons & Dragons that I had been playing.

That program turned out to be a computer simulation of Mammoth Cave in south central Kentucky, which, according to the National Park Service, is a "grand, gloomy, and peculiar place." Melville used the very same in *Moby-Dick* to illustrate the girth of a sperm whale:

> Let us now with whatever levers and steam-engines we have at hand, cant over the sperm whale's head, so that it may lie bottom up; then, ascending by a ladder to the summit, have a peep down the mouth; and were it not that the body is now completely separated from it, with a lantern we might descend into the great Kentucky Mammoth Cave of his stomach.

Visitors to the cave nowadays must walk on special bio-security mats intended to prevent the spread of the fungal White-Nose Syndrome that infects bats.

Crowther programmed the original simulation in FOR-TRAN, for use on a PDP-10 mainframe computer. He may have abandoned the project by 1976, when another programmer, Don Woods, found a copy on the computers of the Artificial Intelligence Lab at Stanford University. Woods contacted

Crowther and got his permission to expand the program. A BBN alumnus named Jim Gollogly further adapted the game by porting it from FORTRAN into the programming language C, for UNIX. These subsequent commercial versions—endorsed by Crowther and Woods in exchange for royalties—added various elements, such as a points scale. If players collected every possible treasure, they would receive code for a "Certificate of Wizardness" with facsimile signatures of Crowther and Woods. The game was eventually included on the first IBM personal computers and thereby introduced to a large audience.

To play *Colossal Cave Adventure* now one must choose among the many available versions. I downloaded one of several for DOS, which had been patched together by members of the old Digital Equipment Computer User's Society Bob Supnik and Kevin Black. Alas, a post by an individual calling himself codescott123 on the *Colossal Cave Adventure* forum claims:

> If you are using the Bob Supnik code for creating your new port, you are *not* working from the *original* Adventure FORTRAN code. Bob Supnik created a FORTRAN port of the original PDP-10 Adventure code... so the port would run on the PDP-11.

Every video game has its fundamentalists, its strict adherents to the original text. Those asterisks, as we will see, recall the textual vernacular of the game itself. Original or not, Supnik's version is the one I decided upon. Video games, in one sense, resist the notion of originality; there is no single

handwritten urtext of a video game, only countless copies, many of them hacked.

Fortunately, *Colossal Cave Adventure* maintains its frustrating charm even if any possible aura it once possessed has been dispersed. The game is, as one scholar of interactive fiction described it, "an interactive textual simulation of a caving expedition, augmented by fantasy-themed puzzles." That description does not quite capture the game's simple elegance. Even downloaded onto a malfunctioning and absurdly heavy Sony Vaio laptop, it remains a joy to play. There are no chunky spaceships, no vaguely Italian plumbers, no graphics at all—only text. Clicking on the .exe file opens a black window with white letters:

```
Please wait while I initialise.
```

I find the politeness of "please" and the presumed formality of the British spelling endearing, but what most catches the eye is that first-person pronoun. Who does that "I" purport to be? Who is it exactly that is initializing? The program itself?

```
Welcome to Adventure!!  Would you like
instructions?

   >_
```

I type "yes," which causes the program to load the following Introduction in a box within the DOS window:

```
Somewhere nearby is a colossal cave, where oth-
ers have found fortunes in treasure and gold,
```

though it is rumoured that some who enter are
never seen again. Magic is said to work in the
cave. I will be your eyes and hands. Direct me
with commands of 1 or 2 words. I should warn you
that I look at only the first four letters of each
word, so you'll have to enter "NORTHEAST" as "NE"
to distinguish it from "NORTH". (Should you get
stuck, type "HELP" for some general hints. For
information on how to end your adventure, etc.,
type "INFO".)

The double spaces between sentences recall a bygone era
of punch cards and dot-matrix paper, with its perforated
edges that allowed loading into a printer. The use of first per-
son again seems to indicate the impossible notion of sentience,
the program itself serving as our friendly guide.

After a few lines crediting Crowther and Woods and the
programmers responsible for the current edition, the instruc-
tions end with an emphatic:

GOOD LUCK!

Then the game begins.

You are standing at the end of a road before a
small brick building. Around you is a forest. A
small stream flows out of the building and down a
gully. In the distance is a tall gleaming white
tower.
 >_

The blinking cursor, depicted here with an underscore, waits for me to enter an instruction of one or two words. Options are limited; free will does not truly exist in the game's world. I cannot drink stream or break dance. Attempting to climb tree earns the disappointing admonishment: "I don't know how to apply that word here."

Typing enter building, however, leads to:

```
You are inside a building, a well house for a
large spring.
    There are some keys on the ground here.
    There is a shiny brass lamp nearby.
    There is food here.
    There is a bottle of water here.

    >_
```

I cannot even ice skate on the "frozen rivers of orange stone." Every instruction I type, if the program recognizes it, closes off a number of possibilities and opens up others. As with Dungeons & Dragons, it helps to keep some graph paper handy and to draw a map of each room in order to maintain my bearings.

Issuing commands in the correct sequence allowed me to make some progress through the unseen maze. I had to drop the "three foot black rod with a star on one end" before I could TAKE BIRD. Once the bird frightened the "huge green fierce snake" I could move on. Naturally, detailed diagrams and walk-throughs now proliferate online; after an hour of wandering and getting lost and being killed by knife-wielding dwarves, I cheated, and sped my way through the cavern to

safety. I did so knowing full well that, as Johan Huizinga wrote, "cheating as a means of winning a game robs the action of its play-character and spoils it altogether, because for us the essence of play is that the rules be kept—that it be fair play." It is a sin I will repeat, without ever repenting, with many other games. Devoting more time to finishing the game using solely my own logic and memory might have been exponentially more rewarding, but I understood that every minute I spent frustrated by my inability to think of simple two-word commands could have been better employed hunting dragons on my Atari 2600.

I wiggled the joystick and mashed the lone button, but nothing happened in the colorful world of *Adventure*. Once it occurred to me to toggle the GAME RESET lever on the console, the border around the room changed from pink to yellow and a castle of the same color filled the top-center of the picture. Only the left joystick worked, indicating that it was a one-player game. I had forgotten that from my childhood. A black key appeared to the left of the castle.

My avatar was a simple square the same color as the border, which I could move left and right, up and down, and diagonally. Of all the stand-ins and representations of players I had seen in video games—from the insatiable yellow maw of *Pac-Man* to my painstakingly armored and transmog-ed toon in *World of Warcraft*—that square avatar in *Adventure* remains the most memorable. A decent, detailed drawing of a specific person, say of René Descartes, looks like him and him alone. The rest of us who are not René Descartes can recognize a shared humanity because we all have eyes, a mouth, and a nose in the same general place. (Such is not true, I

would later learn, of my avatar in *Spore* (2008)). But a portrait of Descartes is a portrait of him alone.

A smiley face, however—made up of just a circle, a semi-circle, and two dots—is vague enough that it could be said to represent everyone. A prime example is Evil Otto, the bouncing nemesis in *Berserk*. In *Understanding Comics*, the illustrator Scott McCloud discussed the universality of a smiley face. "The more cartoony a face is," he wrote, "the more people it could be said to describe." The square avatar of *Adventure*, in a way, pushes this kind of thinking to its logical endpoint: we know that it is a stand-in for any—or all—of us.

"I called the square 'The Man,'" Robinett told me. As with *Pac-Man*, it never would have occurred to me to think of that block of pixels as gendered. I asked Robinett how he arrived at that shape. "I decided to make it a square just for symmetry. And I wanted it to be narrower than the passages you had to move through, that was obvious." Though he called it The Man, Robinett understood its ungendered universality. "So I drew this little square and it's sort of the ultimate blank slate. It's about as abstract as you get."

The geometric simplicity of The Man spoke to the limited technological resources at Robinett's disposal, which were nevertheless considerably greater, in some respects, than those of Willy Crowther and Don Woods. Robinett explained his fascination with *Colossal Cave Adventure*:

> Willy Crowther basically invented the rooms and objects, and then Don Woods expanded it and added a lot of cool stuff. And I recognized that the rooms and objects thing could conceivably be adapted to the video game medium. I

think I did a pretty good job adapting it, especially because it was hard to fit it into 4K. So in adapting it to the video game medium, it changed a lot. I could make these animated creatures that chased you around. There's not really any way to do that in a text adventure game. The dragon's chasing you, he's getting closer, he's 80 feet away, he's 70 feet away, he's 60. It just wouldn't work, right? So I think I did a good job of implementing the rooms and objects idea as a video game. I just introduced some innovations, and they worked.

Robinett's love of *Colossal Cave Adventure* sent him on an adventure of his own. "I made a pilgrimage to Mammoth Cave a long time ago and I have seen the frozen rivers of orange stone."

The square avatar was only the beginning of the innovations Robinett introduced. He decided to create a network of rooms as well as objects The Man could carry from place to place. He also managed to invent a way to represent movement between rooms by, as two of our more astute scholars of video games once put it, "rendering a large virtual space in screen-sized segments." The innocuous gap in the pixel border around each room depicted on my TV screen was what made that possible.

Robinett graduated from Rice University in 1974, where he studied a combination of computer science, linguistics, and art. All three disciplines found expression in his work for Atari. "I thought I was going to Vietnam right after I graduated college,"

he told me, "so I didn't really see any point in taking accounting courses. I had six semesters of art courses from art professors. One thing I learned was that some of these guys can be very, very arrogant and snotty about what's art and what's not." Instead of ending up in Southeast Asia, Robinett landed a job programming in FORTRAN in Texas and then earned a master's degree at Berkeley before accepting a job at Atari in November 1977. He began his short but important tenure there with the cartridge game *Slot Racers* (1978), and soon after created *Adventure* (1979), the first true masterpiece in video game history.

Slot Racers, he said, was "nothing to write home about, but you kind of needed to do one game like that. You needed a little bit of experience with the 2600 to understand how a chip inside of it worked. So I was lucky that I had a practice game before I did *Adventure*." The experience proved invaluable, especially as an object lesson in the limits imposed by each cartridge's memory. "Memories were so small for Atari video games back then. *Adventure* fit into 4K. 4,096 bytes of ROM. There was a ROM chip and cartridge that plugged in and the amount of RAM was 128 bytes, 1/8th of a K," he said. "Memory was expensive." For instance, in 1978, Intel's 16-bit 8086 CPU could address just 1MB of RAM and cost a staggering $360. As of the middle of 2016, $350 could buy a PlayStation 4, which with 500GB of memory can store—by my questionable calculation—125 billion times more memory than an Atari cartridge. For gamers, at least, there might not be a clearer reminder of Moore's Law.

With *Slot Racers* under his belt, and with a richer understanding of the technology at his disposal, Robinett began pondering *Colossal Cave Adventure*. He said, "The game blew me

away and I decided right then that's what I was going to do, but I had to have some kind of an answer for how the controls were going to go." Above all, "How are you going to get from room to room?" When he pitched the idea for *Adventure*, his supervisor George Simcock insisted that he could never translate the fantasy elements of *Colossal Cave Adventure* into an appealing (that is, profitable) graphics-based game. "He said it was impossible," Robinett said. Simcock forbade him from working on *Adventure*. He did it anyway.

The memory limitations proved helpful. When I lived in Budapest in the mid-1990s, a number of my friends and colleagues were computer programmers who had grown up behind the Iron Curtain. The main reason many of them were so excellent at their jobs—several went on to invent LogMeIn, which is now worth a cool $1.3 billion—was that they had to make do with scarce resources. They were able to create programs on par with those coming out of the West, but relied on only a relatively small fraction of the computing power. A similar dynamic is evident among the first pioneers of video gaming, and perhaps nowhere more prominently than with Robinett and *Adventure*. Robinett spent six weeks building a prototype. His boss still refused to budge. "He was pissed that I had disobeyed him," Robinett said.

In the summer of 1978, Robinett became fed up with his job. "I was burned out. I was being treated like a bad employee who wasn't doing what he was told to do." He walked out: "I told the people at Atari that I was going on vacation for a few weeks, and they said they don't hold jobs here. And perhaps this wasn't very smart. *Adventure* might never have happened." In his absence, Atari's marketing department had

played the game and liked it, as Robinett said, "because it was different." A few weeks later, he went back to work on the defining game of the Atari 2600 era.

Robinett often biked from Menlo Park to Atari's offices in Sunnyvale, arriving and leaving at all hours of the night. He described his routine of stopping halfway, where a convenience store sold the Coca-Cola and candy bars he needed to re-energize himself after another long day of coding. "I remember quite a few times I'd work as long as I could then I'd get into kind of a daze," he said, "then I was faced with a thirteen-mile bike ride home and I had an empty tank. My mind will still be going a hundred miles an hour and I was on one of those bike rides when I decided to just have an object that you can pick up into an inventory screen."

Sitting in front of my TV, joystick in hand, I thought of Robinett peddling through Northern California in the middle of the night while I—that is, The Man—grabbed the digital key he had created. I noticed that the game made two different four-note jingles when I picked up or put down that or any other object. "I just used the sounds that were easy to make," Robinett said. "It turns out that the sound effects are arpeggios." As with the sound effects of *Pong*, a little bit of luck produced an extraordinary result:

> In a way, those four notes were little musical compositions. I didn't choose the notes but I did recognize that it worked—the first thing I tried worked and I didn't change it. I think I got lucky to some extent, but I get a little bit of credit for recognizing that that worked and I didn't need to change it.

As The Man, I carried the key back to the gate and into the castle.

Moving out of the top of my TV picture transported me to the bottom of what I instinctively understood to be another room. The new color of the space, and the new color of The Man, helped indicate the same. That innovation seems so obvious now, but only because every subsequent generation of video game designers has incorporated it. "There was no other way to implement a rooms and objects network of rooms on a rectangular TV," Robinett said. "Maybe there was some other way, but if there was I couldn't think of it. I wanted to do rooms and objects like *Colossal Cave* but on the Atari video game, which is a screen, right? I decided we can only show one room at a time on the screen." *Adventure* succeeded in depicting a massive world on a tiny television set and in doing so created a sense of a seemingly unlimited area of play. The effect calls to mind the opening prologue of Shakespeare's *Henry V*, in which the Chorus apologizes to the audience for the inability to depict a huge military battle on a small stage:

> But pardon, gentles all
> The flat unraisèd spirits that hath dared
> On this unworthy scaffold to bring forth
> So great an object. Can this cockpit hold
> The vasty fields of France? Or may we cram
> Within this wooden O the very casques
> That did affright the air at Agincourt?

Shakespeare managed to use the apparent limitations of his medium. So, too, in his own way, did Warren Robinett.

Nevertheless, I continued to get lost in *Adventure*'s maze for hours, even on the easy setting. Since I'd first played it decades ago, I'd forgotten that the game had little in the way of a defined narrative. Maybe the game's original players simply didn't notice that lack, so enraptured were they in the game's mechanics. Also, they would have had little else to compare the game to.

My aimlessness didn't bother me all that much, but only because I had no understanding of the objectives of the game. Nothing on the screen explained The Man's purpose. Was I supposed to free a princess from a castle? Would there be a boss fight at the end? There was no way to know. Games back then did not yet include tutorials. After repeating the same steps several times and expecting different results, I made a truly desperate decision and opened the instruction booklet. The story related within shared only a tenuous relationship to the gameplay. Here is the premise of *Adventure*: "An evil magician has stolen the Enchanted Chalice and has hidden it somewhere in the Kingdom. The object of the game is to rescue the Enchanted Chalice and place it inside the Golden Castle where it belongs." In other words, I was supposed to find the Holy Grail. Three dragons—Yorgle, Grundle, and Rhindle—had been dispatched to stop me.

I dropped the key and grabbed an arrow which represented a sword I would use to slay the dragons. However rough those pixelated dragons might appear to young gamers today, I remember how perfectly they served as the visual manifestations of the era's cutting edge technology. To me, they still look great, as did the bat that might have come straight out of Mammoth Cave.

Unfortunately, I forgot where I left the sword, and then got lost again in a multi-screen maze, where I encountered one of the dragons, though it actually looked like a duck. When it killed me, much too easily, I remained visible in its belly but was unable to continue playing. I hit the RESET switch again. Instead of starting the game from scratch, however, I was magically transported back to the yellow castle. Robinett had developed a good alternative to forcing the player to begin again at the beginning. "I decided to give you a way to reincarnate," he said. The castles I had unlocked remained unlocked and any objects I had moved—a key or bridge or magnet, for example—remained where I had left them. In a video game, death is rarely the end.

Though not every aspect of the gameplay was intuitive, there are reasons to play it other than nostalgia—above all that it is one of the earliest games to *feel* like today's games. I asked Robinett to account for *Adventure*'s enduring appeal. "This user interface was good. It was easy to understand. It was simple." He went on: "I made a breakthrough. Sometimes I say I discovered a sweet spot within the medium." That's true, but there's also at least one other way to account for its lasting legacy.

I wondered if Robinett got the idea for the first Easter egg in video game history during one of those long Coca-Cola-fueled bike rides. In those early days, programmers rarely received royalties or public recognition for their creations. Robinett explained the situation:

Each video game back in the late '70s was designed by one person. You had the idea, you wrote the codes, you did the graphics, you did the sounds, you tested on kids, you debugged it. You decided when it was done, you wrote a

draft of the manual. You did everything. There was nobody else working on one of these games. They were tiny little memories. It didn't take much to fill up the little ROM. So that's why it made sense back then for one person to do the whole thing, but you didn't get any public credit at all. It was going to be *Adventure* by Atari. So it pissed me off.

Robinett decided to leave his mark anyway. By the time his bosses learned what he did, there was nothing they could do.

I restarted my quest, but this time I had a different goal: a secret chamber that Robinett hid deep in the game. "Well, I wanted to get credit for it—public credit," Robinett said. When writing the code, he found a way to do just that:

I don't like being pushed around so I found a sneaky way to hide my name in the game without telling anybody in the company, because if I'd told anybody they would've went and found my name and erased it, right? So I didn't tell anybody and they manufactured 100,000 cartridges and sent them all over the world; you can't put the genie back in the bottle.

Players who select game 2, set the difficulty switch on the console to b, and block off a great deal of free time might be able to find in *Adventure*'s maze a seemingly invisible gray dot one pixel in size. "It was my attempt at irony, I guess. Small and insignificant-looking, yet important." Locating that dot is the first step to accessing the secret chamber.

Tom Hirschfeld's 1982 pulp paperback *How to Master Home Video Games* includes a chapter called "The Case of the Proud Programmer." It lists twenty-seven steps to finding

the Easter egg, including "Descend with bat and sword into the Catacombs, where you can force the bat to exchange the sword for the Golden Key" and "Mr. Robinett has placed a tiny secret room at the bottom of the screen, slightly left of center. Enter it with your Bridge." A tutorial video online would likely prove easier to follow. If all goes well, The Man will arrive at a secret room, where only the most intrepid adventurers will find the vertical words CREATED BY WARREN ROBINETT flashing on the screen. "I called it my signature," he told me. "Like down in the corner of the painting."

After the higher-ups at Atari discovered his Easter egg, Robinett did not stick around for long. "I was kind of demoralized actually and I quit right after I completed *Adventure*," he said. In 1980, he co-founded The Learning Company, the educational software firm responsible for the award-winning puzzle game *Rocky's Boots* (1982). He and the other three founders sold The Learning Company in 1995 for $606 million. Later he designed one of the early and pioneering virtual reality systems for NASA, and after that, transitioned to academia. "I didn't continue to make video games for the rest of my life. Could have, but that's not what happened."

Robinett's place in the video game pantheon is assured. *Adventure* remains a pop culture standby. Ernest Cline, for instance, featured *Adventure* in his popular 2011 science fiction novel *Ready Player One*. "*Adventure* blew me away when I first played it, because it was the first game where you had an avatar—even if that avatar was just a square," he told me. "I loved trying to reach areas you weren't supposed to be

able to get to with the bridge, and that's how I discovered the Easter egg." As Cline explained it, that Easter egg "changed [his] whole life." That was true for many of us.

When we spoke, Robinett was writing what sounded like a terrific book of his own. "It's about the implementation of *Adventure*, the program that implemented it, and the reason I did it is because I don't think there's anybody else that could say why I made various decisions." Like creating a video game, writing a book is always a leap of faith. "I hope it's a reasonable number of people that are interested," he said.

In his forward to *The Video Game Theory Reader*, Robinett argued that "there is not only skill and technique, but also an art, to piling bit upon bit to make a video game." Would Sir Kenneth agree? After all, Robinett has made his own experience universal, in creating The Man to represent each and every one of us, and in making a game in which the central mechanics were—or would become—second nature to millions of people. No one had seen anything quite like it before. It was the first graphical action-adventure game and was also among the first puzzle games. Like *Gotcha* and *Pac-Man*, it created elements of what might be called, for lack of a better term, the maze game. Most video games owe it a debt of one sort or another.

I had to ask Robinett why he never made another game. "I have made some attempts to make a product, two or three times, but something got in the way each time," he said. "So I intended to make another software product, but it's 33 years since 1983." He asked himself, out loud: "So what in the hell happened, Warren?" He still sounded open to the idea of making a new game after all these years. "But I want to do it on my terms."

CHAPTER 5

arcade projects

The Garden State Parkway runs south-southwest and skirts past Atlantic City and the Pinelands down to the peninsula of the Jersey Shore. The place names on the street signs attest to the bygone Lenape population. A few miles before Cape May, Elivi and I got off the highway at Exit 6. If we had gone left for a few miles, we would have hit the town of Wildwood, where as a little kid I visited some of my first video game arcades. At first, however, we went right and took Indian Trail Road to the grounds of the Burleigh Mini Storage rental facility. I had driven past the place a hundred times and never noticed it. My father and a buddy of his from Ireland were waiting for me in the parking lot.

My father used to be a plumber. He owned a small business in West Chester, PA, which was also the home of Commodore International, manufacturers of the Vic-20, C=64, and Amiga home computers. He and my mother now lived down the shore full time. He called me one day because he

heard that the owner of the storage facility needed to sell the contents of several abandoned units. In one, there were photographs of several generations of an African-American family. The owner attempted to locate the owners, but never did find them, which I find heartbreaking. Another unit contained the contents of a Wildwood Crest motel that had been torn down and turned into condos. My father said among the motel's possessions was an old arcade cabinet, and it was available if I wanted it. He had no other information.

The parking lot's seashells crunched under our tires. The fetid marsh air smelled rotten, but I kind of liked it. Elizabeth Bishop's poem "The Bight" came to mind:

> At low tide like this how sheer the water is.
> White, crumbling ribs of marl protrude and glare
> and the boats are dry, the pilings dry as matches.
> Absorbing, rather than being absorbed,
> the water in the bight doesn't wet anything,
> the color of the gas flame turned as low as possible.
> One can smell it turning to gas; if one were Baudelaire
> one could probably hear it turning to marimba music.

We arrived too late to see the machine for ourselves. A couple of guys had already loaded it into the Irishman's van.

They told me it was an original *Donkey Kong* machine. It was hard to believe that I had lucked into my own arcade cabinet of the 1981 classic designed by Shigeru Miyamoto, the man who has done more than any human alive or dead to advance video games as an art form. My first thought

concerned how I would rearrange the living room furniture to accommodate the six-foot-tall totem of gaming bliss.

My father's friend drove the machine to his HVAC shop, where he would test it and, if it worked, let his kids play it until he could spare half a day to deliver it 100 miles to me in Philadelphia. The *Donkey Kong* cabinet was thirty-five years old and there was no telling what condition it was in. If it no longer functioned, I vowed then and there to restore it.

I would end up backtracking on that promise.

Wildwood remains the quintessential Jersey Shore town. Atlantic Avenue, which runs more or less parallel with the shoreline, still boasts dozens of retro 1950s-era "doo-wop" motels. In the evenings, the display of vintage neon is almost without parallel. When I was a kid, my parents owned a small summerhouse a few towns up the coast in Avalon. Once or twice each year we would go to the Wildwood boardwalk for a night of roller coasters and skee-ball and other semi-rigged games of chance. I once won a copy of The Doors' "Greatest Hits" LP by successfully tossing metal rings into the tops of milk jugs. It was the first record I owned, and it sounds terrible now, but each scratch and skip tells its own story and I have no interest in replacing it. Despite the excitement of the carnival games, the real allure of the Wildwood boardwalk was, obviously, the plethora of arcades.

I blew through my weekly allowance one quarter at a time, and in this respect I was far from unique. As the coin-op trade magazine *RePlay* boasted in 1980, "everybody and his brother" was getting into the arcade business. (The exclusion of women here was part of a larger trend in the coverage of

the video game industry.) A cover article the following year claimed annual profits of $7 billion, up from $3 billion the year before. In addition to the arcades, I remember seeing game cabinets in drug stores and supermarkets, bowling alleys and mini-golf courses. Every hotel seemed to have a small, overheated playroom with three or four games and a change machine that ate dollar bills and spat out quarters.

Playing a cabinet video game back then felt like a privilege, or an honor—and it still does, maybe now more than ever. Back then, it also became a social ritual in which we made new friends based on a shared interest in mastering a series of electronic puzzles. I recall figuring out a simple pattern in *Tron* (1982) that ensured my advancement to the next round and feeling like a hero when everyone else began to replicate my—obvious, as it turned out—innovation. A sense of community existed in every video game arcade. Our successes and failures were both public and short lived.

After leaving the storage facility, Elivi and I drove over the bridge to Wildwood, with a rare South Jersey snowstorm battering the car and the recently deceased David Bowie's "Moonage Daydream" ("I'm the space invader...") blaring from the speakers. I fell into a kind of reverie. Some of the coin-gobbling games I remember most vividly from those early days were *Frogger* (1981), which involved getting a pixelated amphibian across a road without him (or her) being splattered by a car; a *Donkey Kong* remake or copycat cabinet called *Kangaroo* (1982); that *Tron* game, based on the Disney movie that was incomprehensibly awful even to a geeky sci-fi fan at the dead center of the intended target audience; and *Ms. Pac-Man* (1982), the first video game sequel I

ever played, one that somehow surpassed the seemingly lim-itless pleasures of the original.

In the history of the medium, *Pac-Man* stands out as one of the high-water marks. The Japanese designer Toru Iwatani created it for the company Namco, which released it in May of 1980. People who have never played a video game in their lives, if such creatures still exist, can nevertheless identify that voracious yellow circle. *Pac-Man* is probably the most widely recognized video game character around, likely in part be-cause the game originated with Iwatani's desire to appeal to female gamers. "I thought about something that may attract girls," he once explained to an interviewer. "Maybe boy sto-ries or something to do with fashion. However, girls love to eat desserts," he reasoned. "So the verb 'eat' gave me a hint to create this game." The original title *Puck-Man* referred to the Japanese word for "munch" or "chomp." According to one persistent legend, the American distributors changed the name to prevent would-be vandals from scratching away at the P and turning it into an F. If the puerile humor of my nine-year-old self is any indication, that was a wise decision.

In *Pac-Man*, the player navigates the yellow mouth around a maze, eating dots until death catches up to it, as it invari-ably does. (Some people have seen a sinister side to the game, including one author who argued recently that the "sound of Pac-Man's insatiable appetite for dots had become synony-mous with the sound of consumerism run amok, just as the sound of Pac-Man dying has become a universally recogniz-able marker of defeat." Being subject to academic methodol-ogy is one sign that games have truly arrived.) The Pac-Man avatar had the *tabula rasa* universality of a smiley face,

making it—like The Man—a perfect stand-in for each and every player.

"There's not much entertainment in a game of eating," Iwatani admitted, "so we decided to create enemies to inject a little excitement and tension. The player had to fight the enemies to get the food." The enemies Iwatani created are ghosts, which surely explains a portion of its appeal; the game's ghost story added another mythic element and played on our innate human fear. Who among us has never felt menaced by ghosts, real or imagined? Each of the original four apparitions possessed a distinct personality. According to Iwatani, "I wanted each ghostly enemy to have a specific character and its own particular movements, so they weren't all just chasing after Pac-Man in single file, which would have been tiresome and flat." The red ghost, known as Oikake or Chaser in Japanese and Blinky in English, always chased Pac-Man while Machibuse (Ambusher), Kimagure (Fickle), and Otobokke (Feigning Ignorance) pursued their prey in their own roundabout ways.

I distinctly recall the sense of astonishment I felt when I first played *Pac-Man*. It seemed as though I had encountered the newest and most advanced technology in the world. As a reward for doing a few chores around the house, I got to do something never before experienced by my parents or my two uninterested older brothers, who had covered the walls of our shared beach-house bedroom with Pink Floyd and Ted Nugent posters.

Yet *Pac-Man*, at the same time, was the game to reach out of the subculture of the arcade and into the mainstream. Among other things, it inspired a television cartoon series

and the hit song "Pac-Man Fever" (1982) by a duo called Buckner & Garcia, which I did not recognize at the time as a parody of Nugent's insipid "Cat Scratch Fever." There were also dozens of official spin-offs and sequels—not to mention innumerable bootlegs and what might generously be called homages.

Operational *Pac-Man* machines are scarce nowadays, but I drove to Wildwood that day in the hopes of finding one. A few free versions of the game exist online; these reproduce the sound effects and bring back some nice memories, but using the arrow keys instead of a joystick feels wrong. The version ported onto the Atari 2600 was not much better. The dimensions of the maze—oriented more horizontally than vertically—were absurd and the ghosts flickered on the screen, demonstrating little of their usual verve and individuality. The cartridge version just looked awful, particularly in contrast to *Adventure* and *Yar's Revenge*. It's not likely to darken my 2600 again.

In general, I have not returned to Wildwood often as an adult. At some point, I grew less willing to hang out amid swarming, sunblock-reeking crowds. Even correcting for nostalgia and the way in which aging makes us less tolerant of the follies of youth, I also believe that the boardwalk has grown rowdier and less civil. Around the time that the video game arcades began their decline, Wildwood became ground zero of an underage bacchanalia that seems to attract every recent high school graduate in the Delaware Valley. Senior week now lasts all summer.

On the boardwalk that winter day, the only place open was a combination casino and gaming room called Gateway

26. I couldn't even find a place to buy a Def Leppard t-shirt. A poker tournament was going on when Elivi and I arrived. In the rear of the cavernous hall, the game room boasted a number of basketball-shooting challenges, lots of machines involving plastic rifles and images of animals, and only two classic arcade cabinets. Fortuitously—and perhaps unsurprisingly, given the environs—one of them was *Ms. Pac-Man* (1981).

Ms. Pac-Man is the greatest incarnation in the history of the franchise, a game no one who has ever played it can forget, and yet it had a much different effect on me than it did when I was young. To signal Ms. Pac-Man's gender, and despite her lack of hair, the designers gave her a pink hair bow as well as lipstick and eyelashes. As I now understood, the universality that had made the original avatar so powerful had been sacrificed to create a stereotype. Before the release of *Ms. Pac-Man*, I had never thought of the Pac-Man character as male or female. Even worse, at the time, I felt like I was the last to learn that he was in a serious relationship.

Amid the girlish graphics of the machine's signage, Ms. Pac-Man was also depicted with long, sultry legs that were nowhere to be seen in the actual game. Her blue high heels matched her eye shadow. She apparently felt the need to don makeup and get gussied up in order to attract a man—or a player. The game's animated cut scenes introduced a bit of lore in the form of a budding romance between her and Pac-Man, who was apparently playing hard to get. She chased him across the screen with even greater zeal than that of the ghosts.

In her indispensable online video series Feminist Frequency, the critic Anita Sarkeesian has said that "Ms. Pac-

Man was not only one of the first playable female characters, but she also holds the distinction of being the first Ms. Male Character in video games." Sarkeesian, who is among the most brilliant and insightful critics of video games today, went on to say that Ms. Male Characters "are defined primarily by their relationship to their male counterparts." Sarkeesian rightly cited Minnie Mouse and Supergirl as other examples. Many games originally conceived as being for the masses contribute to the perpetuation of social norms, and this is one of the more pernicious—and enduring— examples.

Despite the incomprehensible storyline and what many might regard as sexism on the part of the game makers, the simple fact that the mazes changed after every few levels made *Ms. Pac-Man* more compelling than its precursor. I began playing, and soon the joystick started to raise a blister on my palm, similar to how a violinist might get a bruise on her neck from the instrument's chinrest. I topped the day's high score, reaching 25,100, and was crushed when the machine did not give me the option of entering my initials to commemorate my achievement forever—or at least until someone beat my score or unplugged the machine.

As heartened as I was to see some young kids step away from their plastic guns long enough to cruise through those mazes a few times, I also hope they learn to see the game's flaws. I saw only one other adult play *Ms. Pac-Man*. She was only a few years younger than me, and thus part of the same generation of early video game lovers. When she finished, I discreetly strolled past the machine to make sure she hadn't bested my high score. Then Elivi and I bundled up again, took

a short walk on the snowy beach, and I decided to find and support more video games designed by women.

The day finally arrived when my father's friend and his wife would be driving through Philadelphia, on their way to a weekend in the Pocono Mountains. He offered to drop off my *Donkey Kong* cabinet on the way, if and only if I had some people available to help me carry it out of his truck. I secured the necessary backup in exchange for my neighborhood's primary currency: a cheesesteak from the local institution, Dalesandro's. The van pulled up in front of my row house and I finally feasted my eyes upon the behemoth. It wasn't an 800-pound gorilla, but it was close enough.

At first glance, the cabinet showed some superficial scuffing and at least one nasty cigarette burn, but I felt optimistic I could revive it, swapping in new versions of any severely damaged parts. I borrowed a hand truck and my friend Troy and I wheeled the game through a narrow grocer's alley to the back patio. When we stopped to catch our breath we noticed a few more scratches to the exterior. Slowly, we navigated the truck down three steps to the backyard, and then to the flapping-open Bilco doors leading to the basement. It would be a tight squeeze. I began to formulate my argument for installing *Donkey Kong* in the living room instead of the cellar. Fortunately, I guess, the machine fit through the eye of that particular needle with an inch or two of leeway on each side.

We stood it up and shimmied the hand truck out from under it. The power cord had frayed over the years, but we

were able to replace it and fasten a new three-pronged plug to the end. Our house was built sometime around 1860, and while an electrician had changed most of the old knob-and-tube wiring, we never thought to ask him to add additional outlets in the rear of the unfinished basement. I unearthed a 60-foot, appliance-grade extension cord, a holdover from the window A/C units of our previous home, and the game came beautifully and miraculously to life. A rather unusual question appeared on the screen:

HOW HIGH CAN YOU GET?

The white plastic t-molding running along the edge of the machine showed some yellowing and it had chipped away in several spots. A door on the front of the cabinet had been unlocked, thus granting access to the wooden box that would have collected quarters. A small button on the inside of the coin slot added credits, which meant I could play for free and for as long as I desired.

When he first envisioned *Donkey Kong*, Shigeru Miyamoto wanted to make the game about Elzie Crisler Segar's cartoon character Popeye the Sailorman. Unable to secure the licensing rights, he invented new characters that have become even more well known than the original templates: the antagonist Bluto became an ape, the love interest Olive Oyl became the blonde-haired Pauline, and the hero Popeye traded in his sailor suit for a carpenter's red overalls, taking the name Jumpman. It was Miyamoto's first game as a director. About his inspiration, he once joked, "Nobody ever threw barrels at me, but I did read a lot of manga comics in Japan and see a

lot of cartoons and you'd often see silly things like that happening."

Donkey Kong arrived in arcades during the summer of 1981 and gave countless ten-year-olds like me something to do between showings of *Raiders of the Lost Ark*. It was, as the genre is now called, a platformer, in that it involved controlling an avatar—Jumpman—through a series of difficult obstacles, ascending and descending multiple platforms along the way. The instructions on the front of the cabinet included helpful advice: "Jump button makes Jumpman jump." The game mechanics were straightforward and intuitive. The player helped Jumpman climb up a construction site to rescue a Fay Wray-esque blonde woman from the clutches of a big gorilla.

The joystick on my cabinet was particularly stiff, which made climbing up the ladders and evading burning barrels all the more difficult. After several months or years of dormancy, an unknown previous player's high score of 7,650 remained atop the screen. On the few occasions I beat her admittedly modest achievement, every time I unplugged the game my score disappeared and 7,650 appeared again. That number was somehow embedded in the long-term memory of the game's small, internal computer. Much to my chagrin, the machine's short-term memory was not quite as sharp. Like Sisyphus, I resigned myself to starting every day at the beginning.

Nowadays, whenever friends come by to grill food out back or play Dungeons & Dragons, we invariably end up in the basement for a few two-person sessions. Everyone from my generation gets excited about the fact that they don't need

a bulging pocket of quarters. On the Wildwood boardwalk, I never saw a reset button. If I wanted to play longer, I needed to empty more wastebaskets and rake more leaves and then wait an eternity until someone would drive me back to the arcade. Free and unlimited turns on an arcade cabinet and the ability to play all day and all night were childhood fantasies of mine that people who grew up on home consoles will never understand.

Once a month or so, usually when Elivi isn't home, I go to the basement and plug in the *Donkey Kong* machine for a solo session. The physical shapes of arcade cabinets clearly affected the design and gameplay. The controls consist of one joystick and one button. I can move left and right or up and down; the button makes Jumpman do the thing he was born to do. That was essentially the extent of the player's agency in that era of arcade games. Though the game was a major success, it was an inauspicious beginning for one of Miyamoto's two signature characters.

Two years after *Donkey Kong* first appeared, Jumpman returned to the arcades. He now had a new name and a new profession—and his game *Mario Bros.* (1983) featured a second joystick. Jumpman became Mario, trading in his carpentry job for a career as a plumber. He was joined by his brother, Luigi. They ran and jumped through a series of sewers like Jean Valjean, though harassed by turtles rather than by Javert. As the video game critic and theorist Ian Bogost told me via e-mail, "*Mario Bros.* (not *Super*) was weird and sort of alienating, and the whole premise of these plumbers overcome by

turtles felt utterly alien in the apparent contextless context of some kind of underground sewer." However odd, the game made Mario an instant icon.

Miyamoto has credited Mario's lasting appeal to the way the games present us with universal experiences and challenges: "Everyone is afraid of falling from a great height. If there is a gap that you have to cross, everyone is going to try to run to jump across the gap. These are things that are uniquely human and are a shared experience across, really, all people." Mario's speed and strength power-ups are only temporary; his avatars are often unremarkable and awkward, which is to say closer to digital versions of ourselves than the player characters in most games, before or since. Miyamoto has explained that decision: "My vision of Mario has always been that he's sort of representative of everyone. He's kind of a blue-collar hero. And so that's why we chose these roles for him that were things like carpenters and plumbers." The baseline mode of existence in his games is something akin to our own. We must work hard and practice and repeatedly fail in order to get further along.

Given the rough condition of my cabinet, I decided to attempt to return it to its pristine glory. The Vintage Arcade Superstore in Glendale, California, refurbishes and sells vintage games. Their prices run from $1,495 for fully restored machines like *Rolling Thunder* (1986) and *Street Fighter II: The World Warrior* (1991) up to $6,995 for *Discs of Tron* (1983) and $8,495 for the *Star Wars* game (also 1983) that players have to sit inside to operate. At a mere $5,995, Atari's original *Pong* (1972) was alluring.

Before I called to ask for restoration advice, I thought about that Doors' "Greatest Hits" LP upstairs in the living

room and how the scratches, and the distortions they cause, make me enjoy the music more and not less. The record sounds like it was carried to the underworld and back, but there's also a vibrancy and warmth that doesn't come through listening to the same songs in iTunes. Every warp reminds me of the distance in time and technology between its creation and my present enjoyment. That entropic decay calls to mind the object's origins and its ties to a particular time. Why should a video game be different?

The philosopher and critic Walter Benjamin's most famous essay "The Work of Art in the Age of Mechanical Reproduction," published in 1936, described the effects of industry upon the arts. "Even the most perfect reproduction of a work of art is lacking in one element: its presence in time and space, its unique existence at the place where it happens to be," Benjamin wrote. "This includes the changes which it may have suffered in physical condition over the years as well as the various changes in its ownership." Reproducing a work of art by mechanical means stripped it of its historic context and hence its authenticity. Right now, Benjamin is no doubt spinning vinyl in his grave.

With Benjamin in mind, the scratches and even the burn hole in the front of my *Donkey Kong* no longer looked to me like flaws, but like trophies that attested to its age and history. Much more than game cartridges, arcade cabinets show the wear and tear—the obsession, the love—of hundreds if not thousands of players over the years.

Instead of restoring the machine to some false, idealized original state, I left the damaged parts in place and applied some mild soap and a little water where necessary. It does not

look new, but the game demonstrates perfect fidelity to itself and to its years of love in the game room of a beach-town motel, to its neglect in a storage facility, to getting banged around in the back of a van, and finally to being subjected to the dust of a Philadelphia row house basement. The dents and scratches—and the true history to which they attest—are what make that *Donkey Kong* cabinet and all of those old arcade games so persistently wondrous.

CHAPTER 6

the first auteur

Every exegesis of Shigeru Miyamoto and his games seems to begin with his reverence for the imaginative capacities of young people. "I think that inside every adult is the heart of a child," he once said. "We just gradually convince ourselves that we have to act more like adults." His desire to regain that sense of innocence, beaten out of us by the workaday world, has inspired some of the most iconic video games ever made. Starting with *Donkey Kong* and working exclusively for Nintendo, Miyamoto has developed several of the most influential franchises in the history of the medium. Even non-gamers are likely to recognize characters from *Super Mario Bros.* (1985), *The Legend of Zelda* (1986), *Star Fox* (1993), and maybe even *Pikmin* (2001). My oldest nephew Alex, who has many of them tattooed on his arms and legs, often acted as a guide for my expedition through Miyamoto's worlds and as a font of information about Nintendo history.

Miyamoto's role at Nintendo has varied over the decades. He has worked as a designer, director, producer, and departmental manager. Currently, he serves in the capacity of "Creative Fellow." He took inspiration from his precursors in the video game industry, but like William Crowther he also drew upon his own experiences as an amateur spelunker. While he is no hermit, Miyamoto does not grant all that many interviews, so a sort of accidental mythologizing has taken place. One reporter described what has become the accepted story about Miyamoto's childhood in the idyllic rural countryside of the Kyoto prefecture: "One day, when he was seven or eight, he came across a hole in the ground. He peered inside and saw nothing but darkness." In the days that followed, the young Miyamoto returned with a lantern. "Over the summer, he kept returning to the cave to marvel at the dance of the shadows on the walls." Every great myth most certainly contains a kernel of truth.

Since before the time of Plato's most famous allegory, caves have inspired humans to consider what might exist beyond the limitations of our senses. The cave also serves as a defining metaphor for humankind's fascination with representations of ourselves. But caves are not just places to become trapped in another, perhaps artificial, world; they have also long been sites of human art and ritual. The late art historian Helen Gardner once noted that cave paintings "had magical meaning for their creators" and in *The Golden Bough*, Sir James George Frazer arrived at a similar conclusion: "All the beasts thus represented appear to be edible, and none of them to be fierce carnivorous creatures... The intention of these works of art may have been to multiply by magic

the animals so represented." Miyamoto's video games work a different kind of magic: that of granting us superpowers, transporting us to enchanted realms, and providing us an infinite number of lives. In the present day, with the sprawl of civilization all too often standing between us and the natural world, video games can provide symbolic visits back to the caves and sacred circles of our myth-making past.

Whatever the influence of that cave and those shadows on the wall, Miyamoto is also a student of the broader natural world—of expansive vistas as much as the subterranean. He once reminisced about what turned out to be a fortuitous hiking trip near Kobe:

> We had gone on this hiking trip and climbed up the mountain, and I was so amazed—it was the first time I had ever experienced hiking up this mountain and seeing this big lake at the top. And I drew on that inspiration when we were working on the Legend of Zelda game and we were creating this grand outdoor adventure where you go through these narrowed confined spaces and come upon this great lake. And so it was around that time that I really began to start drawing on my experiences as a child and bringing that into game development.

Between Atari's early days in the 1970s and Miyamoto's heyday in the late 1980s and 1990s, the amount of memory that could be stored on a cartridge grew so large that game makers could create immersive worlds unto themselves.

Nintendo traces its origins to the Marufuku Company, founded in 1889 by the Kyoto-born entrepreneur Fusajiro

Yamauchi to manufacture a playing-card game. He changed the name to Nintendo—roughly, "in the end, luck is in heaven's hands"—in 1951, just six years after Willy Higinbotham's work in the New Mexico desert found its hideous expression at Nagasaki and Hiroshima. The end of World War II brought revolutionary change to Japan. The nation had suffered a total defeat; millions had died in war, its cities lay in charred ruins, and a severe food shortage ravaged the nation, now occupied by the American military. For the first time, citizens heard on the radio the voice of Emperor Hirohito, once considered a living god and direct descendent of the sun deity. Hirohito implored his listeners to "endure the unendurable and bear the unbearable," and indeed they did.

Miyamoto was born amid this turmoil, in 1952, in the rural town of Sonobe. He earned a degree in industrial design and began work at Nintendo in 1977, the same year Atari released the VCS console. His early projects at Nintendo involved designing or co-designing the arcade games *Sheriff* (1979), *Radar Scope* (1979), and *Space Firebird* (1980). American video games, as well as knock-off versions made by domestic companies, had already proved popular in Japan. One of Miyamoto's main influences and inspirations was *Space Invaders* (1978): "Before I saw it," he has said, "I was never particularly interested in video games and certainly never thought I would make video games."

As with so many older games, finding playable versions of Miyamoto's novice efforts can prove daunting. For the curious critic as much as the hardcore nostalgic, one of the great boons in recent years has been the ever-increasing amount of gameplay footage available online, much of it of games largely

forgotten otherwise. Who posts these videos, I cannot fathom. They are the librarians and archivists of our age, cataloguing the endless ephemera produced by digital technology.

Space Firebird was an action game reminiscent of *Space Invaders*, albeit with better music and sound effects. Hirokazu Tanaka's compositions for Nintendo have earned him the reverence of contemporary aficionados of chiptune music—songs made out of vintage computer sounds. I may have heard echoes of Igor Stravinsky's *The Firebird* in Tanaka's soundtrack for *Space Firebird*, particularly in the kinetic energy and contrapuntal elements, but perhaps that was just wishful thinking. Meanwhile, *Radar Scope*, a fixed shooter, did not sell as many copies as Miyamoto's bosses had hoped, but their decision to allow him to transpose some aspects of it into a subsequent effort changed the company's fortunes, not to mention video game history.

The home video gaming mania that began in the United States reached Japan with Nintendo's 1983 release of the Famicom console there. Two years later, the 8-bit machine hit the North American market under the name Nintendo Entertainment System, or NES. Nintendo would go on to sell a staggering 62 million of the consoles worldwide. The primary creative driver behind that success was Miyamoto. The larger memory of the NES allowed for both more expansive and more detailed games. Video game design changed, "to where we were creating worlds," as Miyamoto put it, "and we were trying to create worlds that people would want to immerse themselves in, the way you immerse yourself in a book or in a movie." Players of *Super Mario Bros.* and *The Legend of Zelda* did precisely that. One reason for their popularity was

Miyamoto's introduction of cartoonish, Disney-like characters as avatars. Games had already come some way since The Man.

Miyamoto greatly expanded the area of play. In *Adventure*, the square Man had moved from one room to another, without being able to see beyond the room he, or she, occupied at any given moment. In *Donkey Kong*, the entire game, though much smaller, had been visible on the screen at once: Jumpman started at the bottom and had to scurry his way to the top. *Super Mario Bros.* was something different: a side-scroller, like the popular arcade game *Defender* (1981). Mario stayed more or less in place near the center of the screen, while the background moved right to left to create the appearance of forward movement and progress.

Super Mario Bros. came to define the NES and the entire post-2600 home console market. Even now, thirty years later, the game generates a level of excitement that transcends mere nostalgia. On a recent Saturday afternoon, while the East Coast of the United States was being buried in snow, a few neighbors came over for hot chocolate and freshly baked cookies. Perhaps our sugar intake played a small role, but the first thing I noticed upon popping *Super Mario Bros.* into the NES and running it through surround-sound speakers was that otherwise reasonable, stolid grownups can quickly revert to hysterical and squealing children. Six of us gathered in the living room and laughed and cheered and moaned for hours. Miyamoto would have been pleased by our utter refusal to act like adults.

Part of our enjoyment derived from the controller itself, which has its origins in Miyamoto's expertise in industrial design. As most Americans my age probably know, the con-

troller has five buttons, the leftmost of which is shaped like a black Swiss cross that allows for directional movement. As a lightweight plastic rectangle, it felt immediately familiar to those of us who grew up with cassette tapes. The bright red, M&M-like plastic buttons on the right are marked B and A; they read right-to-left. Rubberized SELECT and START buttons protrude from a recessed section in the center. That device freed us from the phallic manhandling of a joystick.

In deference to the increase in TV sizes, the cord on the plastic NES controller reached much further (90 inches) than that of the old Atari 2600 joystick (41 inches). My friends and I could theoretically sit back and relax, but that was not what happened. We were, all of us, much too riled up. We took turns in two-player games, which meant that Player 2 had to be Mario's brother Luigi. No one ever wanted to be Luigi. The point of the game, as in *Donkey Kong*, is to rescue a damsel in distress. In this case, she is held hostage in the Mushroom Kingdom by a vile creature called Bowser. But the objective of the game often feels like little more than an excuse to keep playing. We needed to successfully traverse eight worlds just to face Bowser in a boss fight. We never got close, nor could we find access to the strange Minus World, a section of the game supposedly created by a glitch in the original program. Yet we hit RESET again and again.

We only stopped when composer Koji Kondo's wordless "Underground Theme" got to be too annoying: *den*im-*den*-im-*den*im, den*im*-den*im*-den*im*. Turning off the TV brought our trance to an abrupt end. Time had stopped. My eyes had glazed over. The blizzard that day dropped a total of 18 inches in Philadelphia. With the roads of our hilly neighborhood

entirely impassible to automobile traffic, we pulled on our boots and took a walk out into the knee-high snow. The general consensus emerged that Luigi sucked, but in retrospect I cannot point to objective data that supports that conclusion. We walked up toward what is thought to be the oldest continually-used road in North America, where we watched the falling snow become illuminated by the streetlights and, still addled with sugar, sang *den*im-*den*im-*den*im at the tops of our lungs into the winter night.

A few days later, when I had the NES to myself again, I put in the original *Legend of Zelda*. Miyamoto and Nintendo have created many sequels over the years, several of them better than the original, and in doing so have effectively re-imagined and reinvigorated the fantasy realm of Hyrule for every subsequent generation. More than any of the particular games, that world constitutes Miyamoto's masterwork. In much the way an oenophile might enjoy a vertical tasting of different vintages from the same winery, I came to better appreciate the depth of Miyamoto's vision by playing various incarnations of his signature franchise, after acquiring five Nintendo consoles and their corresponding *Zelda* games.

During my extensive travels in Hyrule, Miyamoto's genius became apparent, and not only in his memorable characters or fully-realized fictional worlds. What was most striking about the *Zelda* games is their combination of innovative narrative and design elements to create something close to a pure gaming experience. The increasingly sophisticated controllers for each successive console demonstrated in material terms the growing profundity of Miyamoto's creations. Each of his games took full advantage of the digital advances that went hand in hand

with advances in design. The NES cartridges allowed for far larger game worlds than did their Atari 2600 ancestors. The enormous scale of the first *Zelda*—which would be surpassed a thousandfold in future games like *World of Warcraft*—made completing it in one sitting impossible for all but the most manically inclined. A chip in the cartridge itself allowed the player to save three different quests through the game. It's easy to forget that save functionality did not always exist. Someone had to come along and invent it.

The Legend of Zelda popularized another gaming mechanic that opened up similar creative possibilities for later game designers. By pressing one of the black buttons on the controller, I could pause the game and open up an inventory screen. There, I toggled between the different items in my possession. Unlike in *Adventure*, where The Man could carry one object at time, my avatar had access to bombs, arrows, health potions, and more. Robinett had tried to incorporate a similar inventory screen in *Adventure* but had decided against it. "I thought it was really fucking awkward," he told me. The problem for Robinett had been one of verisimilitude:

> I didn't want the game to drop out of real time. Well suppose there is a dragon chasing you and you can just press a button and scratch your head and think about what to do? Well that's not what happened when St. George fought the dragon, was it? St. George couldn't push a button and suspend time. I chose to keep *Adventure* in real time.

Miyamoto had no such reservations about bending time, and he also had a technological advantage. He could effectively

incorporate that inventory-screen mechanic because, in part, there were more buttons at his disposal. I would need all of them.

Even in its first incarnation, Hyrule boasted a varied topography, albeit one rendered in simple graphics and mostly differentiated by color. The game drew on Robinett's method of moving the avatar—in this case, a character named Link— off the edge of one screen and into the next one. The scenery changed from forest to desert, from riverbank to graveyard, and of course to the caves just waiting to be explored.

The further I ventured into Hyrule, the more I discerned its autobiographical nature. Sure enough, I found a hidden cave behind a waterfall. In it, an old man offered some truly puzzling advice: MASTER USING IT AND YOU CAN HAVE THIS. That sage provided Link a powerful sword with which to slay his foes and rescue Princess Zelda, who had been abducted by the evil Gannon. This villain lacked Donkey Kong's goofiness and Bowser's smile and bouncing gait. Although he looked a bit like a pixelated pig in a cape, Gannon seemed more aggressive than previous video game bad guys. He could change into a blue fireball and roar with ferocity. "One thing I'm not really good at is creating truly heroic characters or truly villainous characters," Miyamoto has said, "with the one exception being maybe the Zelda series, where I think we did a pretty good job of defining the roles." Upon defeating Gannon, Princess Zelda told me: THANKS LINK, YOU'RE THE HERO OF HYRULE.

Link's services would be needed again in *Zelda II: The Adventure of Link* (1987), produced at first for a Famicom

peripheral called the Family Computer Disk System, and only later on a cartridge for the NES. The game replicated the top-down perspective of the original but also incorporated awkward side-scrolling elements, as if the new designer Kazunobu Shimizu could not decide what kind of game he was making. I suppose Miyamoto was busy elsewhere. Visually, it now looks like an aberration in the franchise. For that reason alone, it has—like Luigi—gained a cult following.

In 1990, Nintendo put the NES out to pasture and released a new console: the 16-bit Super Famicom. The following year, it landed on North American shores as the Super NES. The system sold over 49 million units worldwide—13 million fewer than the NES, but nevertheless it was one of the most commercially successful consoles of that era. The SNES controller added another set of buttons to the right-thumb area, which in the *Zelda* game *A Link to the Past* (1991) allowed more elaborate combat options. That game also introduced the storytelling concept of parallel realms, which would become a staple of future entries in the series. Link could alternate between the Light World and the Dark World by finding portals or with the aid of a magic mirror; this narrative and design decision exponentially expanded the field of play.

The game that best defined the SNES era was not a *Zelda* game, however, but the Miyamoto-produced *Super Mario Kart* (1992), the recent versions of which still enliven family gatherings with my nephews. Mario's go-kart riding competitors included Donkey Kong, Bowser, the dinosaur Yoshi, and of course Luigi, demonstrating Nintendo's willingness to cash in on previous creations. That game also featured some of the strangest—and greatest—music in video game history,

including a number of synth-heavy and vaguely Caribbean-influenced jams that reminded me of a West German disco I visited as a teenager.

Music may be the one aspect of games that has not improved since the days of NES and SNES. The compositions in contemporary games are often more elaborate and sonically rich than their predecessors, and some video game soundtracks are truly marvelous in their own rights, but the limitations of those early 8-bit and 16-bit technologies prompted the creation of a musical vernacular that cannot be replicated, not even by the chiptune composers and musicians working with old machines and tones.

Miyamoto was not solely responsible for Nintendo's wildly successful invasion of the American market. In 1989, Nintendo had already changed the way we interacted with technology by introducing the handheld Gameboy, which made it possible to play cartridge video games on the school bus, in church, or under the covers after bedtime. The Gameboy is one of the important ancestors to today's smartphone games, and I can now download many original Gameboy games onto my iPhone for a quick hit of nostalgia during the morning commute. That device was not Nintendo's first mobile system, however: the company's Game & Watch devices had already come and gone. Nor was it the first handheld game to employ removable cartridges. Players of Milton-Bradley's 4-bit Microvision (1979) could switch, at their leisure, between *Block Buster*, *Bowling*, *Connect Four*, and *Pinball*. One seemingly simple title, however, distinguished the Gameboy from all previous handheld games and became the first killer app for mobile devices: *Tetris* (1984).

Playing *Tetris* on the Gameboy felt like the perfect meeting of function and form. When I recently picked up an old Gameboy, the 2.6" LCD screen proved too small for my forty-five-year-old eyes, but otherwise the machine struck me as revolutionary as ever. Even on a tiny screen, *Tetris* remains one of the video games that has transcended the medium and found its way into the public consciousness. Despite the simplicity of the controls and of the four shapes at the player's disposal, no two sessions are ever alike. I remember playing for hours, until whole afternoons vanished and I would spend the evening with those puzzle pieces still embedded in my vision.

I owned two Gameboys in the 1990s, the first of which was stolen from my dorm room and the second I left behind in the hospital where my sister was about to give birth to my nephew John. Back then, I spent an untold number of hours playing *The Legend of Zelda: Link's Awakening* (1993). Returning to it felt both familiar and utterly foreign: I did not remember much of the game, nor the person I was when I first played it. Produced by Miyamoto, *Link's Awakening* was not set in Hyrule nor did it involve rescuing Princess Zelda herself. Instead, it featured a series of puzzles and the search for some musical instruments. It also presented the player with several mini games and a gameplay tutorial, two tropes that have become commonplace. The vastness of the world was even more impressive on such a tiny screen. With the exception of a few extraordinary apps and the occasional Pokémon hunt with my youngest nephew, Logan, mobile gaming doesn't interest me all that much. I find it more rewarding to attend closely to one thing at a time and to give a video game my

complete attention—something that often feels impossible on a mobile device, when a call or text could interrupt at any moment.

I played the Gameboy until my eyes could not take it any longer, then fired up what is roundly viewed as one of the greatest console games ever made. *The Legend of Zelda: Ocarina of Time* (1998) on the Nintendo 64 solidified Link as one of the most recognizable characters in all of video games—and in both Japanese and American cultures. That generation of consoles, which also included the first Sony PlayStation, would help to bring about nothing short of a Renaissance in the medium.

One defining element of Miyamoto's games is their appeal to the so-called casual gamer. They involve little violence and enough cartoon weirdness, and are so ingeniously and intuitively constructed, that they require few skills humans don't already possess. Miyamoto shows that, with video games as with novels and movies and fine art, popularity and quality can sometimes be synonymous. Beyond all this, the lasting appeal of Miyamoto's games derives in large part from their insistence that if we look hard enough, we, too, can find secret passageways and hidden wonders all around. Miyamoto's oeuvre reminds us that the world—our real world—is not as mundane as it might sometimes appear. I take great comfort in that.

CHAPTER 7

the renaissance

The Italian Renaissance of the 15th century witnessed a renewed interest in the scientific and mathematical inheritance from antiquity merging with a new wave of humanistic thought spreading across Europe. It gave us Leonardo da Vinci's *Last Supper* (1494-99) and Michelangelo's *David* (1501-04), among so many other enduring works of art. While bright color palettes and ostentatious displays of gold leaf had characterized a great deal of medieval art, much of it, generally speaking, was also static, owing to the absence of depth of field. While some artists in antiquity and the Middle Ages did find brilliant ways to provide the appearance of three dimensions on a canvas, it was only during the Renaissance that the illusion of distance gained mathematical precision.

Many Renaissance artists, responding to a heliocentric reconfiguration of our place in the cosmos, broke free of flat-earth imagery. "This penetration of the panel surface by spatial illusion replaces the flat grounds and backdrop areas

of the Medieval past," Helen Gardner wrote in a book that has been updated over the years by subsequent art historians and now bears the title *Gardner's Art Through the Ages*. The use of perspective created the appearance of depth on a flat surface. And painters were not the only ones changing how people saw the world, and themselves. Sculptors like Michelangelo and Donatello were able to create representations that seemed more fluid and lifelike than anything that had preceded them. And one could say that the Sony PlayStation and the Nintendo 64, successors to the SNES, accomplished something similar.

A cultural rebirth does not happen overnight. In 1990, shortly after I went off to college, the SNES appeared, offering far more computing power than its predecessor. New games like *Super Mario World* (1990) featured richer graphics and more colors. That side-scroller looked far sharper than the previous version; comparing the two games is an easy way to understand the great leaps made between generations of video game technology. And since there is a mutually beneficial and symbiotic relationship between software and hardware, the advances in technology opened up new possibilities for telling stories.

Adam Theriault is a user-interface expert in Austin whose personal collection of video game consoles could fill a museum. As he told me, "Nintendo has made innovative peripherals the cornerstone of their console and game development, but the SNES gamepad is, without a doubt, the blueprint for today's modern controller." For that device, the designers replaced the hard corners of the NES controller with rounded sides that fit comfortably in the hands. The added pair of

color buttons for the right thumb remain a staple of most contemporary controllers. The two new shoulder triggers on the edge of the device, however, represented the biggest innovation. "The more fingers you can engage," Theriault said, "the less a game designer has to map different behaviors to the same buttons. No one wants the 'jump' button to be the same as the 'open the map' button." Because the molded plastic in my hands had more buttons, Mario could take more elaborate actions.

Narrative ideas that had once been impractical to implement, if not impossible, were now at the fingertips of game makers. The graphics improved in stride: one of the other ways in which *Super Mario World* incorporated the newfound creative freedom can be seen in the graphical elements that hinted at a three-dimensional perspective. Some interactive obstacles in the game's Dinosaur Land, for instance, appeared to be in front of other objects or closer to the viewer, yet they still operated on the same flat horizontal plane. Mario could climb up a ramp by jumping onto it or he could run in front of the same ramp. The perspective was new, though it did not make logical sense any more than did the depth of field in a medieval triptych.

A question arises: why would I expect the spatial logic of a video game to reflect that of our own world? It had long seemed perfectly reasonable to be chased by giant turtle-monsters and to die and be reborn an infinite number of times in a system of Nietzschean eternal return. *Super Mario World* felt consistent with itself and with the previous games in the franchise. Yet that tiny matter of a confusing depth of field consistently broke the spell the game otherwise cast. It felt like a flaw in the design, a

technical challenge that Miyamoto and his team could not yet overcome even with the new computing power.

The video game designer Hironobu Sakaguchi, working for the Japanese company Square, also attempted to move beyond the prevailing limitations of graphical representation. His SNES cartridge game *Chrono Trigger* (1995) employed a different approach to creating depth of field. Taking obvious inspiration from *The Legend of Zelda*, it featured a spritely protagonist, a spacious realm to explore, and fantastical quests to complete. The game showed off what the new system could do in comparison to the NES, especially in its many external screens (which served purposes other than mere inventory) and a manga sensibility in a Studio Ghibli-like opening (and now de rigueur) cinematic scene that did not resemble the actual gameplay in any meaningful way.

Chrono Trigger's instruction booklet described the gobsmackingly enormous scope of the game: "This is a fateful story of those who discovered the trigger of time. From a timeless past to an unimaginably distant future, many events and encounters await your arrival. Get ready for an epic adventure that transcends the boundaries of space and time!" The game introduced several features that broke up the traditional linearity of video game storytelling. Not only could the player's avatar, Chrono, and the other adventurers move through time, but the side-quests made the entire world feel larger and, in a sense, more lived in. *Chrono Trigger* also had different possible endings, making the player's decisions all the more important.

The game's most salient feature, however, was the not-quite-right visual perspective. After the opening sequence, the camera flew over a heavily-pixelated town that sat next to a

river. Two elements were meant to create an illusion of depth: gray clouds scurried across the sky and colorful balloons drifted supposedly upward toward the top of the TV screen. The scene appeared distorted, though. Whereas the balloons should have become smaller as they floated into the distance or larger as they approached the camera, they didn't change in size as they moved. For all the power of the SNES, Sakaguchi still could not make the graphics scale in relation to the viewpoint of the player. The result was a warped, fun-house perspective. The game looked cool—even beautiful—but it also displayed the persistent limitations of the technology.

Yet, in another way, *Chrono Trigger* proved groundbreaking. The floor of Chrono's mother's house resembled a medieval tapestry repainted in the style of Chagall and comprised of 16-bit pixels. The game was a mess of linear perspective, but a glorious one. Like a few other titles of that era, *Chrono Trigger* utilized a top-down point of view, but one seen from a mathematically impossible angle. As in a Cubist painting, the game used a flat surface—in this case, my TV screen—to depict multiple sides of each object. While the results were decidedly mixed, those awkward visual elements caused subsequent designers to think about perspective in new ways. The game had one foot in the previous, flat era of the Atari 2600 and NES, and one in the age of more sophisticated 3D imagery, which would dawn a few years later. As a stepping stone between two epochs, *Chrono Trigger* played an integral part in video game history.

Attempts to create 3D worlds in video games certainly predated the SNES. Computer games had employed 3D imaging

as far back as the line-art of *Spasim* (1974), a 32-player game for the PLATO computer network system. The library in my high school owned a 3D flight simulator program that ran on a 5" floppy diskette. It was tedious. I distinctly recall playing the *Star Wars* arcade game (1983) in which one piloted an X-wing fighter apparently flying into a Death Star rendered in similar 3D vector graphics. The classic game *Q*bert* (1982) used colored blocks to create the illusion of height and depth. Many *Mario Kart 8* (2014) players today do not fully appreciate how effectively Yu Suzuki's *Virtua Racer* (1993) arcade cabinet set a standard for 3D racing games.

But it was not until the Nintendo 64 and Sony PlayStation that 3D games came into their own and became the norm. Two years after the release of *Chrono Trigger*, Sakaguchi produced another incredibly influential title, the role-playing game *Final Fantasy VII* (1997), for the latter console. That entry in the long-running series was the first to move beyond 2D rendering. Boasting a CD-ROM as opposed to a cartridge system, the PlayStation gave developers much more memory to work with, and Square used it to their advantage. The characters, though roughly rendered by current standards, possessed depth and roundedness. The shadows on the walls of the cave, those distorted representations of ourselves, finally gained perspective. Subsequent versions of the game appeared for Windows (1998) and Android and iPhone platforms (2014). To date, over 11 million copies have been sold.

The hero of *Final Fantasy VII*, Cloud, was a more fully developed character than previously seen in video games. Cloud is a burgeoning eco-terrorist mercenary who sets out to prevent his former colleagues at the evil Shinra megacor-

poration from depleting the planet's natural resources. Many reviewers pointed out that Cloud was, as one put it, "easily the most interesting and complex character ever presented in a game." The characters in video games were no longer universal abstractions, but instead had lives and personalities of their own. In this way, *Final Fantasy VII* brought the fun of Dungeons & Dragons-like roleplaying onto the screen.

Another influential, though far less well-known, 3D game for the PlayStation was Masaya Matsuura's *Vib-ribbon* (1999), which the MoMA added to its collection in 2012. The simplicity of the game stood in contrast to the far-ranging complexity of Cloud's story. A line-drawing rabbit named Vibri walked across a tightrope-like string and encountered four different kinds of obstacles, which I could attempt to overcome by using the four corresponding buttons. When the music got faster, my reaction time needed to keep up. It appeared so simple at first, that I had no reason to expect I would soon sink countless hours into what was the most addictive single-player game I have encountered.

Vib-ribbon also happens to be among the most brain-achingly bizarre things to ever lighten my television set. When I pressed the wrong button or mistimed my actions, the lines that made up Vibri herself became mangled. The straight line also warped and, like other important games of its era, used 3D visuals to great effect. As I made more mistakes, she devolved from a rabbit to a frog and eventually to a worm. With some practice, I would supposedly be able to get her to transform into a fairy princess. That did not happen often. I did find it interesting, though, that the point was to become a princess rather than rescue one.

Vibri would squeal every time I messed up, which was genuinely upsetting. She sounded as if she were in serious pain—and it was my fault, of course. I hated it and yet I kept playing and playing. My inability to help Vibri overcome even the simplest obstacles hurt me as much as it did her. At times, she would sit down and cry 3D tears. It did not represent a radical transformation in video gaming, but, perhaps more interestingly, demonstrated how incremental changes in technology can lead to new artistic breakthroughs.

All the while, maddening nursery-rhyme chants, performed by the Japanese ensemble Laugh & Peace, played in the background. The links on the band's MySpace page were broken the last time I checked, which made it impossible to listen to "Pineapple Chocolate Glycogen" or the other uploaded tracks, so I made do with those in the game—until I could no longer take it.

I turned to an older-generation iMac—specifically, to its CD burner—in order to experiment with one of *Vib-ribbon*'s other unique features. The game allowed me to play along with a soundtrack of my own choosing, so I opened iTunes and made a mix of 15 songs, in different genres and with different tempi, and then fed it into my PS3. The complexity of the obstacles in the game changed depending on the beat of the music. Slower pieces, like the Berliner Philharmoniker's recording of *Atmosphères* (1961), made the game too easy, while the complex rhythms of Fela Kuti made it impossibly difficult. Over the following months, I tinkered with my playlist until I got it just right with some moody, mid-tempo lounge music. With my custom, laid back soundtrack, and despite the utter strangeness—or because of it—*Vib-ribbon* has stayed in more or less continual rotation.

Even as the PS1 and N64 Renaissance brought video games into a new and glorious era, it disenfranchised a large number of casual gamers like me. A new level of dexterity was now essential if one hoped to be even half-decent at the increasingly complex games. "I think this is where controller design also began to resemble the Blackberry or the programmable VCR, all not in a good way," Theriault told me. "The jump to 3D and more computing power saw the need for the player to manipulate the world further—camera control, enemy selection, etc. Couple that with the complexity and this was a huge line drawn in the sand."

As much as I enjoyed being challenged by the increasingly devious puzzles and complex narrative structures, my own incompetence with all those buttons eventually became frustrating. Operating the latest controllers was not a skill I cared to acquire. I sold my NES to a college classmate and bought books with the proceeds instead of putting them toward an N64. That was when I stopped playing console games entirely and turned to reading—and eventually writing—a lot more fiction. *Moby-Dick* (1851) offered intellectual stimulation without that feeling of fumbling helplessness. Unfortunately, I got out at exactly the wrong time, right before the release of *Mario 64* (1996).

According to Theriault, *Mario 64* was the first game to provide "a set of training wheels that got a broader audience to understand what navigating a 3D space meant." In effect, that game taught many people—but not all—how to play all future 3D games. It became a digital litmus test. "The thing that people often seem to come down on one side or the other one is 'you're good at 3D games because *Mario 64* held your

hand,' or 'you struggled with 3D because you came in a gen-
eration or two later and it's already been figured out but you
missed the tutorial.'"

With that advice in mind, I headed to a shop near my
house called Classic Game Junkie and scored a copy of *Mario
64*. A sales associate cleaned and tested the cartridge for me
on the spot. Before heading home, I picked up the requisite
cheesesteaks and a case of beer and then two friends came to
my house to put Theriault's theory to the test. Paul, an Ivy
League scholar of medieval Islam, was a non-gamer. Scott was
a hardcore gamer who had published a guidebook to *World
of Warcraft* and had spent thousands of hours playing N64
games. The three of us set out to learn just how effective those
Mario 64 training wheels really were. Could a casual gamer
and a non-gamer learn to master that controller and success-
fully navigate 3D space?

The designers of the N64 included a thumbstick in the
center of the controller, and this little appendage would for-
ever alter the way we played console video games. Miyamoto,
in an interview, once explained his creative process at that
transitional time in video game history: "In order to show
those 3-D solid objects, you had to begin worrying about
where the camera would be placed, how it would maneuver
around the object." The thumbstick on that M-shaped con-
troller allowed me to move the camera. The ramifications
were enormous. The game's perspective was no longer con-
trolled by the game designer. The player now had a god-like
ability to control what she was looking at, and thus how she
experienced the game. The effect was liberating—and is per-
haps the emblematic feature of the video game Renaissance.

Miyamoto has said, "It dawned on me that, yes there's a main character in the game, but there's also the camera. And we need people to understand why the camera is moving—so the camera itself is almost like a character." With that new paradigm arrived a new visual logic and a new kind of story-telling. "So we came up with this idea that there was Mario, and there's a character who's carrying the camera and that they're going on an adventure together," Miyamoto said. That character turned out to be a familiar turtle from *Super Mario Bros.* "We thought he was the perfect character to be holding the camera as he floats around on his cloud and follows Mario on this adventure."

Since *Mario 64* is a single-player game, none of us had to be Luigi. We each took turns practicing how to make Mario run and jump and squat while simultaneously moving the camera around. The coordination involved did not come naturally, but with enough encouragement Paul and I got pretty good at it. Mario's realistic motion brought to mind another of the great contributions made by the Italian Renaissance: the rediscovery of *contrapposto*. Donatello's marble statues in particular, according to Helen Gardner (or her later acolytes), "took the first fundamental and necessary step toward depiction of motion in the human figure—recognition of the principle of weight shift." In doing so, they "closed a millennium of Medieval art and turned a historical corner into a new era." When I made a quick movement with the thumbstick, Mario did not simply turn in place; his momentum carried him in the wrong direction for a moment and his weight appeared to shift. The game designer Steve Swink has noted that "this foot-plant animation sells the impression that Mario is a

physical being, albeit a cartoony one, walking across a real environment." We saw that for ourselves and played all afternoon, until empty beer bottles lay strewn across the coffee table. Later that evening, Paul purchased a PlayStation 4 of his own—his first video game console. The *Mario 64* training wheels had worked.

Not to be outdone by Nintendo's innovations, in 1997, Sony released a controller that boasted two thumbsticks instead of just one. It also had approximately fifteen buttons in total—which meant bigger, more complicated games. (The exact number of buttons on that controller is a source of some dispute among gamers. "You could get away with saying 17 buttons, depending on what you want to count," Theriault told me. "The multi-purpose analog button didn't really have any in-game functionality for anything, bringing it down to 16…"). Either way, holding a PlayStation controller in both hands made me appreciate even more what Atari 2600 game designers were able to accomplish with one button and a joystick. By the 1990s, as games became more complex, they also became more violent and were increasingly marketed to adults. Even so, those of us who grew up with consoles and visiting arcades were left behind by the games themselves. Therein lies the irony of the video game Renaissance: when games came into their own, their new intricacy also threatened to chase away many of the first gamers.

Since the start of the video game Renaissance, the game industry has expanded to immense proportions. Ten years after its launch, the original PlayStation had shipped over 100 million units. The PS2, released in 2000, sold even more. Since its launch in 2013, and despite the competition from

Microsoft and Nintendo consoles, Sony has already sold over 35 million copies of its latest iteration, the PS4, many of them, obviously, to otherwise casual or non-gamers like myself and my neighbor Paul. Clearly, the innovations of the video game Renaissance have excited an untold number of gamers, young and old. But while I have come to love many recent games, I find myself most often returning—for reasons other than nostalgia—to the classics.

Although *The Legend of Zelda: Ocarina of Time* employed a 3D perspective and was widely hailed as one of the best games ever made, it could not replicate the sense of awe and discovery of playing the first incarnation on the NES. For fans of any video game franchise, the best game of the series is usually whichever one she played first. For many gamers, their favorite game is the one that first opened their eyes to the seemingly endless possibilities of the medium itself.

CHAPTER 8

dialing up

In late 1994, I dropped copies of *The Brothers Karamazov* (1880) and *Mulligan Stew* (1979) into a backpack, loaded some programs onto my Mac Quadra 660 AV, and moved to Budapest. I did not speak a lick of Hungarian and had no job prospects whatsoever. My college girlfriend had gone to study music at the Liszt Academy and invited me to join her. A six-month stint organizing the remainder tables at Borders provided the airfare, some small savings, and a valuable reality check for any would-be author. My plan was to stay for nine months, at which point my return ticket would expire.

At the time, I had no way of knowing that I would live in Hungary for nearly five years or that Elivi and I would eventually end up happily married. Even more unlikely was the fact that while I was abroad a global computer network would begin to reconfigure humankind's understanding of the world and of itself. Most improbably of all, I would soon end

up working for an American start-up company and help usher in the era of online video gaming.

Our first apartment in a shabby, communist-era pre-fabricated high rise on the remote edge of the city did not have a telephone line, much less internet access. I couldn't have played console games even if I'd wanted to because we didn't own a television. Fortunately, I had installed a few computer games on my Mac. In some regards, computer gamers and console gamers were, at that time, two distinct gaming cultures. Today, many games are designed for (and for playing across) different platforms, but most people I knew back then considered themselves devotees of one or the other. I was a computer gamer by default because I was also an aspiring writer and so needed a word processing program.

While the cool kids in my elementary and middle schools had been playing *Adventure* on the Atari, I was, per my parents' questionable judgement, using a nerdy Commodore 64 to type lines of BASIC code onto a black-and-white TV. Following the instructions in the back of a magazine, I once managed to program an interactive game in which I could use a joystick to move large chunks of pixels around the screen. Without a cassette-tape recorder peripheral or a disk drive, however, both of which were commonplace for C=64 users, I had no way to save the game. When I switched off the power, my masterpiece disappeared like a Tibetan sand mandala scattered to the four winds. I spent hours on the C=64 playing the text-based descendants of *Colossal Cave Adventure*, like Scott Adam's *Adventureland* (1978) and *Pirate Adventure* (1978). Later, writing short stories and eventually novels would remind me of playing those games. By carefully

stringing together words, I could make my literary characters undertake adventures of their own. Maybe my parents had been right about the C=64 all along.

The second computer I owned was a pre-Windows PC that had proven too slow to run even the simple billing software for my father's plumbing business, much less any worthwhile games. Nevertheless, in 1989, I took that computer and a heavy monitor off to college to write philosophy papers, which I saved to 5" floppy diskettes and carried across campus to the printer at the library. For all its flaws, that discolored keyboard was a dream compared to those heavy and unresponsive keys on the C=64.

The Mac I later took to Europe was a pizza-box style desktop that ran a Motorola-made CPU at a blazing 25 MHz and proved up to the task of long *SimCity* (1989) sessions. My friends back home in the States raved about Éric Chahi's *Another World* (1991), Rand and Robyn Miller's *Myst* (1993), and of course the popular first-person shooter *DOOM* (1993), but it was simulation games and god games that truly excited me. I relished the idea of controlling the fate of a metropolis or civilization, but I never realized at the time that I was a mere demi-god subservient to Will Wright and Peter Molyneux, creators, respectively, of *SimCity* and *Populous* (1989).

In the beginning, the almighty designer decides upon and establishes the physical landscape, giving form to the field of play, which could range from one narrow, 2D space like that in *Tetris* to the multi-continent landscapes of *World of Warcraft*. She brings forth the living creatures of her new world— perhaps a yellow circle with a mouth that eats dots, an Italian

plumber, or an anthropomorphic hedgehog that can run blindingly fast. These become the god's subjects, and yet sitting at my keyboard as a mere player, I, too, possessed some degree of divine agency over their fates.

Vladimir Nabokov once told an interviewer that "[his] characters are galley-slaves," implying that Humbert Humbert in *Lolita* and Charles Kinbote in *Pale Fire*, et al., served at the whim of the author, that he had fated them to ferry his plots and themes across great distances. The novelist and critic Tom Bissell picked up on Nabokov's metaphor as useful when thinking about video games. As he put it, "A good game attracts you with melodrama and hypnotizes you with elegant gameplay. In effect, this turns you into a galley slave who enjoys rowing." I would agree, in part: when playing a video game, I must employ game-specific skills and knowledge that the creator has taught me. But in many games—the best games—I also make choices and decisions that are wholly my own, that arise out of who I am. In those moments, one can become both author and reader.

Being represented on a computer screen by an avatar can lead us to ask, "Who am 'I' when I play a video game?" In taking control of The Man or Mario, we undergo a kind of transubstantiation or metousiosis and become a square or a cartoon plumber. If a better analogy might be Exorcist-like demonic possession, the question arises: who possesses whom? The word "avatar" is derived from the Sanskrit *avatāra*, meaning descent. In Hinduism, the word describes the visit of a deity, in human form, to our earthly realm. Vishnu, for instance, assumed the form of a dwarf. That sense of mythic shape-changing, of accepting a fictional mantle, and

of immersing ourselves in another, lower world persists in our current, video game usage of the word. When I am The Man, I remain myself, but in a new form. But at what point is The Man or Mario or Cloud possessing me?

Peter Molyneux is often recognized as the creator of the genre known as god games, in which the player wields supernatural powers in reigning over a population of subjects and worshippers. Molyneux's most famous titles are *Populous* and *Black & White* (2001), though he might now be best known for a project called *Godus* that in 2012 raised over a half million pounds on Kickstarter, but which petered out before its many financial backers received their promised rewards. I recently fired up *Populous* on my current iMac for the first time in ages. A window with single- and multi-player options appeared, the latter of which referred to the possibility of playing against other gamers online, whether anonymous or not. Not knowing anyone else who still played it, I clicked on the first choice. A blue-faced god appeared in profile on the left, facing a red devil-like creature on the right. The credits appeared. The list was remarkably short. *Populous* apparently required only two programmers: Molyneux and Glenn Corpes. Three people were responsible for the graphics, FX, and music. Four others were listed without titles or roles. I found it amazing that it took just nine people to make such an influential and complex game. Today, by comparison, the development team for *World of Warcraft* is made up of 235 designers, artists, producers, and engineers.

Watching the credits a few times presented more opportunities to hear Rob Hubbard's masterful syntho-pop soundtrack. It looped back to the main theme of frenetic, arpeggiated

keyboard figures reminiscent of a horror-movie soundtrack. There were plenty of woodblocks and fake drums and string effects. The composition sounded chromatic; it did not adhere to any particular key, but was not precisely atonal either. I called in my resident music expert to explain what I was hearing. Elivi—now a professional flutist and feminist musicologist—recognized that Hubbard had composed the song in what is called the Mixolydian mode, an ancient system of music invented by Sappho (c. 630–570 BCE). It existed long before our contemporary system of major and minor keys. Choosing an ancient Greek style of composition for a game about a powerful pantheon of gods was a brilliant creative decision on Hubbard's part.

The game screen appeared: something that looked like a poorly animated swimming pool took up most of the window. It reminded me of the river in the beginning of *Chrono Trigger*. My immediate thought was that the makers of *Minecraft* owed an aesthetic debt to the wonky, pixelated look and feel of *Populous*. The mouse controlled an orange hand with which I could click on some icons placed in a grid around the pool. At the top of the window, a book was open to a page depicting a map of what I presumed to be my realm, which I had named Cogito. My territory looked like an island or coastal region with a small strip of land extending off the eastern edge of the map. The swimming pool was actually a close-up of one small part of my world. Instead of moving my orange hand in the area of play, I would, from the Olympian perch of my Ikea office chair, decide upon the visible area. Because I was a god, my subjects and the relevant section of the world would come to me.

What sort of god would I be? Merciful, perhaps, but mercy can take many forms. My vengeance would be swift and ruthless. My deeds would rattle the very foundations of Cogito for millennia. I would rule not with love but by fear. Unfortunately, *Populous* was decidedly not one of those games that taught me how to play it, not even in the "tutorial" setting. I had forgotten much about it since first falling into its thrall in the 1990s. My omniscience failed me. After forty-five minutes, I decided that the concept of the game, and my memories of it, had been far more interesting than the tedious gameplay itself. In fact, the last game that had annoyed me so much was an NES title based on the 1990 Arnold Schwarzenegger sci-fi vehicle *Total Recall*, which has been judged "one of the worst movie-based games ever." *Total Recall* was maddeningly tough to the point of utter frustration and potential nerd rage—and still, I preferred it to *Populous*. Who knew being a god could be so tiresome?

My own short career developing video games in Budapest began with *Cosmo's Conundrum* (1996), an online trivia game that featured a monkey riding a satellite across outer space and offering cash prizes. The short-lived American company E-Pub had opened an office in Hungary, where it could hire programmers more cheaply than in California. I started writing trivia questions for them on a freelance basis. I typed them up on my Mac, saved them to a 3.5" floppy diskette, and took a commuter train and then the 4/6 tram across the Danube to deliver them to E-Pub's office in Pest.

Cosmo's Conundrum was promising enough to garner $5 million in privately funded investments, which E-Pub used to expand its range of online games and products. I accepted a

full-time job co-designing an online version of hangman, at which time Elivi and I moved to a nicer apartment in the Buda hills, from which we could see four of the bridges over the Danube. At the office, I got my own desk and my first e-mail address. Our first attempt at the game, which featured a cartoonish corpse named Hugh dangling distastefully from a tree, proved too literal. When Hugh lost too many limbs he would sing, "I Ain't Got No Body." The team back in New York tasked with selling banner ads hated it.

For the second iteration, we came up with a gameshow host named Wolfgang who would serve as a master of ceremonies. The imagery looked a bit like a Terry Gilliam cut-out animation drawn in Photoshop by an artist wearing mittens. Players who logged on had to wait in a lounge area until enough competitors arrived. My company's real innovation was a chat program that allowed them to communicate in the meantime. To facilitate the social aspect of the game, I had the idea to allow the player to upload images with which to represent themselves. They had to be tiny, if E-Pub were to house them on its servers, but I was not aware of another online game or web site offering that option. While I have no other proof to back this up, I still don't miss an opportunity to inform people that I invented the first custom avatars in an online video game.

Back at our apartment in Buda, I quickly grew bored of both *Populous* and *SimCity*. Leaving those worlds behind and surrendering my divine right to rule called to mind Friedrich Nietzsche's most famous pronouncement. I had turned my back on my people. Would they continue to exist and to toil in my absence? When Nietzsche's so-called madman exclaimed, "God is dead. God remains dead. And we have killed

him," his creator could not have known how those words would resonate down the decades. The sense of existential dread Nietzsche conjured found expression in art as diverse as Edvard Munch's original rendition of *Skrik* ("The Scream") in 1893 and Rainer Maria Rilke's *Duino Elegies* (1912), written on the eve of World War I: "Wer, wenn ich schriee, hörte mich denn aus der Engel / Ordnungen?" "Who, when I scream, will hear me among the Angelic order?" Already in Nietzsche's secularizing era, many were starting to believe that the answer had become: no one.

In his 1966 essay "Variations on the 'Death of God' Theme in Recent Theology," the scholar F. Thomas Trotter distinguished between three ways of interpreting the death of God. He ascribed to the French philosopher of Existentialism Jean-Paul Sartre the literal notion that God had existed, but had died. He perceived in the work of Martin Heidegger, the German philosopher and member of the Nazi party, the belief that God was merely absent. And he credited the Austrian-born Israeli philosopher Martin Buber with a belief that God was merely in eclipse. All three thinkers sought to account for and explain this absence in more and more people's lives, as have innumerable others.

What in heaven's name does this have to do with video games? As it turns out, more than might be apparent. The death of God that so many were remarking on—and that, in practical terms, meant growing secularism—helped inspire the Modernist artistic movement, which, among other things, created new modes of storytelling. Authors began to write more about free will and less about fate or divine judgment. At the climactic moment of a story, characters now needed to

exercise their agency, often in facing difficult quandaries. Of course, those choices were actually being made for them by their respective creators.

James Joyce's short story "Eveline" is a useful example of a work making clear the transition from a universe overseen by Providence to a wholly secular world. In it, the eponymous protagonist faces a classic dilemma. If she were to choose to pursue her own happiness and leave her native Ireland for Buenos Aires, the very name of which stood in stark contrast to the stifling nature of her current life, she would need to break the promise she had made to her deceased mother. She could be true to herself or she could be loyal to her (abusive, as it turned out) family.

> She stood among the swaying crowd in the station at North Wall. He held her hand and she knew that he was speaking to her, saying something about the passage over and over again. The station was full of soldiers with brown baggages. Through the wide doors of the sheds she caught a glimpse of the black mass of the boat, lying in beside the quay wall, with illuminated portholes. She answered nothing. She felt her cheek pale and cold and, out of a maze of distress, she prayed to God to direct her, to show her what was her duty.

Will God respond to her, though? Is there even a God who could respond to her? That the story ends there suggests that Joyce thought there wasn't.

Since the dawn of our secular age, the climactic moment of a story rarely reveals the hero's fate as having been written

in the stars. Eveline and so many great twentieth-century pro-
tagonists became responsible for their own successes or fail-
ures; in the world of the story, it was no longer fate that
mattered but free will. The implication was clear: we were not
controlled by God or fate, but were now existentially free to
define ourselves.

Game designers today take different views on whether
games offer players free will, or only its simulacrum. "When
we're watching a film we're always an outsider to the char-
acters in the film," Jason Rohrer, creator of *Passage* (2007),
told me. "We're always kind of looking at them as a little
diorama in a box, peering in. We're never down inside the
box being peered at. So we can kind of do both things and
sort of play with all this stuff in a deeper way." By contrast,
"in a video game, the player is faced with a challenge and the
player gets to make their own choice about how to overcome
that challenge."

The designer Tim Schafer is a bit less optimistic—and
more realistic—about the gamer's free will. As he told me,
"even though the player's making the choices, the choices
were carefully selected for the player by the author of the
game. When you do things and you're playing a game, you
can't really do everything." The designers decide the limita-
tions put on the player, which are shaped by the available
technology. In *Pac-Man*, our options may be limited, but that
doesn't mean we don't have any. We can move up or down,
left or right, or we can stand still until the ghosts come and
kill us. That is free will. We cannot, however, escape the maze
entirely. Even the best players in the world will eventually find
themselves chased down. That's fate.

Still, even if the free will in video games is only partial, or even an illusion, no other form of creative expression has granted its audience that godlike sensation. While living in Budapest, I both played god games and helped to design games of my own. Doing so rekindled my nostalgia for the games from my childhood, which I began to play again in 1999 when Elivi and I returned stateside to get married.

At that time, we rented a small second-floor apartment in Philly and I bought a Dell desktop computer and set up a shared AOL account. The modem's long tones and squawks now represent a discordant lost symphony. I accepted an editorial job in the e-commerce industry outside of the city in King of Prussia, but despised commuting back and forth on the Schuylkill Expressway and sitting in a cubicle all day. After eighteen months, I gave up the absurdly large paychecks and returned to freelancing full time. That was when I dyed my hair Grover blue and—taking inspiration from modernists like Kafka and Joyce in particular—I began writing stories and eventually books. I didn't yet realize it, but I had a decade of video games to catch up on.

CHAPTER 9

an american master

One of America's greatest living artists sits in a former clog factory in San Francisco writing corny jokes. Tim Schafer's video game career has spanned every platform from the C=64 to the current generation of consoles. Along the way, his extraordinary talents as a writer, puzzle maker, and industry rabble-rouser have consistently pushed the entire medium forward. *Grim Fandango* (1998) and *Psychonauts* (2005), in particular, are unchallenged classics. His best game, *Brütal Legend* (2009), stands as an important but little known artistic achievement of the early 21st century, on par with Ron English's *MC Supersized* art toys, Zoe Strauss's *Ten Years* exhibition, and Ai Wei Wei's *Coca Cola Vase* in its searching interrogation of our cultural values.

Schafer was born in Sonoma, California, a few miles from San Francisco, at the height of the summer of love in 1967. His generation—which is also my generation—was the first to grow up playing video games. By the time he was ready to

make his own, his predecessors, including Warren Robinett and Shigeru Miyamoto, had already laid a strong foundation. Schafer did not invent video games any more than Orson Welles invented cinema, but by drawing upon the earliest text-based games and the graphical innovations of the video game Renaissance, he unleashed their potential. "I think that games can be enriching in the same artistic way that books and movies are," he told me, and his work has proven that to be true.

Like Miyamoto's, Schafer's oeuvre offers a lesson in video game history. I set out to play all of his important games from 1990 to the present. What I discovered was a true creative *voice*—a word we usually reserve for novelists or composers—which is simultaneously cheeky and self-effacing, deeply respectful of the past and spit-out-my-coffee hilarious.

Schafer was twelve years old when his father brought home a copy of *Adventure* for the Atari 2600. Like so many others, he became enthralled by the game. "I didn't read the manual at all," he told an interviewer. "I was like, What's happening? I'm a square? There was an arrow and there is a horned cup and a castle and a duck is attacking me. I just remember how confused I felt, but also excited as well as confused." That sense of bafflement would inspire him to design some utterly devious puzzle games. "I love when I feel disoriented and confused and I am in a world where anything can happen," he said. "I don't know if a duck is going to swallow me whole. They were dragons, of course, but I love that feeling." The ability to find joy in confusion is a rare talent, one that I have tried to harness in my own writing life.

"I was a nerd in high school," Schafer told me. "I was a member of the computer club. I was not on the football team.

I did not hang out with cheerleaders, so we nerds talked about video games in our portable building out back at the computer club. And I try to think about how, you know, we weren't officially ostracized, but we kind of self-ostracized ourselves in this nerd hut." In addition to *Adventure*, the early text-based games proved influential. "That's how I got into games, with *Zork* in high school. That's why I make adventure games now."

He went on to study computer science at Berkeley, where in addition to his standard course load, he began reading Kurt Vonnegut and taking creative-writing classes. His budding literary sensibility would find expression in his games. After graduation, he found work programming databases for companies like Hewlett Packard and Atari until the perfect job opened up. He learned that Lucasfilm Games, which would soon become LucasArts, needed programmers who could also write dialogue for their games. "I loved Lucasfilm, not because of *Star Wars*," Schafer has said, "but because of the Atari stuff they did." His cover letter was a self-referential text adventure about his own efforts to secure his dream job.

His first task as a "scummlet," or assistant designer and programmer at Skywalker Ranch, involved play testing an ill-fated video game adaptation of a Steven Spielberg movie—though this was not the disastrous *E.T: The Extra-Terrestrial*. Rather, Schafer worked on *Indiana Jones and the Last Crusade: The Action Game* (1989), wherein the purpose, as in *Adventure*, was to find the Holy Grail. Schafer once described it as an "action game that was widely derided and not so popular." It was not the most auspicious start to his career.

For many years, video games had been designed for either a home console like the Atari 2600 or for a desktop computer, one or the other. Those distinctions would soon fade. Schafer started during a transitional time; his next assignment involved taking apart Ron Gilbert and Gary Winnick's C=64 and Apple][computer game *Maniac Mansion* (1990) and reprogramming it for the NES. That game, a point-and-click adventure, re-combined elements of prior games into something new and wonderful. The only familiar element was the objective: to rescue a kidnapped woman (Sandy) from the clutches of an evil fellow (Dr. Fred). Every other aspect evinces a particular kind of cleverness. The 1950s-era B-movie horror setting reminded me of my visit to Brookhaven National Lab. One obstacle required providing a man-eating plant with radioactive water. Another involved making a demo recording of a depressed, green tentacle in search of a recording contract. The game ends with Dr. Fred renouncing his evil ways and becoming a writer: a dénouement I could certainly appreciate.

Maniac Mansion employed an unusual game mechanic: the player had not one but three avatars in the game. In addition to Sandy's boyfriend Dave, I had the option of choosing between two other characters, each with different skills. The content of the game changed depending upon the particular combination of chosen characters. That detail made *Maniac Mansion* playable again and again, which was an important consideration when purchasing an expensive piece of software.

While Schafer had only a walk-on role in *Maniac Mansion*, its weird genre bending would clearly inspire the first game he co-wrote. *The Secret of Monkey Island* was initially published on floppy diskettes in 1990, when I was in my first

year of college. Two years later, the game was remade for the more cutting-edge CD-ROM. Like *Maniac Mansion* and all of Schafer's future games, it melded a gleeful and absurdist sense of humor with some infuriating brainteasers.

"Right around the time we were starting *Monkey Island*, *The Simpsons* premiered," Schafer once told an interviewer. "So we were all watching that together and I think that had a very big impact on what we were doing." The influence of that cartoon series is easy to identify in the game's many sight gags, such as the literal red herring that the wannabe-pirate Guybrush Threepwood has to snatch from a seagull. Other acknowledged inspirations for *Monkey Island* include "Monty Python's Flying Circus" and Douglas Adams's *The Hitchhiker's Guide to the Galaxy*. In other words, even if it did find a wider audience it felt as though that game was made exclusively for me and my friends' lit-nerd sensibilities.

Though the graphics are now dated, *The Secret of Monkey Island* remains one of the best-written games ever made. The attention paid to the script was truly rare for a video game; in most, the backstory, if there was one, felt like an afterthought and dialogue was constructed out of every known cliché. Most video games simply do not tell stories well, in large part because the story itself is subordinate to the gameplay. The author Alex Irvine, known for his novels *The Narrows* and *Buyout*, has worked as the lead writer for the popular turn-based social network game *Marvel: Avengers Alliance* (2012). "Writing for video games," he told me, "is, among other things, a really rigorous exercise in concision. You want to do all the character development and plot advancement of a novel, so the task of the game writer is to

figure out the best way to allocate that very limited space to maximize what the game isn't already doing."

One of Schafer's great innovations was to broaden the space games accorded to storytelling. Another was his use of humor—his irreverence and uncommon attention to language, inspired by text-based games and literary fiction, would soon enliven some signature video games. Johan Huizinga reminded us that "in play we may move below the level of the serious, as the child does; but we can also move above it—in the realm of the beautiful and the sacred." My admiration for Schafer's writing derives in large part from the humor of his games; they indeed operate "below the level of the serious." Playing *Monkey Island*, I laughed out loud many times, alone in my living room, starting when a pirate told Guybrush Threepwood he had "the stupidest name [he'd] ever heard" and ending with the final, root-beer-soaked battle with a ghost pirate. The levity of Schafer's games stands in stark contrast to most of the best-selling, often ultraviolent games on the market. "The fact that something as mainstream and ridiculous as comedy is a niche in the game market is telling," he told me. "I've always wanted to bring in people with well-developed emotional lives to come and play games, and broaden it, because life is broad."

After working on sequels to *Monkey Island* and *Maniac Mansion*, Schafer began making his first game as project leader. In preparation for what became *Full Throttle* (1995), he studied screenwriting, specifically how to structure a story in multiple acts. He drew on cinema in other ways, too. His protagonist, Ben, is, as the misunderstood leader of a leather-clad motorcycle gang, a cartoonish version of the sullen

and stoic heroes of Akira Kurosawa's *Yojimbo* (1961) and George Miller's *Mad Max* (1979).

Loading *Full Throttle* brought up an animated scene that filled my entire monitor. A dramatic piano tone, twanging guitar, and the sound of gusting desert winds must have taken full advantage of the new PC soundcards of its time. A growling male voice delivered one of the strangest opening lines of any video game: "Whenever I smell asphalt, I think of Maureen." That cracked me up. The camera, as if on a film-set crane, lowered into a desert canyon where Wile E. Coyote would have felt right at home, with a two-lane road running down the middle.

Next I saw two rich people sitting in the back of a futuristic limousine. The elderly Mr. Corley owned a motorcycle company, but we would soon learn that his square-jawed attaché Ripburger sought to take it over. Ripburger was voiced by another of George Lucas's employees, Mark Hamill. The vehicle pulled up to a biker bar called The Kickstand, where Mr. Corley attempted to recruit Ben and his gang the Polecats for a publicity stunt at a shareholders meeting. Ben refused out of principle, despite the gang's need for money. The theme of a good man done wrong by a corrupt system would crop up more than once in Schafer's oeuvre.

After a full nine minutes of cinematic scenes, the game began. A rifle-like crosshair appeared on the screen. Moving it over drawn objects allowed Ben to interact with them. An arrow might pop up on the screen, for example, to indicate which direction to go. A number of LucasArts' previous games had used these point-and-click mechanics and decision-tree puzzle-solving as well, but none so successfully as *Full Throttle*.

Those elements would be put to use again in *Grim Fan-dango* (1998), Schafer's next game as writer, designer, and project leader. I asked him where he had looked for inspiration in the early stages of development. "I feel that taking care of the creative part of your brain is super important, but I think it comes from everywhere. It comes from watching movies," he said, but "mostly you got to play a lot of games." *Grim Fandango* featured, as he put it, "a story set in the land of the dead from Mexican folklore." It was also "very heavily inspired by film noir. I love film noir and hardboiled crime detective novels," he said. The game relied on the same puzzle-solving focus as *Full Throttle* and other games on which Schafer worked, but added 3D graphics to the mix.

I controlled the calaca-like Manny Calavera, who is both grim reaper and travel agent at the Department of the Dead. His job entails finding clients among the recently deceased inhabitants of the World of the Living and escorting them on the trek through the Land of the Dead on the way to the Ninth Underworld. The color palette and décor resembled a hardboiled private-detective movie, albeit one that drew from Aztec mythology. There is at least one Easter egg: typing the word "blam" caused Manny to explode. Every time I did this, his component body parts flew outward, and then returned to recompose him. He would say "Ouch" and continue on as if nothing had happened.

Some of the puzzles were easy to solve, especially once I understood Schafer's general tropes, but others drove me crazy. Nearly every item that Manny could interact with would prove useful, if only I could discover the correct sequence. The balloon animal in the shape of poet Robert Frost

was an especially inspired detail. Though now regarded as one of the best games ever made, *Grim Fandango* was Schafer's last for LucasArts. In fact, he would not release another video game for six years.

"You feel ownership over something you don't own," Schafer has said. "The idea of creative ownership versus legal ownership is a weird thing." When LucasArts tried to produce a sequel to *Full Throttle* without his involvement, he avoided a potential boss fight by leaving the company and starting his own. Double Fine studio opened its doors in July 2000. The name derived from signage on the Golden Gate bridge that threatened motorists with excessive speeding tickets. In effect, Schafer finagled something approaching free publicity for his start-up company on a treasured national landmark. He began work on a new game, but it took another five years to ready *Psychonauts* for commercial release to the public.

By 2005, home video game consoles had grown exponentially more sophisticated. Whereas *Grim Fandango* had appeared exclusively on Windows, Double Fine was able to publish versions of *Psychonauts* for the Xbox and PlayStation 2 as well. Because the same games could now be played across different platforms, the distinction between computer games and console games had in some ways broken down. Back in the saddle, Schafer served as creative director, co-writer, and designer for a title that would win an astonishing number of game-of-the-year awards.

The opening cinematic of *Psychonauts* resembled a 1950s-era newsreel about the human brain. The uniformed,

Mr. Potato Head-like narrator sported a fancy, Prussian-style mustache and a helmet clearly borrowed from Otto von Bismark. In a booming voice, he described the human brain as "the ultimate battlefield—and the ultimate weapon." The camera panned back to reveal that he was speaking to an audience huddled closely around him, whom he addressed as "psychic soldiers" and "paranormal paratroopers." They were children, in fact, sent away to a "highly-classified, remote government training facility" known as Whispering Rock Psychic Summer Camp.

Schafer once explained that his own earliest video gaming memory was of an arcade cabinet in the lodge at the summer camp he went to as a child. His personal nostalgia certainly inspired the setting of *Psychonauts*, but the game also took technical inspiration from the video game Renaissance: "I had started playing *Mario 64*, *Final Fantasy VII*, and *Tomb Raider* on the PlayStation," Schafer said. "I really wanted to make a game that would pan around in 3D and was not so limited by the adventure game interface," he told another interviewer. The result was a platformer with a wildly original premise brought to life by Schafer's cinematic and comedic sensibilities.

The most distinctive parts of the game occurred in the minds of the different characters. Schafer had thought about the concept for a long time. "I'm going to do this game where you go into other people's heads," he said. "This fit in with a lot of other stuff that I was interested in when I was studying psychology in college." Schafer and his team designed mind-bending landscapes, stretching the new 3D technology to its furthest reaches. "It was a whole new way to do environmental storytelling. The environment is someone's brain."

In those sections, the player's responsibilities were therapeutic: as the narrator Raz, I could help the other characters with their emotional baggage.

As critic Kristan Reed wrote, "It's hard to think of too many other games that have inspired such heart-warming bursts of *pure fun* merely from the quality of the writing alone." The italics are hers. "It's as if critics the world over exploded in a righteous froth at the undiluted joy of being released from the harrowing shackles of reviewing intolerably beardy World War II/Sci-fi/stealth/D&D epics and actually allowed to play something that *made them laugh*." Despite almost universal praise, *Psychonauts* didn't sell as well as many big-budget games. It did, however, make Double Fine America's foremost indie game studio. For my part, I tend to regard it as a stepping stone to the defining creation of Tim Schafer's career to date.

The scale of *Brütal Legend* far exceeded anything Schafer had previously attempted. It was imagined as big from the start. "I had wanted to do an RTS [real-time strategy] game ever since I played *Warcraft,*" he said. The opening cinematic for *Brütal Legend* is an actual film clip shot at a record store in Los Angeles and starring Jack Black as a customer looking for a legendary LP. Black addresses the camera directly, offering to let us in on a mysterious secret: "I'll show it to you, but you can't tell anyone else where it is." He wanders through the store. "The kids who work here don't know where it came from, of course," he says, "but neither do the old-timers." From a bottom shelf, he removes a black album sleeve. "What I hold in my hand is not just gonna blow your mind, it's gonna blow your soul." That tongue-in-cheek hyperbole

characterizes the entire game and also makes one wonder whether Schafer, in another life, would have ended up an in-demand screenwriter in Hollywood.

Opening the cover of the double album reveals the *Brütal Legend* menu screen. The difficulty options include gentle, normal, and—naturally—brütal. For my first play-through, I chose wisely: gentle. The game's premise is so utterly strange that it goes full circle, all the way back to making perfect sense. A roadie named Eddie Riggs gets crushed in an on-stage accident and in death finds himself transported to a violent fantasy realm. Armed with a battle axe and a Flying V guitar, he unlocks powerful new guitar-solo spells and goes on a series of missions to help free the human race from the demon lord Doviculus, Emperor of the Tainted Coil. The aesthetic of *Brütal Legend* celebrates the lavishly leather-clad, Tolkien- and Nordic-myth-inspired heavy metal ethos of the 1970s, but at the same time insists that we rethink its absurd, cock-rock masculinity.

I had the option to tone down the profanity and outrageous gore of the fight scenes, but didn't. The gratuitous splattering of blood here was central to the artistry and Schafer's cultural critique. In a more prosaic way, *Brütal Legend* also spoke to the fantasy of stepping away from our cubicles and the daily grind in order to return to some savage nature otherwise stifled by our civilized routines. It offered a critique of dullness itself. For a few hours, I could be badass.

The look of the game brought back my boyhood fascination with the sword and axe-wielding warriors of Frank Frazetta's illustrations. "I've always seen this overlap between

medieval warfare and heavy metal," Schafer told one inter-
viewer. "You see heavy metal singers and they'll have like a
brace around their arm and they'll be singing about Orcs. So
let's just make a world where that all happens. That all gets
put together, the heavy metal, and the rock, and the battling,
actually does happen." I came to think of Eddie Riggs as a
bad-to-the-bone version of Link from *The Legend of Zelda*.
My own lack of enthusiasm for heavy metal music didn't di-
minish my appreciation for the game in the slightest. In fact,
all of the things I could hope to experience in a work of art—
access to new ideas, emotional connection, pure and unadul-
terated joy—are present in *Brütal Legend*.

For the time being, *Brütal Legend* remains Tim Schafer's
high-water mark, but he also acted as studio creative direc-
tor—essentially, the person in charge of the company's vi-
sion—for another important recent game. *The Cave* (2013) is
evidence of how game makers today have adapted the latest
technology to our age-old need for play. Like Crowther and
Woods's *Colossal Cave Adventure*, it opens outside of, well, a
cave. Instead of white text on the screen, eight cartoon char-
acters stand in a row behind a campfire. In the background,
smoke and lightning bugs dance in the air of a dense, moonlit
forest. A narrator greets the player in a hammy Don Par-
do-like voice:

> Welcome! Don't let my sultry and mysterious voice startle
> you. For hundreds, nay thousands, nay nay nay, tens of
> thousands of years, people have come to me in search of
> what they desire most. Few find what they are looking for.
> Even fewer ever leave.

The narrator welcomes the player at home into that magic circle around the campfire. As in *Colossal Cave Adventure*, the use of the first person raises the question of who exactly is addressing the reader. Who is the "me"?

The narrator's answer both pokes fun at and pays homage to the narrative point of view used in *Colossal Cave Adventure*: "Welcome to the Cave. That's me—the Cave. Yes, yes, I'm a talking cave. Don't laugh—it makes dating hell. Besides, I have a really interesting story to tell you this evening, so pay attention." The Cave goes on:

> It's a story of seven people and a glimpse into a dark place in each of their hearts. But be careful before you judge. There is a dark place in your heart as well. Some day you will find yourself descending my depths in search of what you desire and you might not like what you find either. But enough about you—this is about them.

Before me stood The Knight, The Hillbilly, The Time Traveler, The Scientist, The Adventurer, The Twins (whom the Cave treats as one person), and The Monk. Each of those archetypes boasted a unique talent. The Hillbilly could hold his breath underwater. The Monk could move small objects with his mind. Half of them—the Time Traveler, Scientist, Adventurer, and one of the twins—were female, notable in a medium in which strong female characters remain in short supply.

In single-player mode, I toggled between three characters I had chosen. It took some getting used to. Like *Super Mario Bros.*, *The Cave* operates as a scroller, albeit one that goes up

and down as well as left and right. Complete free will was not granted to the player. The Scientist can never leave the parameters of the game no matter how hard I tried to make her do so. The cavern served as a storytelling device that illogically and improbably managed to hold these disparate stories together within one field of play. The Twins' elaborate, Victorian-era childhood home stood underground for some reason, as did the Astronaut's Launchpad.

One section of the game involved the Monk's return to his monastery. He began with a long climb up some stone stairs, using his telekinetic power to clear the way. As he neared the top, our not-so-humble narrator returned:

We are now approaching the misty, snowcapped peaks the Monk desires to call home: a sequestered haven of austerity and mental rigor where entire lives are spent in the pursuit of becoming one with the world. Of course, our telekinetically inclined friend is not quite so ambitious. He will be happy enough simply being the one in charge—no matter what it takes.

The Monk found the Zen Master and awakened him with wind chimes. The master greeted him: "Welcome, young apprentice. You have come far, yet your mind is not at peace. To achieve enlightenment, you must pass the four trials of Zenness." That word struck me as odd, but I was so enraptured that at first I did not give it much thought.

Once the Monk retrieved the feather and began his descent, the narrator piped up again: "That was quite a climb just to grab a feather and turn right back around. I think it's

a Zen thing. You know: the journey to enlightenment is more arduous than any mountain path. That sort of crap."

At the base of the mountain, the other two characters I controlled awaited. The feather proved just heavy enough to allow the three of them—or is that the three of me?—to crash through a wooden bridge and gain access to the next part of the story. "Our enlightenment-seeking trio has completed the first trial of Zen-ness," the narrator said, "which I'm fairly confident is not actually a word."

It is now.

When we spoke, Schafer explained that he wants his games to "take you on an emotional journey and let you feel for other characters and go with those characters as they go through a journey." A great work of art, he said, "lets you experience things outside of your normal life and kind of come to know yourself better." Unlike some other game makers I talked to, he emphasized the artistic potential of the medium:

> There's people like me who always considered games art and want to see them treated and protected in the same way and given the same First Amendment protections that books receive. And there's people in games themselves who don't really care about it being an art. They don't want it to change or expand or have anyone else playing them, but I do. And so I guess I'm interested in those kinds of topics like how games work as art and how they connect with people, the unique ways they can forge empathy between people.

With that, Schafer said goodbye and returned to the work of making other people happy.

Our conversation stayed with me for months afterward. The idea that art can make us more empathetic wasn't exactly radical, but hearing Schafer articulate it made me think differently about, in particular, every multi-player game I had played. The ways in which we interact virtually perhaps shape or reflect only part of our real-world personalities; after all, I've no doubt that many vicious trolls are perfectly nice and reasonable in meatspace, at least some of the time, and that the virtual world itself is what gave rise to, or released, their abhorrent behavior. Turn that idea on its head, though, and you arrive at a Schaferian insight: even the most fleeting personal bonds established in a digital world can influence how we behave outside of games.

CHAPTER 10

world of warcraft

On December 12, 2009, in the guest bedroom of a rented bungalow in Baton Rouge, I began a free 10-day trial of *World of Warcraft* (*WoW*). I had recently accepted a two-year position at a venerable literary magazine based at Louisiana State University, but circumstances beyond my control made the job miserable. Logging onto *WoW* and battling monsters became my way of unwinding after another workday spent getting berated for things that had nothing to do with me. The game provided a necessary form of escape. I enjoyed it so much that I continued to play after my job there mercifully ended and I moved back to Philadelphia.

A few months later, a former colleague on the tiny staff of that magazine drove his Jeep the wrong way on the I-10 highway for at least fifteen minutes. He headonned and killed forever, as Denis Johnson might have put it, four young people returning home from an evening in New Orleans. The authorities identified his charred body from his dental

records. I had been in that Jeep several times, often discussing the hyper-competitive endgame elements of *World of Warcraft*, which I did not yet understand. My colleague had been the top-ranked player of his server, a feat that required hours of daily grinding and an unthinkable, perhaps even unbalanced, persistence. Spending forty hours or more each week in the game was not unheard of among hardcore raiders. I've since wondered if there was some connection between my friend's obsession with the game and the apparent mental illness that led to his immense tragedy.

Since first logging on to *World of Warcraft* on that muggy December evening in Louisiana, I spent in excess of 64 days, 11 hours, and 45 minutes in the virtual world of Azeroth before canceling my monthly subscription. That was *far* more time than I had devoted to any other video game in my life. I kept playing even though I could never fully divorce my enjoyment of the game from the reasons I first came to it, or from my sadness about my friend's too-short life and the others he took with him. All I have to show for those two months of my life are a poorly-geared Shadow Priest named Bootzilla Jenkins and lingering questions about why I dedicated so much time to painstakingly cultivating an online alter ego. Why exactly had I found *World of Warcraft* so engaging, even addictive?

After a long time away from Azeroth, and with some hesitation, I decided to restart my subscription and bring my character—or toon, in the parlance of the game—back from the netherworld of digital stasis. I also started a new one more or less from scratch. I wanted to know how a fun social ritual could so easily turn into unhealthy escapism, and why I had apparently crossed that line.

"All that is said about Zen is necessarily untrue," according to Christmas Humphreys. The eminent British barrister and Buddhist convert recognized the difficulty of putting the ineffable into words. We can trace the origins of the Zen school of Buddhism to China's T'ang Dynasty and the reign of Emperor T'ai Tsung (627–650), who took inspiration from Confucian wisdom. Today, the physical practice of Zen meditation is said to promote mindfulness in daily life and aid in the repudiation of the ego. The hope persists that by freeing ourselves from the illusion of individuality and from our self-conscious thoughts we might attain a deeper experience of the truly real. "Zen, being direct experience of Reality," Humphreys wrote, "is beyond the intellect, and therefore beyond description." Zen is not something we understand intellectually, but rather something we experience.

I began meditating twenty-five years ago as part of my first undergraduate class on Buddhism. My practice has been inconsistent since then, and like most human beings I have sought many methods of calming my so-called monkey mind and absconding, if only temporarily, from my egocentric self. Since first playing *The Cave*, I have used the otherwise silly word *Zen-ness* to describe the particularly immersive properties of video games. Zen-ness, as I have defined and experienced it, combines three different sensations: eustress, fiero, and flow.

The word eustress originates with the Greek *eu*, meaning goodness, as in euphoria, and it describes the process of purposely inducing positive stress for the sake of producing adrenaline. The stress I feel in a video game battle feels exactly like the real stress one encounters, say, in a job where

one feels mistreated; but I always know, on some level, that the stakes are low or nonexistent. Choosing to stress out in a controlled and ultimately harmless manner feels good; the fact that a video game is *just a game* makes it more useful and meaningful to me, not less so.

On her blog, the player experience design expert Nicole Lazzaro uses the Italian word *fiero* to describe "hard fun" and "in the moment personal triumph over adversity." If eustress represents a kind of fruitful tension, fiero may very well be the pride we feel upon its release. It was precisely what I hoped would wash over me if I found one of the most elusive prizes in *World of Warcraft*, like a Time-Lost Proto-Drake mount. I think of fiero as the primal thrill we feel when attaining a long-delayed goal. In a video game, learning from one's mistakes and solving challenging puzzles can evoke a genuine, hard-won sense of jubilation.

When the psychologist Mihaly Csikszentmihalyi coined the term *flow* to describe "the positive aspects of human experience—joy, creativity, the process of total involvement with life," he did not have video games in mind, and yet the concept is useful in that context. As Csikszentmihalyi wrote, "we have all experienced times when, instead of being buffeted by anonymous forces, we do feel in control of our actions, masters of our own fate. On the rare occasions that it happens, we feel a sense of exhilaration, a deep sense of enjoyment that is long cherished and that becomes a landmark in memory for what life should be like." I have felt for myself the ways in which a great video game can induce that exhilaration.

Losing myself in a video game and surrendering all sense of time has had much the same effect on me as the practice of

Zen meditation. "All great work—artistic, poetic, intellectual, or spiritual—is produced at those moments when its creators are lost completely in their actions," Humphreys wrote, "when they forget themselves altogether, and are free from self-consciousness." Just as the practice of Zen meditation can encourage the blissful negation of the self, temporarily transferring my own noisy ego to a digital avatar allows for the occasional, cherished moment of Zen-ness.

For the duration of a great gaming session, I am like the fettered prisoners in Plato's cave allegory who have no concept of reality outside of the cavern. Gaming is not, to the best of my understanding, akin to entering a voodoo trance nor to reaching a state of Zen by way of mindful meditation, but it does involve a kind of mental removal from the real world. It's a little bit like getting immersed in a great book, which can be equally stimulating, but I've found that the constant motion of my hands and fingers on the controller or mouse—the frantic lunging, pressing, and clicking—quiets the mental distractions that sometimes find me while reading. When focused on a video game, most of my inner voices grow quiet. Still, I understand that the game remains just that; behind me, there exists sunlight and books and my wife and other people. Yet the temporary tunnel-vision can bring about a peculiar state of mind. I am both present in my chair in the real world and also represented by an avatar in virtual space, but at rare times, those different versions of myself blur. And I have found that sensation in *World of Warcraft* far more often than in any other game.

Azeroth, arguably the most thorough and detailed fantasy world since J. R. R. Tolkien's Middle-earth, originated with a simple real-time strategy game created by the Irvine,

California-based company Blizzard Entertainment and released in 1994 for MS-DOS. In the multiplayer mode of *Warcraft: Orcs & Humans*, one player controlled the Human denizens of Azeroth and attempted to fend off the invading Orcs, who were led by a second player connected on a local network or via a modem. From those limited beginnings, *Warcraft* has become a phenomenon that reaches beyond the computer screen to table-top and card games, a series of novels, manga, and comic books, and a 2016 movie that cost $160 million to make.

The first sequel to *Warcraft*, *Warcraft II: Tides of Darkness* (1995), likewise began on MS-DOS. The visuals resembled those of its contemporaries, with a flat field of play seen from a god's-eye point of view. In *Warcraft II*, Azeroth felt larger and more expansive than Hyrule. True to the hacker ethos of Steve Russell and his ilk, the software included a map editor, with which players could design their own battle scenarios. More importantly, while *Warcraft II* was on its way to selling 2 million copies, advances in networking technology made it easier for players to compete from afar. An online community of *Warcraft* devotees was born.

For *Warcraft III: Reign of Chaos* (2002), Chris Metzen, the longtime writer for the series, was joined by Rob Pardo. Pardo would go on to become Blizzard's Executive Vice President of Game Design and Chief Creative Officer. "As far as game designers go," he told me, "I've probably worked in more genres than most." His efforts for the *Warcraft* franchise and several others—including *Starcraft* (1998) and *Diablo II* (2000)—helped transform Blizzard into an industry powerhouse.

Pardo sees the job of the designer as akin to that of sculptor. "You start with nothing, you can't even put a pixel on a

screen, and then over time you just see this evolution of something turn into a very complex game." Notably, he and others at Blizzard decided to release, with *Warcraft III*, the sculptor's air hammer, disk saw, and chisels—the editing tools he had used to create it. That led to nothing short of a revolution, one nobody at Blizzard could have predicted. "So you can see basically an entirely different game genre spawned from the level editing tools in *Warcraft III*," Pardo said.

In much the same way that various hackers had built upon Steve Russell's *Spacewar!* and Don Woods improved upon William Crowther's *Colossal Cave Adventure*, members of the early online *Warcraft* community contributed to a *Warcraft III* mod called *Defense of the Ancients*, or *DotA*. That hack (in the earlier meaning of the word) led to the creation of the entire multiplayer online battle arena (MOBA) genre, which by the end of the decade came to dominate the entire video game industry and helped popularize e-sports. Blizzard did not reap the immediate benefits, however. A savvy company called Riot Games had the foresight to create and copyright a commercial version, *League of Legends* (2009), that in 2014 brought in more than $1 billion in revenue from microtransactions alone. To their credit, Chris Metzen and Rob Pardo remained true to the original, open-source ethos of video game development. They also went on, a few years later, to create a new game unlike any other.

The massively multiplayer online role-playing game (MMORPG) *World of Warcraft*, released on November 23, 2004, was an immediate creative and financial success. The basic premise is straightforward: the player, inhabiting a character, completes

a series of tasks in a fictional, high-fantasy realm in order to gain greater powers. There is no winning or losing, no final challenge to overcome. If and when a character attains the highest level (the threshold of which still rises every few years) the so-called endgame involves acquiring better and better gear and working in teams. Multi-player collaborations—complex dungeon raids involving a combination of skill and problem solving—can take weeks or months to complete. One does not play *World of Warcraft* so much as live in it. As Ian Bogost told me, "it doesn't make much sense to compare *WoW* to *Super Mario Bros. WoW* is more like Walmart."

At any moment, potentially millions of people around the globe are still traipsing about Azeroth. Life goes on in that persistent world even when one logs off. Stormwind and Orgrimmar, the capital Alliance and Horde cities respectively, have functioning economies and offer every manner of amenity and service for a growing toon. They are digital cities that never sleep.

The sheer size of the world in *World of Warcraft* was remarkable when it launched and it has only continued to grow. Traveling on foot—that is, without using a mount or the in-game flying methods—it would take hours to get from Moonglade (on the northern tip of Kalimdor) to Tanaris (a desert enclave in the south). In the course of leveling up my character, I trekked through the leafy forest of Elwynn, the fetid Swamp of Sorrows, and the snow-capped peaks of Dun Morgh. As is the case with my native Philadelphia, some areas of Azeroth are stunningly beautiful to behold and others difficult to endure.

When I began playing *World of Warcraft* in 2009, the game had already expanded well beyond its initial form

through expansion packs. My time on Azeroth began during *Wrath of the Lich King* (2008), which introduced the continent of Northrend and the Death Knight class, and a seemingly impossible-to-reach level cap of 80. Naturally, owing to nostalgia, I felt most invested in this content, especially the chain of events leading up to the defeat of the Lich King himself. My first few hours of *World of Warcraft*, when I was figuring out the simple mechanics and quest chains, were among the most enjoyable gaming experiences of my life. After a few weeks, and living far from my young nephews, I bought them copies for Christmas so we could play together online. Looking back, I hope that wasn't a mistake.

There have been several occasions when I felt that my otherwise enjoyable search for an inhabitation of Zen-ness in *World of Warcraft* became something more intense and troubling. When I was away from the game I would, at times, feel a phantom-limb sensation of knowing that Bootzilla lived on in my absence. I was constantly two places at once: when hiking in the forest or hanging out with friends, I would catch myself distracted by what might be happening in *WoW* and I would long to log back on.

The very sensations that can make the game so immersive can also make it dangerous. "Video game addiction is a real thing that is supported by mounting scientific evidence," according to psychologist Clayton R. Cook, Associate Professor at the University of Minnesota's College of Education and Human Development. "All addictions have a behavioral component in which there is a strong urge/temptation/desire to engage in specific actions that when done in excess can lead to significant impairments in social, emotional, and physical functioning," he

told me. The extreme cases are truly shocking. In 2012, twenty-three-year-old Chen Rong-Yu died in a Taiwan internet cafe after playing a video game for twenty-three hours nonstop, and he was only one of many reported cases of video game addiction turning deadly. It's easy to dismiss such cases as outliers, but as someone who has spent too much time in a fantasy world, these examples of addiction hit close to home.

While I'm fairly certain that my gaming did not adversely affect me outside the game, there are plenty of examples of the potentially disastrous effects of *World of Warcraft* on people's marriages and physical well-being. In April 2007, before the *Wrath of the Lich King* expansion, a woman wrote a Craigslist advertisement apparently offering sex in exchange for in-game currency. "Hello I need 5000 world of gold [sic] for my epic flying mount," she wrote. "In return you can mount me." She requested a screen shot to prove the possession of the gold and mentioned the name of her server, where she played a level 70 Night Elf druid. "[H]onestly anyone will do," she wrote, "as long as you have the gold."

Even more troublesome, a May 2013 article in the *Los Angeles Times* described the arrest of a married couple on two felony counts of child abuse and two misdemeanor counts of false imprisonment. They had played *World of Warcraft* so obsessively that their children suffered from malnourishment. The parents were sentenced to three and five years in state prison after police investigators found the kitchen appliances, "covered in mold and cobwebs, stacks of trash, debris, mold, and feces throughout the home, a pile of used condoms under a stuffed teddy bear, and inoperable toilets." That feedback loop of small rewards—brief but meaningful

moments of fiero—had led not to a blurring of the line be-
tween real and virtual, but to an apparent decision to replace
the former with the latter.

Then there is the Norwegian mass murderer Anders Beh-
ring Breivik, who confessed to killing seventy-seven people in
2012. He was said to play *World of Warcraft* up to sixteen
hours a day. The names of Breivik's characters included Con-
servatism and Conservative. A number of comments he posted
under those names remain visible on Blizzard's web forums.
One reads:

```
(Better hated than forgotten, or what?)
  :D
```

Breivik's case is an outlier among outliers. It also raises, of
course, the now decades-old debate over video games and
real-world violence, a debate I've always found produces
more heat than light. But again, though I may understand
nothing else about Breivik and the workings of his mind, I can
understand the desire to lose oneself in a game as a means of
leaving the real world behind.

Game design companies certainly calibrate their creations to
be maximally addictive. "Well," Shigeru Miyamoto has said,
"when we first started we were starting with arcade games
where you would put in a quarter and play a game—we needed
to design the game in a way that you would want to put in the
next quarter to keep playing." In his hard-to-find 1982 book
*Invasion of the Space Invaders: An Addict's Guide to Battle Tac-
tics, Big Scores and the Best Machines*, Martin Amis wrote, "Af-
ter all, the obsession/addiction factor is central to the game's

success: you might even say that video-dependence is pro-grammed into the computer." Keeping a player glued to a *Donkey Kong* machine or *Warcraft* session is clearly in a company's best interests. "The tricky part is the video game designers strategically create experiences that capitalize on the concept of intermittent reinforcement," Clayton R. Cook told me, "which is the same tactic used by casinos to hook people into gambling."

Sitting at a computer monitor for long stretches to the exclusion of fresh air and exercise and flesh-and-blood social activities strikes many people as a textbook example of antisocial behavior—if not even a gross repudiation of the totality of human experience—and yet *World of Warcraft* once had a social aspect that I found commendable and even healthy. I've made real friends in Azeroth, people all over the world with whom I stay in touch outside the game. Adam Saltsman, creator of *Canabalt*, cited the social nature of *World of Warcraft* as one of its most notable achievements. "There's a very cleverly constructed role-playing game in there, but as a social construct, as a way for people to spend time with each other and have these shared adventures," he told me. "I think that might be where a lot of the staying power comes from."

That was certainly consistent with my experience. In addition to my nephews, my brother Chris in Denver and my brother-in-law James near Reading, Pennsylvania, signed up as well. We made a formidable team. We ran dungeons as a group and participated in raids made up of twenty or forty players. Most of the time, we simply wandered around killing random monsters and visiting the different playable zones.

The most fun I had in the game was a late-night session, in the spring of 2012, when Chris and James and I joined sixty or so other members of the Alliance to attack the Horde city of Orgrimmar en masse. The attack was so large that the game became glitchy, unable to handle so many eager marauders in the same place at once. Beyond overwhelming the hated enemy, we also very nearly overwhelmed the server. When it was over, we all, as planned, celebrated our triumph by strolling back into Stormwind on the rare Black War Bear mounts we earned for the regicide of the four Horde leaders. My brothers and I still talk about that session, as though it were no different than a memorable fishing trip. We came to rely on the in-game chat function—more than phone calls or text messages—to keep in touch and share personal news. That's a sign of how often we were in Azeroth.

Yet after a few months, my relatives began dropping out one by one. That was not a unique phenomenon. In October 2010, less than a year after I started playing, the game peaked at 12 million monthly subscribers. Five years later, after three more expansions, that number had dropped to 5.5 million. Millions had migrated to other MMOs, MOBAs, and console games. To save face, Blizzard announced that it would no longer report its subscription numbers. The decline was not difficult to understand or to predict.

Every time the level cap increased, the armor and weapons that I had spent weeks and months acquiring became outdated. Worse, the challenges themselves rarely changed, yet I could still hear the cash registers ringing in Irvine, California. "There are some video games where the player gains levels, their ability level goes up and up and up," the game maker

Jason Rohrer told me. He did not mention *World of Warcraft* by name, but he didn't need to:

> Now you're at level 5! Now you're at level 6! Now you're at level 30, oh my gosh now you're a level 30 wizard! Now you can fire really big lightning bolts! And now the monsters have gotten even bigger, right? So the monsters look bigger and scarier, and now you've got these bigger and more powerful lightning bolts that you can dispatch them with. And it kind of makes you feel like you're doing something, like you're overcoming challenges that are getting bigger and bigger and more dramatic, but you're actually just pressing the same button to deal even more damage to an even bigger monster.

To Rohrer, *WoW* and games like it are not the best representatives of the medium's inherent power. "The game is sort of trumping up this fake drama. I think the best video games don't do that. The best video games actually have some sort of challenge and drama increasing over time where the player has to bring their own abilities to bear."

I did find that *World of Warcraft* eventually grew tiresome. It began to feel a bit too much like repetitive busywork, without any sensation of Zen-ness. Furthermore, the brief emotional rewards of completing goals were undermined by the knowledge that another expansion would eventually render my new loot useless. My nephews moved on to more dynamic games, further reducing my incentive to play, and I let my monthly subscription lapse.

Logging on to *World of Warcraft* again after years away felt strangely comforting. I realized that I had felt homesick-

ness for a fictional place. Bootzilla had patiently awaited my return right where I had left him, in front of the Stormwind auction house. Changes in the game during my absence had rendered his gear unsuitable for the latest quests. That gear was only code, of course, which the designers had purposely rendered defunct. I had to complete some quests and run some dungeons to get him back up to speed, but I also knew that another pending expansion of the world would eventually render the resulting achievements obsolete soon, anyway.

For that reason, I created a new character with whom I could revisit *World of Warcraft* more or less from the beginning. First, I chose my toon's gender. Over the years, I have played both female and male characters; this time, for no real reason, I went with male. As of 2015, female players, interestingly enough, constituted about 35% of the *WoW* population, perhaps a higher percentage than one would expect, but based on my own totally unscientific observations, the characters appeared to be equally distributed.

The next choice was my race, which would determine my strengths and abilities. Race would also determine what classes I could be and where my allegiances would lie. As the blogger Gene Demby has written, "post-racialism is apparently a crock even in fictive realms!" Alliance races included Human, Dwarf, Night Elf, Gnome, the alien Draenei, and the werewolf-like Worgen; whereas the Horde consisted of Orcs, Undead, the minotaur-like Tauren, Goblins, Blood Elves, and, of course, Trolls. I decided to be a kung-fu fighting Pandaren, the one race whose destiny could lie with either the Horde or the Alliance. My class options included warrior, hunter, rogue, priest, shaman, mage, or monk.

Thinking back to the Monk in *The Cave*, I made my new toon a Pandaren Monk. The name I chose for him, Anchoviest, derived not from my love of pizza toppings, but the first two letters of my first and middle names. He would exist on the same shard, Nordrassil, as 100-level Bootzilla. By virtue of my many hours spent playing *WoW*, Anchoviest would have access to many of the in-game items Bootzilla had previously acquired: gold to buy gear, heirloom items to make leveling up easier, and the flying drake mounts I had received as loot.

Anchoviest was born unto Azeroth with countless untold advantages; privilege had been programmed into the game. There would be no vow of poverty for this particular monk. He had not even begun his first quest yet and had already inherited a fortune and been pigeonholed by gender, race, and class.

Every race has its own starting area. For the Pandaren, it is an idyllic setting called the Wandering Isle, which happens to be the shell of an enormous sea turtle. The first task involved speaking with Master Shang Xi, a panda wearing a pointed bamboo hat. "Where you pass," he told me, "greatness follows." The walled village and ornate pagodas resembled the set of a Kurosawa film, albeit one that that been animated and colorized. Upon completing one quest, I was greeted with some pseudo-wisdom: "Life isn't about finding yourself. Life is about creating yourself. There is a path before you, but you choose the trials you will face, and the trials you will overcome." The path I chose began with deleting that toon.

My biggest problem with *World of Warcraft*, I found, was not the repetitive game mechanics, but the disconnect between those mechanics and the lore of the fictional world. Starting with *Warcraft: Orcs & Humans* in 1994, Blizzard has

expanded one of the most richly detailed fictional worlds I have experienced, and yet all that lore was shunted to the background when I actually played the game. Nothing Bootzilla did could affect Azeroth in a meaningful way. I was always a spectator to the story, never a true participant.

As it turned out, Rob Pardo took little interest in the lore. "I feel like the story is always secondary, if there's even a true story," he told me, "but I feel that the story is there to wallpaper and give more meaning to the experience. It's always secondary to what's the fun of the game mechanics." That view is embodied in *World of Warcraft*. I never needed to know the story to advance in the game, and learned more about the history of Azeroth from the bloated but enjoyable movie than I had playing *World of Warcraft*.

In *Full Throttle* or *Brütal Legend*, by contrast, the player fully participated in Tim Schafer's story. The events of the game did not happen until I triggered them. That is, I brought the story to life through my actions and decisions. *World of Warcraft* operates differently, in large part because of the contrasting demands of a single-player game and a MMORPG. In Azeroth, the lore of the world is already in the past, which meant that I could ignore it entirely. Given its depth and complexity, that struck me as a shame. My favorite games are the ones that allow me, sitting at my computer or in front of the TV, to contribute to the stories they tell.

For the time being, I nevertheless keep my *World of Warcraft* account active. At first glance, by recycling some old characters and ideas, the most recent *World of Warcraft* expansion,

Legion (2016), looks like it might offer a kind of nostalgic appeal to longtime players. The animations certainly look great, and yet I transport myself to Azeroth less and less often. All of us rely on some form of escape, be it alcohol or exercise, reading literary fiction or binge-watching television. For too many of us, what starts as a needed distraction can become something more, and something pernicious. Even in moderation, all of these activities speak to the seemingly innate human need to quiet the torrent of thought that fills our minds.

Resistance, however, always proves fleeting, if not futile. "You cannot escape life however you may try," Walpola Rahula wrote in *What the Buddha Taught*. "As long as you live, whether in a town or in a cave, you have to face it and live it." As a professor at Northwestern University for many years, the Sri Lankan monk and scholar helped introduce Buddhist thought to the Western world. "Real life is the present moment—not the memories of the past which is dead and gone," he wrote, "nor the dreams of the future which is not yet born. One who lives in the present moment lives the real life, and he is happiest."

Whether as a *World of Warcraft* Shadow Priest or as The Man, playing an immersive video game does not feel precisely like mindful meditation, but it can accomplish something closely analogous. It can also run the risk of temporarily closing us off to important offline elements of our lives. I have learned both of those lessons for myself in Azeroth.

CHAPTER 11

trigger warnings

Each year, as many as 18 million people visit the 1.7 million-square-foot shopping mall in the northeast, primarily working-class, corner of Philadelphia. The complex has changed names, but everyone around here still calls it Franklin Mills, after the state's most famous colonial-era citizen. There, in 2009, the United States government established the first Army Experience Center, which boasted 60 personal computers and 19 Xbox 360 consoles running first-person shooters (FPS) and other military-themed games. In one room, potential recruits could stand in a Humvee and shoot at enemies projected on a 15-foot screen; in another, a helicopter simulation offered opportunities for more elevated warplay. By one account, 33 Franklin Mills shoppers joined the armed forces after playing those games.

The first-person shooter genre has taken hold in the popular imagination as the one that defines the medium. Warren Robinett admitted to me, "there's sort of a core idea of what

a video game is: there's a challenge, you try to shoot the bad guys." That has been the case for decades. The Magnavox Odyssey offered an optional gun peripheral and the NES came with a plastic pistol called the Zapper. In a particularly troubling instance of life-imitating-art-imitating-life, a Texas-based firearms manufacturer recently created a working Glock that resembled that plastic Nintendo toy. The best-selling game of 2015 was a first-person shooter, *Call of Duty: Black Ops III*, in which special operations soldiers investigate a CIA black site once used for the extraordinary rendition of noncombatants. For most gamers, the controller—replete with trigger buttons—serves as a de facto gun, rendering any modern gun accessories unnecessary.

The FPS genre has always struck me as not just endorsing but glorifying guns, militarism, and blind, unconsidered patriotism. They are nothing if not popular; since 2010, over 125 million people have played a *Call of Duty* game, and the series has surpassed $10 billion in revenue. For a long time, I didn't think of myself as a gamer in part because I never wanted to associate myself with the millions of people for whom bloodlust—even virtual bloodlust—became a virtue. Being somewhat respectful of popular opinion, however, I decided to try my hand at some first-person shooters, and to rethink my own prejudices.

I began my education with id Software's *DOOM*, the first—and until recently, the last—first-person shooter I remember playing. However violent, *DOOM* was an exceedingly well-made game. Development began in 1992 when John D. Carmack programed a new 3D game engine, for which Sandy Peterson and John Romero designed the interac-

tive levels and the innovative, first-person point of view which has become commonplace.

At 2 p.m. on December 10, 1993, an employee of id Software named Jay Wilbur uploaded the shareware demo to a server at the University of Wisconsin-Madison, which promptly crashed due to the demand resulting from the pre-launch hype. Using AOL and other commercial networks, thousands of eager gamers queued to await their turns to access a 2.39 MB file that took up to four hours to download. (By means of comparison, a typical webpage in 2016 consisted of 2.3MB worth of data.) What Carmack and Romero and their colleagues managed to accomplish despite the technological limitations at the time remains a marvel. Romero has noted that the memory restrictions led them to streamline the game. He and his colleagues "re-assessed what your objective was supposed to be," he has said, "and we decided to boil the whole concept down to: kill everything and get out alive."

I didn't play it until the following spring. Some coworkers at the Borders where I accepted a post-graduation job were among the almost two million people who had installed it on their computers. In 2016, it took me three minutes to download *DOOM* to my PS3 and less than an hour to tire of it. While dated, the original incarnation remains disconcertingly brutal, even in our desensitized age. It also reminded me why the game became a milestone in the history of the medium.

The most salient feature of *DOOM* is the gun that extends outward from the bottom of the screen toward the 3D-rendered environments, as though the player is holding it. Pressing the correct button on the controller made the sound of gunfire crack through my speakers. The humanoids I shot

groaned and fell to the ground. The plot—as it was developed over later incarnations—featured a space marine working for the Union Aerospace Corporation, an interstellar soldier for hire battling the forces of hell. The flimsy story existed solely to tie together a long series of gory scenarios.

The splattering blood, which most eleven-year-olds would consider tame today, raised any number of important questions. Sitting on my sofa, it might have been easy to believe that violent video games contribute to violent behavior in real life. The story that's inevitably brought up near the start of any debate about video games and violence is about how one of the boys behind the 1999 massacre at Columbine High School had customized a level of *DOOM* to replicate the floorplan of his targeted school. He practiced his assault in so-called God mode, in which the player is invincible.

If anything, though, I suspect that for the majority of players, first-person shooters offer the same release I found when playing *World of Warcraft* after a long day of work. I posed the question to the game designer Brenda Romero, John's wife. Her career began at age fifteen at an Ogdensburg, New York-based developer, where over the span of twenty years she progressed from answering phones to programming and designing games of her own. She has credits on over twenty games, including *Dungeon & Dragons: Heroes* (2003), and across many different genres. Not only did she agree with the shooter-games-as-escapism notion, but she told me that "For John Romero, John Carmack and Adrian Carmack, *DOOM* was cathartic." In other words, the game makers were themselves seeking an outlet. "None had an ideal upbringing," she said.

The year after the dissemination of *DOOM*, the Entertainment Software Rating Board (ESRB) established a rating system similar to that for movies. "This is one of my favorite stories," Brenda Romero told me. She explained to me the chain of events:

> The day before *DOOM* was released, Congress was debating video game violence on the floor of Congress. None of the guys at id had any idea this was even happening. The debates were caused by *Mortal Kombat* (ripping a guy's heart out) and *Night Trap* (which seemed to suggest potential sexual violence). That *DOOM* would be released the day after this was an amazing coincidence.

She wanted to correct the misunderstanding that the ratings system was instituted primarily because of *DOOM*. Even though there have been far more gruesome games, *DOOM* will perhaps always be a byword for video game violence and its larger cultural import.

The violence in *DOOM* felt tame to me in part because of the dated graphics and in part because the designers had literally and wisely dehumanized the enemy. By the logic of the game, I was saving humanity and if that meant violently dispatching some beasts back to the underworld, so be it. The multi-player *Goldeneye* (1997), inspired by a mediocre James Bond movie starring Pierce Brosnan, took no such precautions.

One rainy Saturday, I returned to the nearby Classic Game Junkie shop and then invited a few people over to play my new Nintendo 64 cartridge. Four of us could play at once as familiar Bond characters. Since we all played on the same TV,

I had to watch what I was doing in one quadrant and simultaneously try to sneak looks at my competitors, who were attempting to hunt me down. If shooting creatures from hell had felt vaguely disconcerting, shooting human avatars of my friends felt positively sickening—at least at first.

My friend Scott, a bit younger than myself, had played the game when it was new. He and many people of his generation never considered it overly violent; to them, it remains a standby, if not a classic. I suspect my own aversion stemmed in part from growing up in a time before video games depicted realistic violence. I would have thought that playing against real people who sat in the same room as me would be troubling, but that was not at all the case. Call it peer pressure or comradery or old-fashioned competitiveness, but I felt less repulsed by the gun violence because I was going up against people I liked. They were fine with being shot at and, after a few minutes, so was I. We played for hours, until my hands were sore from strangling the controller.

Armed with new insights into the genre, and, soon, with increasingly powerful simulated weaponry, I played *Halo: Combat Evolved* (2001). My college-aged nephew John had described it as the best first-person shooter of all time, though he did not, of course, grow up in the age of *DOOM*. He has played every incarnation in what is now a long-running series; and he has read the tie-in novels that fleshed out in great detail the lore of the game's fictional world. I know him to be thoughtful and conscientious: if he liked the game, it must certainly have merit.

Halo, a game now exclusive to and synonymous with Microsoft, began as an Apple product and served as a catalyst

for the current era of console gaming. In July 1999, the former Atari hanger-on Steve Jobs addressed the audience of the Macworld Conference & Expo in New York. A video clip of the event shows Jobs introducing Jason Jones, co-founder of the developer Bungie and project leader for *Halo*. "Everything you're about to see is being rendered in real time on a Macintosh," Jones announced. The melodramatic chanting of a male chorus filled the auditorium as if to summon the macho-man gods of war and rouse yet unseen generations of future testoster-trolls.

In 2000, just when Apple was attempting to stake a larger claim in the video game market, Microsoft swooped in and purchased Bungie outright for $30 million. Jobs, it has been reported, was so furious that he called Microsoft CEO Steve Ballmer to complain. *Halo: Combat Evolved* became a launch title for the Xbox system. Twelve sequels, reboots, and spin-offs followed over the next fifteen years, an eternity for a medium that has only been around for about a half century. The series has sold 65 million copies and grossed $3 billion. Perhaps Jobs had intuited that outcome.

When I wanted to play the game, I ran into a problem: I didn't own any of the iterations of the Xbox. In the still-raging console wars, I originally sided with Nintendo but had recently switched my allegiance to Sony's PlayStation. Even now, I advise people new to console gaming to start with a used PS3. It had never occurred to me to buy an Xbox; because Microsoft is an American company, I had always associated its system with these ultraviolent, artless games that pandered to the domestic, bloodthirsty, and blockbuster-minded audience. Fortunately, I knew that my 28-year-old

neighbor Steve, like my nephew John, was a *Halo* fan. He agreed to let me buy him a cheesesteak in exchange for borrowing his console—and on the condition that I also lent him my NES and N64 so he had something to play for a few days. That seemed entirely reasonable.

The plot of *Halo* is not, in the broadest sense, so different from that of *DOOM*. It involves a genetically-enhanced soldier known as Master Chief, who is awakened from cryogenic sleep when the evil Covenant aliens attack his spaceship. The gameplay tutorial is intelligently mixed into early scenes conveying this backstory; my learning curve had been woven into the narrative. As it turned out, playing *Halo* is surprisingly easy. I began to understand one aspect of its appeal: I could get good at the game very quickly.

As Master Chief, my duty was to transport an overly-busty holographic woman to safety while fending off the Covenant and, naturally, saving humanity from extinction. I made my way through a labyrinthine spaceship, shooting monsters along the way. Brightly colored blood splashed on the ground and the bulkheads every time I killed another alien. The controller vibrated in my palms. The rapid-fire sound of machine guns filled the living room. I hated it.

In 1985, the scholar Donna J. Haraway published the first version of what later became *The Cyborg Manifesto*, an interdisciplinary look at the importance of technology to feminist theory. "The culture of video games is heavily oriented to individual competition and extraterrestrial warfare," she wrote. "High-tech, gendered imaginations are produced here, imaginations that can contemplate destructions of the planet and a sci-fi escape from its consequences." I could not get her

work out of my mind when playing *Halo* and other first-person shooters. The hours I spent firing at things began to wear on me physically, emotionally, and intellectually.

For days after returning Steve's Xbox, I felt simultaneously exhausted and jittery. I have never done cocaine in my life, but for a little while I believed I now understood the physiological effects. The novels I was reading stopped making sense. I couldn't focus on even menial tasks around the house. I puttered in the garden and took a long walk along Wissahickon Creek, and yet I still could not shake the hyperactive turn my mind had taken. *Halo* is an elegantly and intelligently designed video game. I understood my nephew's appreciation for it, but did not share it. Fortunately, we could stick to playing other games together and hanging out IRL.

I wondered if it would be possible to detox from *Halo* with a game that celebrated the wondrous diversity and creation of life rather than its destruction. I had heard Will Wright's *Spore* (2008) described as a god game, along the lines of *Populous*, but soon found that description lacking. Whereas *Populous* represented the viewpoint of a supreme being overseeing all of creation and provided the player at home the opportunity to play God, *Spore* allowed me to simulate the vagaries of biological adaptation across the vast scope of existence, from cellular beings to interplanetary colonizers.

I turned to eBay to find a used DVD-ROM, which was supposed to be compatible with my iMac, so I did not anticipate the massive headaches delivered to my door a few days later. The problem originated with a decision on the part of Apple Inc. that I had failed to consider. For some reason, the newer iMacs no longer have CD or DVD drives. Thankfully,

I kept an old, stripped-down, 2.4 GHz-processor iMac around for distraction-free writing time (the same I had used to make a *Vib-ribbon* mix). I had bought it in 2008, the year *Spore* was first published, so I figured it had to work.

Instead, I was greeted by a dialogue box that read:

An update for SPORE™ is available.
Do you want to download and install update now?

I ignored the temptation of the flashing Yes button. Clicking No opened a small welcome window and then my entire desktop went black. *Spore* was less than a decade old. The difficulty of installing such a relatively recent game made me worry about how difficult it might be in the years to come to play the original incarnations of games. The physical technology itself is evolving at a rapid clip, after all.

The game finally and mercifully loaded. In it, I had at my disposal a limited number of choices and possible decisions, but it rarely felt that way. Beginning a new game gave me the option of starting at one of three epochs: Cell Stage ("Nurture your own creation from its humble aquatic origins to its evolution as a sentient species"), Creature Stage ("become the first sentient species on the planet"), or Tribal Stage ("build your tribe of three to a burgeoning village"). Only by completing the latter was it possible to unlock the Civilization and Space stages.

The long-tone music for the menu screen recalled a combination of the soundscape of the McNamara Tunnel at the Detroit airport and György Ligeti's *Atmosphères*, made famous in *2001: A Space Odyssey*. Kent Jolly had created soundtracks for the *Sim* series, and for *Spore* he shared a

"Generative Music Design" credit with the ambient-music composer and record producer Brian Eno. As the music played, I found that at the Cell Stage, the first decision involved the diet of the emerging species. Like me, my little beast would be a carnivore; it looked a bit like a crawfish with eyestalks sticking out from its fishy abdomen.

The random planetary name Ramder appeared, but I deleted that and called my world Francis. Next, the screen showed a series of animated meteorites crashing and exploding into Francis. I saw that it was good. A rock sank to the bottom of the ocean and cracked open to reveal my crawfish. A new window appeared to inform me, "Throughout *Spore*, the choices you make impact your future." That was solid advice.

I found it interesting that to Wright and the developers of *Spore* (which included Jenova Chen, in a minor role) the eventual colonization of other planets represents the pinnacle of evolution. The dream of moving humans to Mars and elsewhere remains a common one in our popular entertainment, and with the manned International Space Station flying overhead and occasionally visible to the naked eye, that development appears to be at least within the realm of possibility. What made *Spore* so enlightening to me, however, especially after all of that first-person shooter violence, was not the interstellar fantasy, but what the game said about the consequences of our decision making as a species right here on earth. *Spore* is neither hopeful nor despairing. It offers no comforting pats on the back nor scolding and dire warnings.

Spore displayed elements of the god game genre (control over an entire life cycle of a player-invented species), but also included the mechanics of real-time strategy games (competing

for resources online with species created by other players) and simulation games (recreating an entire habitat). Most people who play *Spore* know that Wright was also responsible for the popular *Sim* franchises, which began in 1989 with *SimCity*, a game I had enjoyed immensely while living in Budapest. *Spore* felt like a natural extension of his oeuvre. And while the scientific accuracy—for instance, treating evolution as linear progress—should be addressed, that game was so rich in detail, so nuanced and visionary, that it could be taught in every middle-school biology class.

In October of 2014, Pope Francis diverged from decades of Catholic teachings when he addressed the Pontifical Academy of Sciences. God, according to the pope, "created human beings and let them develop according to the internal laws that he gave to each one so they would reach their fulfillment." That was the very point of *Spore*: to create a unique life form and watch how the player's decision making accelerated or retarded its growth. In his statement, His Holiness sought to explain the compatibility of creationism with evolution: "Evolution in nature is not inconsistent with the notion of creation," he said, "because evolution requires the creation of beings that evolve."

By the pope's own definition, *Spore* could have been considered the ultimate god game. Those of us, however, who are convinced that life as we know it came about by way of an improbable but ultimately random chain of events in an unfathomably vast universe would more likely consider it something closer to an evolution game. To Wright's credit, while playing *Spore* I continually found myself thinking of our own terrestrial species and questioning our own choices and

priorities. The game reminded me that building the conditions to which we must adapt as a species is fundamentally up to us. I also felt better after nurturing digital life rather than blowing it to smithereens.

Midway through the journey of my own life, I was able to confirm the fact that shooting simulated guns at representations of living things was not something I wanted to do. But, still eager to learn what it was that made the games so appealing to others, I reached out to the novelist Brian Evenson, who contributed a licensed tie-in novella to the 2009 anthology *Halo Evolutions: Essential Tales of the Halo Universe*. I wanted him to persuade me of the game's virtues. "*Halo* has a kind of reassurance to it, even in the moments where it gets odd," he told me.

Yet Evenson also described what turned out to be his "limited enthusiasm" for *Halo* and his thoughts about first-person shooter games in general. "I hate *Call of Duty*, really find it unplayable, probably because I feel there's a kind of unexamined politics that go along with it," he wrote me in an e-mail. "The closer the FPS gets to feeling like a) real life or b) a military training simulator the more unplayable I find it. They also seem boring to me—same weapons and roughly the same sorts of opponents, slightly different situations."

In his novella "Pariah," Evenson addressed an aspect of the *Halo* lore that had annoyed him. He dug deeply into the protagonist's origin story. "That idea of the created hero, and the secret military SPARTAN project that created him, and him being given a number rather than a name, strikes me as dystopic, problematic, and not sufficiently examined by the franchise," he told me. His critique was rooted in personal tragedy:

Having known someone who was essentially a guinea pig during the first gulf war, ordered to take experimental non-FDA approved drugs, and whose son was born with birth defects perhaps as a result of this, I think that very small aspect of the game justifies in people's minds the idea of the military using its soldiers as guinea pigs.

As I had found, video games and the American military-industrial complex have been intertwined since Willy Higinbotham got *Tennis for Two* up and running on that analog computer at Brookhaven National Lab. Today's first-person shooters provide a natural and disconcerting link to that earlier era. The FPS genre is unwittingly honest about what Tom Bissell called the medium's "martial patrimony." Today, the American military uses video games to recruit and train soldiers, and not just at shopping malls.

The official website of the US Army has an area dedicated to free video games. GET INTO THE ACTION, it reads. The main image on the page is a screenshot from a first-person shooter: a rifle juts *DOOM*-like from the bottom of the picture, supported by a desert-camo-gloved left hand. The gun points toward a floating target in a sandy wasteland of crumbling structures that resembles a Middle Eastern village. "Relax and have some fun with these browser games," the page entreats me. "Play a few rounds of target practice, dodge defenders in the Special Teams Challenge, or simulate basic rifle marksmanship."

Game developers have long cooperated with the military; the symbiotic relationship at the heart of the military-entertainment complex is built on the exchange of financial resources for

technical assistance. That partnership entered what might be considered a new phase in 2002 with the release of *America's Army*, a technology platform created by the military for the purpose of appealing to and recruiting civilian video gamers. It has clearly worked. To date, over twenty-five iterations of that game have been downloaded more than 40 million times—and, astonishingly, 40% of the soldiers who enlisted in 2005 had played *America's Army*, many of them at their local shopping malls. The militaristic ends of these video games go beyond mere recruitment. For the past several years, the Boeing corporation has been working on a laser cannon for the US Army. In early tests, the High Energy Laser Mobile Demonstrator (HEL MD) has already succeeded in shooting down drones and 60mm mortar shells at a Florida Panhandle test range. The weapon was designed with video gamers in mind: it is operated by an Xbox controller. Even if it's true, as George Orwell wrote, that "propaganda in some form or other lurks in every book, that every work of art has a meaning and a purpose—a political, social, and religious purpose," the use of video games for the purposes of military recruitment strikes me as particularly insidious.

Playing ultraviolent games made me realize that it was not the games themselves that bothered me. Rather, the problem was my own discomfort with the pleasure I took from them. I wasn't disturbed by the violence, I realized, as much as by my enjoyment of it. It was Tim Schafer, of all people, who impressed upon me the benefits of exploring our own violent impulses. As he put it, the "idea of exploring in the shadow, the shadow archetype inside your own mind, I think is valuable." The introduction to *The Cave* reminded us that, "there

is a dark place in your heart as well." First-person shooters appeal to that very place. Schafer offered a useful analogy:

> And just like sometimes my daughter plays with dolls and she's really mean to them, I used to interject and be like, *Hey hey hey why are you being so mean to your dolls?* And she was pretending to cry and making them cry and I realized that no, it's important to explore, how does it feel to be mean to someone, how does it feel to be cruel in a safe environment? That's what dolls let you do and that's what video games let you do.

Were I to follow Schafer's advice, I would treat first-person games as an opportunity to learn about myself—about any aggressive tendencies I possess, where they might come from and what they might mean.

By entering the ritualistic space of the magic circle created by immersive video games, we are able to live lives that are not our own. In those simulated lives, we open ourselves to experiences—including even killing—better left beyond the usual ken of human existence. No one of us is obligated to like every style of game. In the end, I personally don't care for first-person shooters, but I do recognize how the genre could potentially lead thoughtful players toward greater self-awareness. I did find the adrenaline rush of simulated gun violence pleasurable in short spurts, but the lack of narrative depth—that it all felt so senseless—made me yearn to return to quieter and more contemplative, and indeed artful, video games.

CHAPTER 12

exile and the kingdom

The stark winter light of Scandinavia can prove disorientating for those of us unaccustomed to just a few short hours of sunlight each day. The jet lag of a transatlantic flight, Newark to Stockholm, six time zones away, only added to my sense of displacement and confusion. My wife and I traveled to Västervik, a coastal town in southern Sweden, to visit her mother and enjoy a kind of working vacation: Elivi, a classical flutist, was to perform at two Christmastime church services. The Svenska kyrkan (or national Swedish Church) still had the money and the desire to hire world-class musicians. Part of my own preparation for the trip involved re-watching Ingmar Bergman's *Winter Light*, about a pastor's crisis of faith and subsequent existential dread, and arranging to borrow a video game console—any video game console—from a friend of the family.

For all of my petty complaints about the inconveniences I faced, I could not, and cannot, come close to fathoming the panic and indignity endured by so many people I met while

traveling all the way to the top of the world. At the time of our trip, the Syrian refugee crisis had taken over the headlines of *Svenska Dagbladet* and throughout Europe. Tens of thousands of human beings had fled Africa and the Middle East for the perceived safety and security of Europe. Sweden has a population just a bit larger than New York City's and yet had welcomed as many as 10,000 asylum seekers every week. The arrival of so many had strained the nation's infrastructure. "Even we have our limits," migration minister Morgan Johansson announced a month before our own arrival. Out of necessity, Sweden had revised its remarkable open-door policy. "Those who come to our borders may be told that we cannot guarantee them housing," Johansson said.

Every major airport maintains a unique and bizarre ecosystem of hyper class-consciousness, even in the more progressive Scandinavian nations. The plush, four-foot long carpets that only certain, well-heeled boarding passengers may tread upon come to mind. Adding a humanitarian crisis to the mix can lead to some unexpected sights, such as the *Ms. Pac-Man* arcade cabinet installed by the Red Cross in Stockholm's Arlanda airport. The vintage machine had been restored to its Reagan-era glory and customized for charity purposes. The front of the game had a sign in Swedish and English: "Put your foreign coins to good use and help someone while having fun." The symbols for US dollars, British pounds, and Euros, all rendered in a retro typeface, indicated that players who had not brought a pocketful of quarters overseas could still play.

Beneath the coin slot, coins and paper bills covered the bottom of a clear plastic box visible on three sides. Every shekel,

ruble, and renminbi offered a tiny bit of hope that someone newly arrived to Sweden might receive a bit more nutrition or a warmer place to sleep. The airport has also apparently installed similarly customized *Space Invaders* (1978) and *Galaga* (1981) cabinets in other terminals. I found it strange, and ultimately cool, that there were more fully intact vintage arcade cabinet games in a Swedish airport than in an arcade I'd visited on the Jersey Shore. They were being put to excellent use.

For the duration of our stay, immigration was the primary topic of every dinner conversation, news broadcast, and sermon. "Exile is strangely compelling to think about but terrible to experience," Edward W. Said once wrote. "It is the unhealable rift forced between a human being and a native place, between the self and its true home: its essential sadness can never be surmounted." I have never experienced exile, and it's unlikely that I ever will. Nor can merely talking about it with informed observers allow one entry into the experience of the refugee. Oddly enough, though, one of the PlayStation 3 games I carried over with me did prompt in me new ways of thinking about this increasingly common condition.

I knew little about *Journey* (2012) beyond the fact that it was directed by Jenova Chen for an independent studio called thatgamecompany and had won a number of Developers Choice Awards, including for game of the year. Several gamers I trusted had recommended it. Tim Schafer had told me that *Journey* was among the video games "that stretch what people think of as games." One friend told me that it had made her cry. "The goal is to get to the mountaintop," according to the game's website, "but the experience is discovering who you are, what this place is, and what is your purpose."

Navigating the menu of the borrowed PS3 in Swedish took some getting used to, and the controllers smelled like salmon. The sky started to get dark around three in the afternoon and the long, blustery nights were perfectly conducive to brewing some Söderblandning tea and gaming. I played *Journey* to completion twice, initially in single-player mode in Sweden and then again in multi-player mode when I got safely back to my home to Philadelphia.

The game features a protagonist who at first glimpse, and to my untrained eye, appeared to be a woman wearing something akin to a Yemeni hijab or Afghani burqa. While the character's gender is never made explicit, and did not really matter, I continued to perceive her as female. When the game began, she stood stranded and alone in the desert with the sun beating down. Given the title and her appearance, and with no sense whatsoever of the game designers' intentions, it was impossible for me to avoid thinking of her journey in terms of the ongoing global crisis.

All that was visible of the face of the Traveler, as I later heard her called, was a pair of white eyes and a yellow line across her forehead. Gold-patterned trim that appeared to be vaguely Middle Eastern or Central Asian accented her flowing, deep red attire. The sweeping, East-meets-West soundtrack further added to the foreign flair. A lone and plaintive string instrument, a viola or cello, established a melancholy theme. Standing-stone grave markers had been festooned with ribbons that fluttered in the wind. The setting reminded me of photos I had seen of the Taklamakan Desert on China's Silk Road. The Traveler's goal—which became mine—was to reach the top of the Mount Doom-like peak in the distance.

I began by crossing through a cemetery and toward a distant beacon. A series of ruined buildings half-buried in the sand spoke to the collapse of a once proud civilization. Operating the controller to simultaneously move my avatar and change the visual angle of the picture felt like participating in a beautiful animated film. The sunlight reflected off the sand; the stone ruins appeared both nightmarish and elegant, like the setting of an opium-induced dream.

Within some of the partially submerged structures I found cages that held ribbons or flags. One objective was to free them. A brief tutorial taught me how to release the ribbons; doing so provided additional power or energy to the Traveler, measured in the brightness and length of her scarf, which trailed progressively longer behind her as she completed tasks and advanced through the stages or levels of the game. Interaction with the found ribbons offered her the ability to float above the ground and even fly some distance.

The gameplay otherwise involved solving a number of puzzles and climbing, flying, and running through several different regions, such as a sunken city and an underwater tower. At the end of each level, an ancestral figure shrouded in white granted an expanded view of a map animated with hieroglyphics; the game told an immersive story without the benefit of language, spoken or written. After several hours of play and a number of trials, some requiring problem solving skills and others precise movements, the Traveler died a slow and painful death in the snow. The screen turned blindingly white. I thought I had done something wrong. As in so many stories, whether mythical, biblical, or from Hollywood, she was resurrected and transformed. In this case, the Traveler metamorphosed into an

angelic being emitting radiant light. She and I then proceeded to the game's rapturous finale.

The sensation that accompanies finishing a well-constructed game or novel is like that of waking from a pleasant dream and not wanting the morning to begin just yet. While other joys await in replaying or rereading, the knowledge that I can never be surprised in the same ways can be difficult to stomach. When I got halfway through Elena Ferrante's series of Neapolitan novels, I stopped reading entirely for several months because I didn't want them to end. And yet I knew full well that rereading and replaying have their advantages too. Nabokov once said, "One cannot read a book: one can only reread it." The second time through a book or a game, I notice much more, details and leitmotifs that had been hidden to me the first time. I knew that I wanted to luxuriate in the textures and moods of *Journey*'s digital environment. And having played it offline and thus alone, I had not yet made a connection with another player. I couldn't even imagine what the multiplayer mode would consist of.

During the flight home, I replayed on my iPad another game that defies convention and the usual definition of what a video game is. While the puzzle game *Monument Valley* differed from *Journey* in scale, genre, and basic interactive style, it also shared some thematic concerns. Designed by Ken Wong for the indie developer Ustwo in 2014, *Monument Valley* takes inspiration from minimalist Asian art and the impossible architecture and visually baffling images of M.C. Escher. Like *Journey*, it features a female protagonist with a cartoonish black body wandering in a supposedly exotic pseudo-oriental setting.

Monument Valley opened with a lone figure dressed in white standing on a square structure. The instructions read: TAP THE PATH TO MOVE IDA. Touching the screen next to the girl created a quiet gong-like sound as she walked to that spot. I was then advised to HOLD AND ROTATE a wheel on the side of the structure; doing so prompted the twang of an Asian-made string instrument, perhaps a pipa, and by way of an optical illusion, it changed the basic shape of the structure and provided a path for Ida to ascend a flight of steps to a platform. What had occurred was in fact geometrically impossible, but the strange illogic smacked of nothing less than a unique creative vision.

A floating four-sided building appeared. It featured Mughal-style onion dome accents and the Roman numerals I-X indicating that the game included ten playable chapters. Chapter II was titled "The Garden" and in it, I was told, IDA EMBARKS ON A QUEST FOR FORGIVENESS. The new geographic structure—or monument, in the parlance of the game—required me to think in three dimensions instead of two: by rotating elements of the building, Ida could ascend to the platform at the top of the building. Once there, she removed her white, conical hat and from it a cube emerged, completing her goal for that level.

In Chapter III, called "Hidden Temple," we are told that IDA HAS AN UNEXPECTED MEETING. A spectral shape in a sultan hat awaited her atop a flight of steps. The words "Long have these old bones waited in darkness," appeared on my finger-smudged screen. "How far have you wandered, silent princess? Why are you here?" Solving the next riddle involved moving sections of the structure so that she could

ascend to another platform, where she again removed her hat to reveal another hidden shape. Each subsequent chapter further complicated Ida's journey with trickier geometric puzzles, even more unusual spatial logic, and wandering flightless crows that blocked her path. Her adversaries reminded me of characters from some troubling Jim Crow-era cartoons.

I found myself trying to unlearn some of my own basic assumptions about movement in 2D and 3D worlds. The game insisted that I look at the flat surface of my screen in new ways. Another meeting with the ghost—reminiscent of the white-robed ancestors in *Journey*—doled out some lore: "This was the valley of men. Now all that remains are our monuments, stripped of their glories. Thieving princess, why have you returned?" I got the sense that she had once been exiled. At the end of the level, another shape, apparently stolen and now brought back, emerged. Ida removed her hat again, displaying a black head with a round white mask.

Her physical appearance—the way she had been designed—immediately brought to mind Frantz Fanon's *Black Skin, White Masks*, about the psychological effects that white European imperialism had and continues to have upon people of color. "And in one sense," Fanon wrote, "if I were asked for a definition of myself, I would say that I am one who waits; I investigate my surroundings, I interpret everything in terms of what I discover, I become sensitive." In one sense, Ida was doing much the same.

Had she stolen the sacred geometric shapes of her people and regretted it enough that she was now returning them? Was she a shoplifter? A tomb raider? Remorse felt

like an unusual—and potentially rewarding—theme for a game. The message behind *Monument Valley* was one of atonement, but I also found myself growing steadily more curious about the point of the game and about the apparent racial undertones.

At the end of *Monument Valley*, Ida was transformed— again like the Traveler in *Journey*—from a little black girl into an angelic bird-goddess who ascends to the heavens. From her new and exalted position, she blessed the crow people, changing them from black to bright, primary colors. Ida's blackness seemed to be not a source of pride, but a condition, perhaps even a form of punishment, from which she needed to be freed. *Monument Valley* is in many regards a terrific game, but in the end the implications of the story it told did not sit quite right with me.

Once back in the United States, I reached out to the Swedish airport authority and offered to donate the *Donkey Kong* machine in my basement to the charity arcade, but they declined. I also ordered my own PS3 so I could play *Journey* again. I chose a model with a fake, dark wood grained finish that matched the casing of my Atari 2600. For my second time through that digital wasteland, I hooked up the console to my home Wi-Fi network and played in multiplayer mode. Doing so magnified the game's resonance.

Now, while traversing the desert or searching through dark catacombs, I would encounter other Travelers. Perhaps it was the same one: I never saw two at once, so I could not be sure. Somewhere, other PS3 users had undertaken the same journey and by virtue of being connected, online strangers could meet more or less at random. There was no verbal or

textual method of communication. That was by design, as Jenova Chen told me. "Language is a very poor information exchange," he said.

Paradoxically, Chen and his team had not included any capacity for dialogue as a way to *increase* communication among players. As Chen explained:

> I often felt it's difficult to express myself with words. Words often come with a lot of baggage as well. Noise. If you see a guy with a nametag that says BeachBoy1983 it brings us a lot of information that does not belong to the world of *Journey*. It takes you out of the world the moment you see those texts. It's important that the relationship stays in the world. The emotions come from the world, not outside of the world. Language is essentially cut out.

He added that "identities are actually barriers for me to connect." It was in embodying this idea that the game became firmly connected, in my mind, to the plight of refugees.

In my northwest Philadelphia neighborhood, it is standard practice for strangers to say hello as we pass on the sidewalk. People tend to be quite nice. The traditional greeting here is "How you doin'?" to which the traditional answer is "How you doin'?" If someone responds with an actual answer—"I'm fine, how are you?"—they are almost certainly from someplace else. In Västervik, the small and, I would have thought, tightknit town, my greeting people on the street with "Hej" caused them to avert their eyes and quicken their pace. It was weird. I had apparently violated some sort of unspoken protocol. It would never have occurred to me that a blue-collar

pocket of Philly could be politer, at least on the surface, than small-town Sweden.

In *Journey*, though the Traveler's physical repertoire was limited, I found that while verbal communication was not possible, gestural communication was. Encountering an anonymous and mute stranger in a video game thus forced on me a similar calculus to the one I faced in Sweden. What was the appropriate way to interact? Would we help each other? Ignore one another entirely? Would we ask the *Journey* equivalent of "How you doin'?" and continue on our own ways?

I conducted an experiment. I ran my Traveler to the top of a sand dune and jumped in the air, in the hopes of bringing myself to the attention of my new companion. She raced up to join me, which I took as a good sign. I slid down the hill and then ran back to the top. The other Traveler did likewise. We goofed around for a few minutes, then completed a few tasks together and eventually got separated. That moment of silly interaction stayed with me for a long time afterward. We had, however briefly, stopped the forward march toward the mountaintop and taken a moment to enjoy each other's company. I felt a moment of connection to another human being with whom I could not speak and who I knew absolutely nothing about.

Finishing the game for the second time, I discerned so many details—slow changes in the color palettes, recurring musical themes—that I had not caught during my first journey. Nabokov would not have been surprised. After the credits rolled, a list of eight "companions met along the way" appeared. I had apparently interacted with that many different players, and their Sony network user names were now

visible as was mine to them. I caught myself imaging who my companions might have been. At the time, the PlayStation Network was available in over 60 countries. Was one companion an elderly blind man in Argentina? Another a nine-year-old girl in China? My next-door neighbor? I had no way to know. It was because we couldn't talk, I decided, that anonymity had become the game's most arresting feature. However alike we might have been, or however different, did not matter.

The game had ended, much too soon, where it had begun: with the Traveler transported back to the desert sand and me anticipating a few hours in a virtual world unlike most others I had found. *Journey* breaks down the barriers between players without the use of language, and thereby suggests, in the simplest yet most profound way imaginable, that our apparent differences—across language, national borders, oceans—are no impediment to acceptance of one another, or of otherness itself.

Journey and *Monument Valley* both demonstrate the ability of video games to raise important questions about who we are and how we get along in the public sphere. I personally regard them both as profound—albeit flawed—works of contemporary art. For all of its beauty and capacity to bring strangers together in original ways, *Journey* also seems problematic. In his classic study *Orientalism*, Edward Said wrote:

> [A] very large mass of writers, among whom are poets, novelists, philosophers, political theorists, economists, and imperial administrators, have accepted the basic distinction between East and West as the starting point for elaborate

theories, epics, novels, social descriptions, and political accounts concerning the Orient, its people, customs, 'mind,' destiny, and so on.

We can add "many video game designers" and "video games" to the list, and *Journey* has inadvertently fallen into that same trap.

The vaguely Middle Eastern atmosphere and design of *Monument Valley* and *Journey* make for experiences that are supposed to feel exotic or foreign to American audiences. The pseudo-Asian realm of Pandaria in *World of Warcraft* and the Monk's area in *The Cave* come to mind in this regard, as well. *Journey* is a magnificent game, but it might also reinforce a simplistic dichotomy between "East" and "West." On the surface, these games assume that those two entities not only exist but that each is cohesive, unified, and consistent.

Still, whatever doubts I might have about these games are at least matched by their obvious virtues. Spending a few hours playing as the Traveler and as Ida reminded me, as Said wrote in his essay "Reflections on Exile," that the "achievements of the exile are permanently undermined by the loss of something left behind forever." Perhaps the most straightforward way of explaining the distinctiveness of these two games is to say that they are about sadness and loss. In some select cases, playing a video game—that is, being the Traveler or Ida for a little while—can make it easier to develop genuine empathy for people who are seemingly different from ourselves.

As Chen told me, "I felt the connections of people should not be bound by their race, gender, social class, or even age. I

wanted to make a game where those things are irrelevant. It's purely about people. It's a relationship and a connection between two human beings who are in the same world nearing the same goal." *Journey* and *Monument Valley* do not allow us to merely escape from the problems of the workaday world, but also offer a new means of thinking about more timeless, existential problems. All great works of art, even the imperfect ones, do likewise.

CHAPTER 13

new auteurs

One unusually cold spring morning I texted my friend Jim, who, having recently lost his job as a research physicist, agreed to meet me at 30th St. Station at a moment's notice. Three hours later, we were at the Museum of Modern Art in midtown Manhattan. We had come to see a video game installation called *Long March: Restart* (2008) by the Chinese artist Feng Mengbo. While waiting in line at the ticket desk it dawned on me that it used to cost 25¢ to play a video game— now it was $25.

That museums have adopted video games should come as little surprise considering their immense popularity, and the simple fact that museums have been built for seemingly every imaginable kind of artifact. Within a two-hour drive from my home I could be at museums dedicated to mushrooms, bog iron and glass making, the Jersey Devil, and Mario Lanza. There's also the Stoogeum, the mission of which is "to further enjoyment and appreciation of The Three Stooges and to

maintain the legacy of their comedy for future generations." Video games are doing pretty well for themselves, as far as museums go. Having assembled a collection over the past twenty-five years, the Video Game History Museum recently established a permanent home in Frisco, Texas, but please do not confuse that institution with the International Center for the History of Electronic Games (Rochester, NY), The Museum of Art and Digital Entertainment (Oakland, CA), the Digital Game Museum (Santa Clara, CA), or the Computer History Museum (Mountain View, CA), where one can still play *Spacewar!*

Yet what is perhaps surprising is the adoption of video games by prestigious art museums. A cynic might say that this is merely a ploy to attract more and younger visitors. I take a more optimistic view: that the art world's gatekeepers have finally recognized that games—not all, but many—are works of art. In 2012, the same year that museumgoers young and old flocked to an "Art of Video Games" exhibition at the Smithsonian, Paola Antonelli, the Senior Curator for the Department of Architecture and Design, acquired those first fourteen video games for the Museum of Modern Art. I wonder if she bought them on eBay.

The initial games at MoMA included classics like *Pac-Man*, *Tetris*, and *Myst*, as well as more obscure recent games, including *Vib-ribbon* (1999), *Katamari Damacy* (2004), and Jenova Chen's *flOw* (2006). Since then, Antonelli has added more commercial titles as well as *Long March: Restart*. I have no doubt that video games attract a new demographic to these museums. Whether that institutionalization is good for video games, however, is another matter entirely.

Jim and I took the escalator up to the second floor, but did not see *Long March: Restart* right away, even though, as it turned out, it was an astounding 20'x80' in size. After a bit of hunting amid the Contemporary Galleries we found a sign hung outside of a dark and unpopulated corridor:

FENG MENGBO

CHINESE, BORN 1966

It described *Long March: Restart* as "Custom video game software and wireless game controller," which, while accurate, did little justice to what we were about to experience.

Feng Mengbo graduated from the Central Academy of Fine Arts in Beijing and has exhibited his new-media work in solo shows in Hong Kong, Boston, Chicago, New York, and elsewhere. His early acrylic paintings combined childhood memories of China's Cultural Revolution and his fascination with vintage games. A series of paintings called *Long March: Game Over* (1993) had once been hung together in a row to give the appearance of a side-scrolling game in which a Red Army soldier traveled through China battling demons, ghosts, and deities. *In Taking Mount DOOM by Strategy* (1997) and *Q3* (1999) Feng had re-programed commercial video games, customizing them in much the same way people had used the *Warcraft III* "World Editor" software to invent something new. His epic *Long March: Restart* at MoMA represented a natural continuation of his work.

Jim and I found that we were the only people in its dedicated gallery. An Xbox controller sat like a sculpture on a table at the start of the corridor. Touching an object on display in a museum

not only felt like breaking a taboo, but also a bit disgusting. While I am not especially mysophobic, I was reminded of the borrowed PS3 controller in Sweden that had smelled like smoked fish. There was no telling how many grubby paws had handled the controller in front of me since someone last ran a disinfectant wipe over it. I tried not to think about it. A diagram on the wall offered instructions. The left thumbstick allowed me to move, the B button to Jump, and the X button to "Throw soda."

The side scrolling *Long March: Restart* made dynamic what in Mengbo's earlier work had been static: an 8-bit Red Army soldier in a blue uniform fought off a series of enemies and jumped past obstacles in an experience that combined elements of *Super Mario Bros.* with imagery from Socialist Realist propaganda. The game seemingly took place during the long retreat of China's Red Army under the command of Chairman Mao, after the struggle against the ruling Nationalists during the mid-1930s. Nintendo turtles and characters lifted from other games wandered in front of a digitized Great Wall, mashing nostalgia with history. I began thinking of the game as *Super Mao Bros.*

As I made the soldier move forward, the immense size of the game screen required me to physically scroll along with him. "I wanted to enable the character to move freely along the stretched scroll," Feng has said. "Because of the vast space of the exhibition hall and the intentionally designed pace of the character, the gamer and the audience would have to dash to catch up with the character." Controller in hand, I walked quickly sideways down the corridor.

All along, a second screen behind me featured a view of the same action so enlarged and distorted that it appeared abstract. Individual pixels of what I took to be snow looked

like glitches in the image or static interference in the projection. As with the Barnett Newman painting upstairs, my experience of the work of art involved being cowed by its magnitude and enveloped in its color, except here the images surrounded me on two sides and I was also subjected to the game's chaotic sound effects. The music consisted of chiptune renditions of what sounded like revolutionary marches.

Toward the far-right end of the first screen, I entered into a kind of boss fight against an enlarged Mario. My only weapons were red and white Coca-Cola cans, which served as loud and carbonated bombs. When I defeated him, my soldier disappeared off the right-hand side of the screen in much the same way The Man in *Adventure* would leave one room on his way to the next. In this case, the adjacent area wrapped the game around to the screen behind me. I had to spin in my shoes and start walking back down toward the corridor's entrance.

The actual gameplay seemed like a secondary concern; the mechanics themselves were not all that interesting, in part, surely, because the game had to be easy enough for museum-going non-gamers to play. Watching Jim take his turn at *Long March: Restart* gave me the opportunity to observe the game's details. Some of the villains were borrowed from the arcade fighting game *Street Fighter II: The World Warrior* and other classics. When the game ended at the Tiananmen gate, the former entrance to the Forbidden City, Jim handed over the sticky controller to the next player in the queue that had formed, no doubt attracted by the noise.

The rest of the games in MoMA's permanent collection were kept in the bowels of the building, away from public view.

Overall, with so many holdings and so little exhibition space, the curators had difficult choices to make. At the time of my visit, they had seen fit to display Van Gogh's *The Starry Night* (1889) and René Magritte's *The False Mirror* (1928) instead of Jason Rohrer's *Passage* (2008) or Adam Saltsman's *Canabalt* (2009). Fortunately, I had downloaded both games to my phone for the ride home. While Jim and I waited for our return bus, our bellies full of sushi, I was reminded of Ralph Baer's eureka moment that led to the creation of the first home console.

Playing a video game in MoMA prompted a number of questions. Why were some games worthy of enshrinement? By what authority was *Dwarf Fortress* (2006) a work of art but *DOOM* not? The distinction, it seemed, was similar to that between literary fiction and commercial fiction or indie music and the mainstream top 40. The games chosen were mainly those made by an individual artist finding expression for her deepest desires and fears, I noted, not a large development team creating a formulaic product intended to appeal to as many people as possible. For my part, I think *DOOM* would be a great fit for MoMA's collection.

Like *Long March: Restart*, Adam Saltsman's indie *Canabalt* is a side-scrolling game. Unlike that behemoth, however, *Canabalt* is playable on smartphones. It proved equally effective even at a miniature scale. The premise could not be simpler nor the gameplay more intuitive. My avatar was a tiny man trapped in a building. He remained in place at the left side of the screen while images of a besieged urban wasteland rushed past. My sole purpose was to escape without plummeting to my death. I accomplished that, or attempted to, by tapping the screen with my finger to jump from one building to

the next, onto rooftops and I-beams and billboards. I went faster and faster, with the rapidly paced music and shaking, crumbling cityscape making me increasingly frantic. Playing it in the Lincoln Tunnel on my way out of New York City made it even more anxiety inducing, in a (mostly) pleasing way.

I contacted Saltsman and asked him about the sparse design of the game. "*Canabalt* doesn't have a lot of things in it," he said. It was the utter simplicity—the lack of boss fights and power-ups—that made it so distinctive. "*Canabalt* is really just about one emotion, or maybe two, and one of the emotions is the exhilaration of going fast," he said. "Everything that's on the end of the spectrum of exhilaration or vertigo or feelings of flight or things like that, that was one thing I really wanted to achieve." A work of minimalism, the game derives its power from its economy of style, sound, and gameplay. But it managed, still, to be a sophisticated experience. Using the familiar model of a side-scroller, Saltsman tapped into some base human fears.

As for the story, he created a narrative with only a few visual elements, including the silhouette of the skyline and construction cranes in the distance, the occasional, Godzilla-like *daikaiju* lumbering past, and the loud military jets zooming past overhead to defend (or maybe attack) the city. All of the details combined to stimulate an intense fight-or-flight sensation. That controlled panic made me think of *Canabalt* as something approaching a perfect video game. It certainly exceeded its modest ambitions.

Jason Rohrer's heartbreaking *Passage* (2007) shares some of the side-scrolling mechanics of *Canabalt*, yet is even simpler in some respects, taking just five minutes to complete.

Those five minutes, however, evoked an emotional response unlike any other I had found in a video game. *Passage* defies any traditional meaning of the word "game." It forced me to think about the entire trajectory of my time on earth. It was among the first video games Antonelli adopted for MoMA, and a 2016 solo exhibition of Rohrer's oeuvre at the Davis Museum at Wellesley College solidified his place among the foremost auteurs of the medium.

In an artistic statement about *Passage*, Rohrer wrote, "A tiny bit of background about me: I turn 30 tomorrow. A close friend from our neighborhood died last month. Yep, I've been thinking about life and death a lot lately. This game is an expression of my recent thoughts and feelings." He has described it as a "memento mori game." *Passage* features a male protagonist who, like so many of his predecessors, travels across the screen from left to right, occasionally finding treasure. When he encounters a lone woman, coming into contact with her binds them together in marriage and makes navigating the game a bit trickier. "Once you meet up with a partner certain things are cut off, things you used to do as a single person you can now no longer do," Rohrer told me. As the digital-studies scholar John Sharp wrote of *Passage*: "The simplicity of the space is not unlike a brief poem—life twists and turns, sometimes leading to rewards and other times to frustration. When we are young, the future is unknown, and as we age, the inevitable end becomes clearer and the past more distant."

The backgrounds changed and the couple aged to indicate the elapsing decades. The game made clear that each decision the player made, large or small, closed off many possibilities. While others might appear, they would be fewer in number

than those that were irrevocably lost. With every year that passes, I certainly perceive, in my real life, more new limitations than new opportunities. It's increasingly unlikely that I'll ever be an astronaut or own a llama or master playing an instrument, except maybe in a video game. *Passage* perfectly captured the reality—which is, to me, equally melancholic and glorious—of aging.

Rohrer's other games also wrestle with problems of ethics and sociology and philosophy. The computer game *Inside a Star-Filled Sky* (2011) is about infinity itself. "I'm just struggling with my feelings, looking at the night sky and being unable to comprehend how far away things are, how small I am, even how small I am relative to the size of the earth," he told me in his charming and demotic way, "and just sort of grappling with my place in the universe." The game is a tactical shooter of seemingly infinite size. I controlled an avatar that reminded me of the descending monsters in *Space Invaders*, who had been set loose in a maze that called to mind both *Adventure* and *The Legend of Zelda*.

My task, as I understood it, was to shoot the occasional beast and descend to another level. Rohrer constructed the game in such a way as to make the player "marvel at how small you used to be, or how big everything is relative to you, or how unable you are to ever explore it all." I found it confusing and asked its maker for advice. "Once you're down through multiple layers, deep down inside the system," he said, "you're supposed to lose track, be disoriented, and forget where you are. And when you come back out you're reminded of it and you realize just how far down you were and how disoriented you were." The goal of the game is something

harder and harder to do in our GPS-enabled world: to get lost. The convenience of living on the grid comes with a series of small and large sacrifices, which most of us willingly accept. *Inside a Star-Filled Sky* reminded me how much I longed to get away, if only for a few hours.

Instead of looking outward to the heavens, *The Castle Doctrine* (2014) examines what it means to live a conventional domestic life. The game's title comes from the legal concept that states that a home is inviolable, and the person who owns it can wield deadly force to repel intruders. The default character is Caucasian and male, a husband and father to two children, yet the game asks the player to rethink his social role. According to Rohrer, the game "takes this whole manifold of ideas around manhood and self-defense and family protection." *The Castle Doctrine* originated with a traumatic personal experience:

> When we were in New Mexico my wife was attacked by a vicious dog. She was pregnant at the time and my two little children were there. The dog was kind of coming up to my children after it had attacked her. Anyways so I'm sitting there in my shorts and sandals. I'm 6' 8" but only weigh 175 pounds; I'm not a very formidable man in terms of self-defense or I've never taken any martial arts and I had no weapons on me, and here I am trying to defend my family.

The need to protect his family raised any number of conflicting emotions about violence and traditional masculinity. "I don't have an answer to any of these things, right, I'm just

sort of, like, this is something I'm struggling with, like, my role as a man."

Rohrer felt the need to protect his family from harm, but had to reconcile his dislike of violence with the fantasy of "being able to be that powerful, protective male, from all the media [he's] consumed over [his] life." *The Castle Doctrine* is perhaps the least likely massively multiplayer game. I had to fortify my home from other players, who were trying to break in and steal my safe. I started with a budget of $2,000 to spend on things ranging from walls ($2) and doors ($8) to Trudy's Shotgun ($320). For additional protection, I chose a Chihuahua ($40) rather than a pit bull ($320). My next task involved sneaking into another player's house and taking his belongings, knowing full well that he could have a gun and a pit bull to fend me off. I won additional resources when my defenses managed to kill an intruder, but when a homeowner killed me I stayed dead.

The Castle Doctrine creatively rethinks the uses of a restart button. "I want death to be death, right? Everything about you is lost when you die," Rohrer told me, and "every time you die you get assigned a new computer generated human name, so you're a new character, a new guy with a new family, and there's no connection in the game between your current life and your last life." Death in *Canabalt* and *World of Warcraft* and in every other game I have played was only temporary. *The Castle Doctrine* harkened back to the pre-*Adventure* games when hitting RESET meant actually starting over, but at the same time turns what was once a limitation into an affecting element of gameplay.

The game is not didactic, however; it allows players to draw their own conclusions, or, at least, pose their own

questions. The big one I returned to again and again was: If I could do something I knew to be morally wrong and not get caught, would I do it? After a great deal of introspection, I decided that I *probably* wouldn't. That tingling uncertainty I discovered in myself made me feel guilty and ashamed. As Tim Schafer had pointed out to me, video games allow us to try out various morally suspect decisions in a controlled, fictional environment, and can thus serve as an avenue to self-knowledge, however troubling that knowledge might be.

Rohrer's games do not aspire to mere entertainment—although they certainly provided that—as much as to personal enlightenment. In the time I spent playing them, I never felt like I was being lectured or harangued or being sold a particular agenda. The great video game designers investigate what it means to be human and, as Rilke wrote, "to try to love the questions themselves like locked rooms and like books that are written in a very foreign tongue." Rohrer told me that he hopes every game he designs "makes you think about something in a different way, or a game that brought a different perspective or kind of pushed the boundaries in some way." I regard *Passage* as his masterpiece. "It is," as Robert Stone once wrote of Norman Mailer's novel *The Executioner's Song*, "so beautiful and wise that its light somehow illuminates the rest of his work and legitimates his vision." In the five minutes it took to play that profound game, I experienced an entire lifetime.

When my eight-pixel-tall wife died, I felt genuinely sad. I could not help but think about my own happy marriage and the fact that Elivi and I will grow old together until one of us dies. Because I remain devoutly agnostic, I understand that

there will probably not be a reset button. That was painful to contemplate. Grappling with my mortality was uncomfortable, but also necessary and constructive—and it made me better appreciate the fleeting here and now. Countless video games ask us to confront death, but not with any real seriousness the way *Passage* does.

When I speculate about the next games that might appear in MoMA, the first to come to mind is *Gravity Ghost* by Erin Robinson Swink. The computer game featured one of the most memorable characters I have inhabited, and its gameplay mechanics provided the ideal balance of frustration and reward—perhaps inspired by the creator's background in psychology and behavioral neuroscience. The game's web site described it as "a game to soothe your senses." Even more appealingly, it explained that "there's no killing. No dying. No way to fail. Just hours of blissing out to buttery-smooth gravity goodness."

Robinson Swink serves as creative director for the master's program at UC Santa Cruz Center for Games and Playable Media, the existence of which says probably about as much about the shifting status of games as does the MoMA exhibit. "I knew I wanted to have a kind of melancholy story," she told me, "melancholy tinged with hope."

The moody, grayscale title screen features the game's title written in chalk with a lighthouse in the distance. Ben Prunty's magisterial, electronic soundtrack is reminiscent of the work Danny Elfman did for some early Tim Burton movies and, to my ear, George Antheil's *Ballet Mécanique*. It was the first video game soundtrack I ever purchased to listen to on its own.

Starting the game brings up a scrapbook belonging to the Bell Family, who were lighthouse keepers. The screen zooms in on a young girl in the family photo. Her face changes and she transforms into a brightly colored angel. Her companion fox leaves. "Hey, come back!" the girls shouts. "Where are you going?" When we next see the girl, named Iona, she is standing atop a round planet, next to a door that juts up from the surface. A bright star shines at the southern tip of that world and two left and right arrow keys indicate how to move her around the perimeter to catch the star and use it to open the doorway. Her long white hair trails behind her like the tail of a comet.

As the game's title implies, Iona has died and gone to the afterlife as an angelic ghost, one somewhat reminiscent of Ida in *Monument Valley*. The mechanics reminded me of the steering in *Spacewar!* insofar as I used a few keyboard buttons and gravity itself to slingshot Iona around one planet in order to gain enough speed. She would swirl in the air and encircle different heavenly bodies, affected by the gravitational pull of each one. I also had to solve various puzzles to help her along on her journey through the constellations. In what I would like to think was an homage to Dona Bailey, the pioneering game designer at Atari in the 1970s, Robinson Swink chose a centipede as one of Iona's benevolent guardians.

The game simultaneously evokes the fantasy of being able to fly and the vertiginous reality of how it would actually feel to do. "I just felt like, *What if we had an entire game that let you have that feeling of flying?*" Robinson Swink said. "But it's a very unusual game in that a lot of the time you actually do feel really out of control, and it's more about sort of

managing where you end up rather than making a plan and executing it."

Gravity Ghost took her three years of full-time work to complete. She explained, "The game is very much a distillation of my childhood fears: being afraid of losing your parents, being afraid that you won't have any friends, seeking out connection with people if you're finding it hard to fit in." I found it easy to sympathize with Iona. "It's not based on a true story or anything," she said. "I always liked ghost stories too."

Some of the game's themes derived from the local legends and stories that Robinson Swink had heard growing up. "[A] lot of Canadian history is just horrible boat accidents," she said. "That's what we hear about, there are songs about that. Lighthouses and all that nautical history is a big part of our history." Her psychology training also factored into the game's design:

> I learned that one of the things that people are really good at is filling in the blanks, given incomplete information. We do it automatically, we do it really well, and it's super fun for us. That's how we process the world. So I think about the story of *Gravity Ghost* as like a series of breadcrumbs. How few crumbs do I need to tell this entire story, and can people put together what happened?

Completing a stage opened up the next, and together the individual planets formed a map of the cosmos. Never before had I played a game in which the mechanics and the storyline felt so perfectly in tune. One is not more important than the other. The message and the medium form a seamless whole,

and that conjunction allows room for the player's agility and agency.

Gravity Ghost, like *Passage* and *Canabalt*, demonstrates that, among other virtues, a work of art often allows each person who encounters it to experience something she has never experienced before and in doing so opens up new potential avenues of self-identity. Art helps us redefine what we can be—it makes us who we are constantly becoming. Or it grants us access to a previously unrecognized one of our multitudinous, Whitman-esque selves. Magritte's *The Treachery of Images* does that for me, as do, for example, Bosch's medieval *Death and the Miser* and Barnett Newman's Abstract Expressionist *Stations of the Cross*. So, too, do some video games.

CHAPTER 14

the art question

Despite his lifelong dedication to painting, René Magritte did not think of himself as an artist. According to one scholar, Magritte identified himself instead as "a thinker who communicated by means of paint." It wasn't the particular medium or genre that interested him as much as the ideas he could communicate. I suspect that were he alive today, instead of applying petroleum products to sheets of stretched canvas he would be in his studio designing indie video games. I also believe he would still reject the label of artist. I suppose it is understandable that many video game developers do likewise.

Despite what I regard as the manifest artistic success of games like *Passage* and *Journey*, the question "Are video games art?" remains a contentious one, but not for the reasons I would have thought. No consensus exists among players, scholars, museum curators, critics, or even game makers themselves. Some will suggest that the question itself is flawed, and that to categorize video games as anything at all risks surrendering

what makes them unique. Adam Saltsman, creator of *Canabalt*—which I think of as a work of art—asked me: "Are religion, or sports, or sex, or drugs, or meditation, or a dozen other essential human experiences 'art'? Does it matter?"

To Rob Pardo, former Chief Creative Officer for Blizzard Entertainment, the question goes beyond video games. "I feel like in any of the debates I've ever seen, and there's been some pretty epic ones online about are video games art, it really comes down to . . . how you want to define art," he said. The question is further complicated by the fact that there are as many definitions of art as there are mushrooms in Mario Land.

Like so many others, Pardo demonstrated little interest in the art question. "In a lot of ways," he said, "I feel it's like a silly conversation." He did, however, make a useful distinction. The question, for him, "gets down to this definition of commercial art versus fine art, which is another interesting debate even within the art world." He added, "Most video games would fall more on the commercial art side of the equation." Pardo seemed content to leave aesthetic debates about video games to others: "I don't consider it particularly important to me to decide one way or the other," he said. "You know, as time goes on people will define it for us."

Erin Robinson Swink, creator of *Gravity Ghost*, said something similar when I asked her if she considered video games to be art. "I don't generally like arguing about definitions—other people seem to really love that sort of thing. I leave it to them," she said. "To me, it's like asking someone if paintings are art."

The late Roger Ebert once put it even more bluntly: "Video games can never be art." In 2010, the movie critic

published a seemingly hasty and now infamous blog post bearing that title. "Let me just say," he wrote, "that no video gamer now living will survive long enough to experience the medium as an art form." The post was a critique of the video game developer Kellee Santiago, who co-founded thatgame-company and served as its president when it made *Journey*. "One obvious difference between art and games," Ebert wrote, "is that you can win a game. It has rules, points, objectives, and an outcome. Santiago might cite a [sic] immersive game without points or rules, but I would say then it ceases to be a game and becomes a representation of a story, a novel, a play, dance, a film. Those are things you cannot win; you can only experience them."

Meanwhile, Tim Schafer has addressed the dispute with his characteristic humor. Double Fine's web site includes a cheeky FAQ section, and one entry reads: "Are games art?" Schafer's answer: "Zzzzzz. Oh, sorry, could you repeat the question? I fell asleep."

Engaging in this question, and the debate around it, has led me down a rabbit hole of exuberant and even vitriolic arguments and counter-arguments. (Gamers, it has been noted, are a particularly argumentative bunch, unable to even decide whether to call them "video games" or "videogames.") The question has been beat to death online, but it keeps restarting because what's at stake is nothing less than the role of video games in our culture, who gets to enjoy them, and where.

The most pleasing art, according to Aristotle in his *Poetics*, is that which best imitates or accurately represents the natural world. After all, "all men enjoy works of imitation."

Furthermore, "although we are pained while observing certain objects, we nevertheless enjoy beholding their likenesses if these have been carefully worked out with special accuracy." That notion—the privileging of realism over abstraction—serves as a foundation of much of our thinking about art. Hamlet's instructions to his assembled actors in Act 3, Scene II of Shakespeare's play reveal the power of this ideal:

> For anything so o'erdone is from the purpose of playing, whose end, both at the first and now, was and is to hold as 't were the mirror up to nature, to show virtue her feature, scorn her own image, and the very age and body of the time his form and pressure.

Closer to our own time, in his posthumously published *Aesthetic Theory*, the German theorist Theodor Adorno took issue with Aristotle's preference for mimetic art. According to Adorno, imitative art only serves to endorse the dominant discourse; instead, true art rejects convention. "The idea of a conservative artwork is inherently absurd," Adorno wrote. A true work of art establishes its own distinct, internal logic and provides us with alternatives to the status quo. For Adorno, the logic of art was the logic of resistance. Art must not be descriptive, but—to use a term in vogue today—disruptive.

Whatever side one comes down on—and there are other definitions, too—the fact that it is possible to define art in polar-opposite ways suggests an important question about who gets to separate art from not-art. The art critic Dave Hickey used the phrase "cloud of bureaucracies" and ceramicist Grayson Perry referred to the "art-world tribe" to describe

those who decide what is art and thus what appears in museums and galleries and in the private collections of the wealthy.

Hickey has written about the negative effects of art's adoption by the mainstream. In his essay "After the Great Tsunami: On Beauty and the Therapeutic Institution," he argued that we have handed over our aesthetic tastes to "a loose confederation of museums, universities, bureaus, foundations, publications, and endowments," which he referred to, collectively, as the "therapeutic institution":

> One might call it an 'academy,' I suppose, except that it upholds no standards and proposes no secular agenda beyond its own soothing assurance that the 'experience of art' under its politically correct auspices will be redemptive—an assurance founded upon an even deeper faith in 'picture-watching' as a form of grace that, by its very 'nature,' is a good thing for both our spiritual health and our personal growth—regardless and in spite of the panoply of incommensurable goods and evils that individual works might egregiously recommend.

The purpose of the therapeutic institution is to neuter any potentially revolutionary ideas and works of art and make them fit for mass consumption. If a prestigious art museum shows or acquires an object, it is automatically validated as a work of art. Thus video games are only art because some mandarins deemed them to be and acquired them for display in a museum.

Notwithstanding his status as one of Great Britain's most celebrated artists, Perry regards his own tastes as "quite middlebrow." In his 2014 book *Playing to the Gallery*, he looked at the

process by which some objects get considered art and others do not, writing about the "dissonance between an intellectual and an emotional understanding of the boundaries of what art can be." Put another way, he recognized the gap between the tastes of the gatekeepers and those of the public. He also recognized the necessity of those gatekeepers. "The artwork needs to be in a context where you might find art," he wrote. "After all, if Duchamp had left his urinal attached to the wall in the lavatory I doubt it would have had the same impact."

Safely guarded and displayed in a spacious white room here in Philadelphia, Duchamp's *Fountain* no longer seems all that radical. It would be more transgressive today if someone actually pissed in it. "Duchamp's aesthetic display of that vulgarest of appliances served an exclusively theoretical end," according to David Foster Wallace, in whose view it was "an attempt to reveal that categories we divide into superior/arty and inferior/vulgar are in fact so interdependent as to be coextensive." Today, if there is in fact a distinction between mass entertainment and the fine arts, it gets complicated more effectively by video games than any other medium.

Like the art world, academia (which is another branch of the therapeutic institution) has also caught up to video games. The Game Center at New York University, for example, offers a fully accredited academic program that is "based on a simple idea: games matter." Students can earn a BFA or MFA degree in Game Design. Video games are thereby afforded the same respect and subjected to the same scrutiny as cinema, theater, and dance. As an art professor and co-author of what has been called "the definitive textbook on game design," Eric Zimmerman strikes me as someone who would side more

readily with *Q*bert* than Ebert, yet he also wanted to distinguish between video games and art, albeit in a different way. In a talk titled "Games stay away from art. Please," at the Goethe Institute in Kraków, Zimmerman cited five reasons why even asking, "whether games are art is simply the wrong question." In doing so, he mounted a strong defense of video games against the encroachment of the art world.

The first of Zimmerman's theses recalled Pardo's argument that the definition of what can be considered art has become so diffuse that it has lost meaning. "A full century ago," Zimmerman wrote, "Marcel Duchamp put a toilet in a museum as a readymade sculpture. From surrealist language games to Piero Mazoni's shit in a can to Chris Burden's performance of shooting himself with a gun—you can find it all in art history textbooks." Zimmerman also questioned the cultural forces and contexts that are capable of declaring something art or not-art. "That's the point of Duchamp's readymade toilet sculpture: the museum transforms the everyday object into art," he added.

Zimmerman was not suggesting that video games *aren't* art, I think, as much as rightly reminding us that by adopting video games the bland and sanitized art world threatens to ruin them. Calling something "art" could potentially impose a set of expectations upon video games, ones that might not be germane to the concerns of their individual creators. To put any work of art in a museum could also stifle the effects it might have had in other, less rigid environments. Official validation comes with a cost.

Video games have already found a safe—maybe too safe— haven inside the ivory tower. Higher education's official approval of video games could end up taking an aesthetic toll

and carrying the same risks as institutionalization in a museum. Scholars and curators of video games mean well and their work will go a long way toward preserving old games and educating the next generation of game developers and players, but I worry that turning games into another field of academic study could have an emulsifying effect. As with creative writing programs in the last century, the codification of video games into an academic discipline has the potential to file down many of the genre's rougher and more radical edges.

Of the video games as art question, Zimmerman also wrote, "In the insider world of designers, critics, and gamers we have long grown weary of this particular debate. But outside our closed circles, people still find it a surprisingly intriguing question." As I understand him, Zimmerman is not only protesting the taming of video games by the fine-arts poohbahs, but also their new accessibility to people outside the "closed circles" of serious gamers. He appears to bemoan the fact that games went mainstream. Yet the distinction between video game insiders and the mass-entertainment culture has broken down. We're all gamers now, which is a fact that not everyone is happy about.

Nothing highlights this reality better than the Gamergate controversy, in which countless trolls took to Twitter and other venues to send rape and death threats to the women gamers and developers who rightly spoke out about the sexism inherent in many video games. The harassment campaign began a few years ago with backlash against designer Zoë Quinn and her remarkable and original *Depression Quest* (2013). Since then, a loosely affiliated movement made up of anonymous and presumably male gamers has beleaguered women designers and critics both online and off. Quinn, like indie developer Brianna

Wu and Anita Sarkeesian of the Feminist Frequency video series, received such harrowing threats that she was forced to flee her home and cancel public appearances.

The Gamergate hashtag has appeared over a million times on Twitter, forming a frequently vicious public conversation about the relationship of video games to mainstream culture. It also provided a way for a vocal group of disgruntled insiders to respond to witnessing their beloved subculture thoroughly integrated into the mainstream, where they might no longer be afforded special status or privilege. "The divide is, in part, demographic," as digital culture critic Caitlin Dewey concisely summed up the matter. "It's the difference between the historical, stereotypical gamer—young, nerdy white guy who likes guns and boobs—and the much broader, more diverse range of people who play now."

Clearly the transition of video games from a small subculture to a global phenomenon isn't sitting well with everyone. I remember how betrayed I felt when my favorite band R.E.M. left their little indie label for the conglomerate Warner Brothers. Devotees like me got swarmed and swallowed up by the millions of shiny, happy corporate-rock fans. The loss of privileged identity can sting, but the irony of Gamergate is that the people being attacked are the true believers in the power and importance of games. Judging by the best games that have appeared in recent years, video games started out exhibiting mainstream aesthetic and political values, and only became more specialized, critical, and ambitious *after* the circle of people who played them expanded.

So are video games art? The answer is as obvious as it is unsatisfying: they can be. To me, the best ones are, but that's not to

say that they require official approval for validation. Don't take my word for it. There exist no committees, no experts, no authorities or institutions—and certainly no sales numbers—that I will permit to define or codify for me the transformative experience of art. Each of us needs a personal and individual and internal calculus to decide if a video game—or a painting or a book, for that matter—can define, and when necessary critique, our cultural values. The video games that I consider artistic are the ones that in addition to telling stories in new ways also celebrate the wonderful diversity of all of us who play them.

Video games, taken together, are not one thing, but a potential form of personal expression for both the creator and the player. They have come a long way since *Tennis for Two*, and they will continue to evolve and change beyond the foreseeable future, hopefully for the better. Perhaps the profit-driven game developers along with the ivory tower and the art world will eventually form a system of aesthetic checks and balances as well as stability—financial and otherwise—for the creative-minded people who choose to make games outside of the system.

In the twentieth century, Dadaism and Pop Art challenged the basic assumptions of what art can be, and did so with such effectiveness that those movements found themselves welcomed into the very therapeutic institution that they set out to undermine. Whether it is punk rock or graffiti, those who rail against the system invariably become part of it. The most radical music of our youth will eventually be used to sell us luxury cars. Something different has happened with video games. The trajectory is toward both greater popularity and greater artistry.

CHAPTER 15

restart

Any lingering distinction that might have still existed between video gamers and the general public was obscured even further one recent spring night here in Philadelphia. A huge segment of the city witnessed a monumental, twenty-nine-story-tall game of *Tetris* played on two sides of a skyscraper. The game was visible—and immediately recognizable—for miles in each direction. For one weekend, the nation's fifth largest city, the birthplace of American democracy itself, became the staging grounds for the largest video game ever played.

By some estimates, *Tetris* is the bestselling video game of all time, with 100 million copies in circulation across all platforms. Many Philadelphians that weekend had likely suffered at one time or another from Tetris Syndrome, that sensation of seeing in the mind's eye the ghost images of those seven color-coded puzzle piece shapes dropping downward and rotating neatly into rows. Invented by the Russian programmer Alexey Pajitnov in 1984, *Tetris* remains hugely popular to this day. It stands

among the most famous and iconic video games, those that have transcended the medium and entered the public consciousness.

Over 2,500 of us bundled in hoodies and gloves and scarves, a few in *Tetris*-themed costumes, lined up along the Schuylkill River on opposite sides of the Cira Centre. We awaited turns to operate the joysticks affixed to laptops at two locations at ground level, where 4G wireless hotspots sent instructions to a server inside the building. Not everyone got to play, but many of those present hummed *Tetris*'s familiar theme music and snacked on greasy food-truck grub. We were joined by Henk Rogers, the Dutch-born video game developer responsible for the highly innovative role-playing video game *The Black Onyx* (1984), but who is best known for acquiring the all-important handheld-game rights from Pajitnov—at the height of the Cold War, no less. He had come to Philly to celebrate the thirtieth anniversary of the game in epic style. With him was Drexel University professor Frank J. Lee, who had made the entire spectacle possible.

The Cira Centre resembled a silver box that has been gently twisted to create sharp and seemingly crystalline angles. Its shimmering, asymmetrical sides rose in contrast from the flat industrial landscape around 30th Street Station, the city's primary train depot. In the daytime, the glass superstructure reflected every cloud and contrail and blended more into the sky than the rest of the city. At night, even with many of the office lights still on, as the employees of a Swedish global hygiene and forest products company worked late, those *Tetris* shapes illuminated the surrounding area in bright colors. The amplified sound effects almost drowned out the sounds of the highway and the traffic around the Eakins Oval in

front of the Philadelphia Museum of Art. At the time, museumgoers could have seen a temporary "Treasure of Korea" exhibition and even Vermeer's "A Young Woman Seated at the Virginals," which was making a rare visit to the city and was displayed not far from Marcel Duchamp's *Fountain*.

For Philly Tech Week, Lee and his team had programed the LED-enabled, internet-connected façade of the Cira Centre. (The previous year, they had created a similarly sized game of *Pong* on the same building and in doing so set the Guinness World Record for the Largest Architectural Video Game ever made.) I met Lee at his university's Expressive and Creative Interaction Technologies Center (ExCITe), where he served as Associate Professor of Digital Media and Director of the Entrepreneurial Game Studio. In sartorial contrast to most college professors I know, Lee arrived for our meeting in a t-shirt, this one bearing the words PONG CHAMPIONSHIP 1972. Several of his students joined us at a conference table surrounded by wall decorations featuring *Pac-Man* and *Super Mario Bros*. "I knew it was theoretically possible," Lee told me of his *Tetris* installation. "I initially had the idea in 2008 and the *Pong* project came out in 2013." Of that five year effort, "four years and ten months was simply convincing Brandywine Realty Trust, that owns that building, to let me hack those lights."

After finally getting permission, Lee's team still needed to overcome numerous technical challenges, large and small. "Even if we could control those lights, if those lights were too slow then you couldn't really create a game out of them," he said. "If the refresh rate was one per five seconds, you can't create anything out of that, that delay." To make *Tetris* work, they needed to establish direct VPN access to the building's

proprietary network, which controlled the lighting system, and map the physical location of each light on the building's irregularly-shaped sides onto a grid. Then they acquired the software (via the collaborative GitHub network) that would allow them to remotely control the LEDs. Only at that point could they configure the LEDs into the appropriate shapes and colors. "Thankfully, we were able to improvise, find, or resolve the technical issues to create *Pong*. And once we created *Pong* we had all the stuff there for *Tetris*." The relief and excitement still showed on his face.

The efforts of Lee and his team reminded me of many of the other game makers I had read about and spoken with while writing this book. All of them shared a commitment to innovation, to pushing past the limits of what seemed possible, and to making something beautiful and unexpected.

From the free-to-play apps on our phones to massive installations in prestigious art museums to the facades of skyscrapers in major cities, video games are everywhere. They are now woven into the fabric of our everyday lives.

Consider games' invasion of the realm of professional sports. Perhaps sensing the shape of things to come, Nintendo recently sold its majority share in the Seattle Mariners. In the years ahead, video games will likely be a better investment than a Major League Baseball franchise. The rise of e-sports, and the proliferation of full-time, professional gamers, is a truly global phenomenon. In 2014, Amazon purchased the web site Twitch for $970 million in cash. The site had already turned video games into a spectator sport by allowing viewers at home to watch other people playing video games while commentating on their own performances, often hilariously.

The top *League of Legends* (2009) and *Dota 2* (2013) players from around the world can now earn hundreds of thousands or even millions of dollars every year in professional e-sports tournaments, many of which are streamed live online.

A professional e-sports organization, often sponsored by companies like Red Bull or New Balance, will field teams in several different games, but the international popularity of *League of Legends* has seemingly surpassed all other games—at least for the time being. The 2014 *League of Legends* championship attracted 40,000 fans to a soccer stadium in Seoul. In 2015, three North American teams—with the names Counter Logic, Team SoloMid, and Cloud9—earned places in the World Championships in Europe, where the South Korean team SK Telecom TI took home the Summoner's Cup and the $1 million prize purse in front of a streaming audience of 14 million concurrent viewers. For the sake of comparison, the 2015 World Series, in which the Mets lost to the Royals, drew a slightly higher average of 14.7 million viewers—and that figure represented baseball's best ratings in six years. In 2016, the month-long *League of Legends* championships took place in the United States, where—like the 1994 soccer World Cup—it strengthened the game's hold in the New World. SK Telecom TI repeated as champions and took home 40% of a prize pool that, according to ESPN, exceeded $5 million. If it doesn't already, the international fandom for e-sports will soon rival that of the World Cup.

The origins of *League of Legends* can be traced, of course, back to "a mod created within the *Warcraft* online community," as Rob Pardo told me. "It became more and more popular, and then people kept on iterating on that mod." In *LoL*,

as it's affectionately known, two five-person teams choose pre-made characters—or champions—with specific abilities and fight for control of a battleground. Destroying the other team's fortified base is paramount. The game is easy to learn and difficult to master, making it perfectly suited for e-sports. Over 100 million people play each month, many of them emulating the moves of their favorite pros.

In his script for the 1961 documentary *Le Sport et les hommes*, the French semiotician Roland Barthes attempted to answer a question that e-sports nowadays raise. "What is sport?" he asked. "Sport answers this question by another question: who is best?" On the topic of soccer, he wrote that "In sport, man experiences life's fatal combat, but this combat is distanced by the spectacle, reduced to its forms, cleared of its effects, of its dangers and of its shames: it loses its noxiousness, not its brilliance or meaning." If we define sports not by the amount of sweat they produce, but by the intensity of competition, e-sports have earned the name.

Moreover, the pleasures to be had in watching *League of Legends* played by skilled professionals are manifold and not all that different from those of watching baseball or football. I would bet all my *Warcraft* gold that the popularity of e-sports will continue to grow exponentially. It seems that for every elderly baseball fan who passes away, a young e-sports devotee will be born. It's only a matter of time before video games appear on primetime network television. The results of some video games could soon show up among the MLB and NFL scores in the sports section of the daily newspapers.

Yet however affecting or involving it is to watch *Tetris* played on a building or *League of Legends* in a sports arena,

the game that I think most clearly defines the potential of the medium is the one I first witnessed that noisy Christmas day down on the Jersey Shore.

Minecraft is fucking baffling. To the uninitiated and even to those of us steeped in video games, it can be all but incomprehensible. There are no tutorials, no hints, no virtual Virgil to guide the descent into that infernal realm. *Minecraft* doesn't adhere to any traditional ideas of how games function. It may very well represent a new generational line in the sand. My nephews' proficiency in it astounded me.

The game was created by Markus Persson in 2011 for the Swedish studio Mojang and eventually got bought by Microsoft for a cool $2.5 billion. My nephews and many younger people I knew were so obsessed by *Minecraft* that it sounded more like a cult than a video game. It has become the third bestselling game of all time, after *Tetris* and Miyamoto's *Wii Sports* (2006), and it boasts 100 million players worldwide. Curious to experience it for myself, I become one of them.

To play *Minecraft*, or rather to attempt to play *Minecraft*, I registered yet another account with yet another company, paid for the file, and downloaded it to my iMac. It was also available for every other make of desktop computer as well as mobile devices and consoles. Upon launching the game, a small window opened and presented the options: Singleplayer [sic], Multiplayer, or Minecraft Realms. The game's logo and rough, retro typeface resembled some of the early desktop computing games I had played, like *Populous*. I played alone so as to not embarrass myself in front of 100 million anonymous children.

I created a world and named it Ervinton. The game loaded in "survival" mode. I had no idea what that meant, though it

certainly didn't sound promising. In lieu of a tutorial or advice, the words "Loading world" and "Building terrain" appeared. I took that to mean that the topography of Ervinton would be procedurally generated and thus unique, albeit within some predetermined parameters. A row of 10 boxes on the bottom resembled a blank film strip. I found myself in the undergrowth of a dense, pixelated grove and looking at the world from a first person point of view. I tried my keyboard: the space bar allowed me to scroll across the boxes at the bottom. Karate chopping the ground with my mouse made a hole. Hitting other objects—mushrooms, trees—added them to my inventory, which soon filled those boxes. The E button opened a *Legend of Zelda*-like inventory screen and things began to make a tiny bit more sense. Then everything went dark.

I didn't know to expect that night would fall and monsters would arrive to kill me. I ended up in a place so dark I could not see. I pushed more keys but to no avail. My eustress turned to real stress. I could no longer see the playable area, had no idea how to move within Ervinton, and officially hated *Minecraft*. In a snit, I quit the game. I had failed the initiation. Stepping away from my computer, I went out for a run in the rain. I was terribly annoyed, but also amused at just how mad and frustrated I felt because of a video game that many children had mastered. "*Minecraft* is marvelous and has almost replaced other video games for a whole generation of people at this point," Adam Saltsman told me. "So that's pretty cool, because that's a video game-y video game. Like all of the things that people have been talking about that are interesting and meaningful that games can do for a while, that stuff is in *Minecraft*." As I came to see it, that was an accurate

description, but the game also seemed at times as much a language as a game, effortlessly learned by impressionable young minds but daunting to aging gamers like myself.

After taking a few days off, I hit reset on my new world and started again. Now I managed to carve a cave into the side of a cliff where I planned to hide when it got dark. My thoughts returned to my own trip to Persson's native Sweden, where even in the southern part of the country the winter nights arrived in midafternoon. The few, short hours of daylight always felt precious and those long nights cast a serious gloom. The daily cycle in *Minecraft* was similar. I felt the strong need to get my errands and work done before darkness fell.

Otherwise, I could not really figure out the point of the game—and maybe the point is that it has no point. I thought back to something Warren Robinett had said to me. "*Minecraft* pushed the boundaries because that's just an open world where you can build stuff and some people just make these little gizmos. You can mess with them and do things but there's no winning and no goal." I liked the sound of that. There would be no boss fight, no leader board, just inevitable death when night arrived again and the monsters returned.

When I got tired of dying, I summoned expert help. My 24-year-old nephew Alex dialed me up on Skype. We set up a private server, where the general *Minecraft* public would not be able to interfere with our grand schemes. Alex walked me through the process of chopping down trees with my bare hands, collecting wood, and building a crafting table. From there, I could create all sorts of things and even fend off the zombies and spiders. He explained how, in other game modes, to find hidden dungeons and mine for rare materials.

Instead of doing that, however, we reset the game yet again in order to create a flat world devoid of trees, mountains, or beasts. With access to the game's entire inventory, we constructed train tracks and set dynamite to blow up trolley cars. We constructed towers that reached far into the sky. The session recalled my daylong sessions with Legos as a child, before they came with detailed instructions about how to build someone else's designs. The free-form logic of *Minecraft* revealed the depth and complexity of the game. Another nephew, Logan, preferred to play in a world custom designed to resemble Middle-earth. *Minecraft* seemed to stand for video games writ large, in the sense that it could come in any form, and serve just about any purpose—art, entertainment, escapism, stress-releasing spider-bashing.

After the initial learning curve, *Minecraft* provided a feeling of total and absolute freedom. It was as though I were playing *Pac-Man* but with the ability to design the maze myself. I felt a sense of pure potentiality. In Ervinton, fate did not exist. I possessed free will with which I could make anything. That was an illusion, but I wholeheartedly believed it. Nevertheless, when the free trial period of the private server ended, I didn't bother to subscribe and pay a monthly fee to keep it running. The Edenic world of Ervinton ended not with a bang but a lapsed payment to the Microsoft Corporation.

Those of us who came of age in the Atari era can easily recognize just how far the medium has come. Yet every year we will lose access to more of the early pioneers and playable versions of their creations. There exists a sad irony: while more people are playing games than ever before, more and more games that they might have one day enjoyed are disap-

pearing. Soon it will be all but impossible to play *Donkey Kong* on an arcade cabinet or *Mario World* on an SNES. Ports and emulators will offer some idea of what it was like to play *Adventure* on a boxy black and white TV, but future gamers won't fully understand how it felt any more than we can appreciate the terror of watching the Lumière Brother's filmed train come barreling out of a cinema wall in 1895.

At the same time, new technologies and new ways of telling and sharing stories will continue to appear; more immersive virtual-reality headsets will make the games from my childhood appear as crude as cave paintings, while augmented-reality games following in the wake of *Pokémon Go* (2016) will continue to transform our world before our eyes.

A work of art can plumb the timeless human condition. Think of *Inferno* and *Moby-Dick*—and of some exceptional video games. *Journey* and *Passage* and *Brütal Legend* offer all the things humans have always desired from stories: personal connection, alleviation or intensification of loneliness, and sometimes the losing-oneself freedom I associate with Zenness. As Brenda Romero told me, "Games are the ultimate interactive art form. They inspire us to code, to draw, to create, to imagine. They provoke kids to learn about history, math, science and political systems. Games are a new stage, a book that changes as you change it."

When we play a video game, together or alone, we enter a magic circle of ritual, a vital place separate from our regular lives where we can gain new perspectives on the world around us. In the two years I spent writing this book, I found this to be true again and again. Just as my entire day can be made better by an hour at the gym or a walk in the forest, so too

can a session of *World of Warcraft* or *Gravity Ghost* or *The Cave* inspire new ideas about existing in the here-and-now. Perhaps what most surprised me about the latest games is that spending time with them has offered me new avenues of self-discovery.

Beyond any personal benefits some games can offer, video games today—played together online with friends or anonymous strangers—also challenge us to adopt a more enlightened, democratic, and civil level of discourse. So far, it seems, we have largely failed to meet this challenge; perhaps the medium needs to first break free of its militaristic origins. The widespread and diverse shared space made possible today by digital technologies continues to present challenges to which we, as a community, have not yet risen. As Gamergate shows, all too clearly, games can often reveal the terrifying underbelly of our society. I'm confident, though, that we can do better.

As the medium grows in the years to come, the ways in which we interact digitally can change too. To create a nurturing culture, each of us will need to first recognize that which is cultivated and constructed about our real identities and, second, attend to that which is personal and real and intensely human about our own—and each other's—digital representations. Our task now is learning how to negotiate our simultaneous selves, and how to effectively code-switch between them with grace and decency.

APPENDIX

my 11 favorite games

Adventure	Atari (1979)
Brütal Legend	Double Fine Productions (2009)
The Cave	Double Fine Productions (2013)
Gravity Ghost	Ivy Games (2015)
Journey	thatgamecompany (2012)
Katamari Damacy	Namco (2004)
The Legend of Zelda	Nintendo (1986)
Monument Valley	Ustwo (2014)
Shadow of the Colossus	Team Ico (2005)
Vib-ribbon	NanaOn-Sha (1999)
World of Warcraft	Blizzard Entertainment (2004–present)

ACKNOWLEDGMENTS

We are living in a golden age of video games and of video game criticism, both online and in print. Many thinkers helped shape the book you are holding right now. Most of them are cited in the end notes, but I want to single out three here in particular. As far as the historical record goes, Steven L. Kent's *Ultimate History of Video Games* lives up to its name. Anita Sarkeesian's Feminist Frequency video series has provided a great deal of inspiration and clarity, and Tom Bissell's *Extra Lives* is the bright star that all subsequent books about video games, including this one, will use for navigation. I also owe a large debt to each of the people who offered advice and shared with me their insights about video games: Ian Bogost, Jenova Chen, Ernest Cline, Clayton R. Cook, Brian Evenson, Frank J. Lee and his students in the Game Design Program at Drexel University, Rob Pardo, Warren Robinett, Jason Rohrer, Brenda Romero, Adam Saltsman, Tim Schafer, Erin Robinson Swink, Peter Z. Takacs, and Adam Theriault.

Special thanks to everyone I've gamed with these past two years, especially Scott Andrews, Carlos Alberto Muñoz Barahona, Jane Bennett, Brian Boyer, Wah-Ming Chang, SeQuita Coleman, Daniel DiFranco, Chris Ervin, Jim McCambridge, Ellie Miller, Steve Savarese, James Scheifley, Mike Sulkosky,

and the countless anonymous players who joined me in Azeroth and elsewhere. To Oskar Ferlin and his family, Troy Hendricks, Tamás Kovács-Bernárdt, Noah Larsen, Peter Laufer, Bayo Ojikutu, Ruth Ost, Richard Powers, and Curtis White; Madison Smartt Bell, Elizabeth Spires, and everyone at the Kratz Center for Creative Writing at Goucher College; Jim Brown and Robert A. Emmons Jr. at the Rutgers-Camden Digital Studies Center; to my early readers Paul M. Cobb, Alex Irvine, Owen King, and Amber Sparks; my editor Dan Gerstle and everyone at Basic Books; my agent Markus Hoffmann, as well as Claire Anderson-Wheeler and the entire team at Regal Hoffmann & Associates.

To my wife Elivi Varga, of course; my parents Margaret and Joseph Ervin, and my entire family, especially my nephews Alex Ervin, John Leonardo, and Logan Scheifley. Finally, my heartfelt thanks goes out to the legions of gamers who are every day finding ways, great and small, to build the diverse and inclusive gaming community we all deserve.

NOTES

ix "Midway upon the journey of our life..." Dante Alighieri, *Inferno*, translated by Henry Wadsworth Longfellow. www .gutenberg.org/cache/epub/1004/pg1004.txt. Accessed October 6, 2016.

ix "Who gives a shit..." Warren Robinett, in discussion with the author via Skype, January 25, 2016.

Introduction

2 "I soon learned...." Chloi Rad. "Minecraft Sales Surpass 100 Million Copies," IGN. June 2, 2016. Http://www.ign.com /articles/2016/06/02/minecraft-sales-surpass-100-million-copies. Accessed September 30, 2016.

4 "Since 1959..." Thomas Pynchon, "Is It O.K. to Be a Luddite?" *New York Times*, October 28, 1984. Https://www.nytimes .com/books/97/05/18/reviews/pynchon-luddite.html. Accessed October 20, 2015.

4 "...today a full 67%..." Entertainment Software Rating Board. "About ESRB." Http://www.esrb.org/about/video-game-industry -statistics.aspx. Accessed October 8, 2015.

4 "As of 2010..." Ibid.

4 "...40% of all gamers..." Ibid.

4 "A 2015 study revealed..." Maeve Duggan, "Gaming and Gamers," Pew Research Center, December 15, 2015. Http:// www.pewinternet.org/2015/12/15/who-plays-video-games -and-identifies-as-a-gamer. Accessed September 24, 2016.

4 "women over 35…" Daniel Lisi, *World of Warcraft* (Los Angeles: Boss Fight Books, 2016), 48.

4 "In many respects, video games…" Ana Douglas, "Here Are the 10 Highest Grossing Video Games Ever*," Http://www.businessinsider.com/here-are-the-top-10-highest-grossing-video-games-of-all-time-2012-6?op=1. Accessed October 14, 2015.

4 "The *World of Warcraft* franchise…" Ibid.

5 "In 2014 in the United States alone…" Nick Statt, "For Video Game Industry, 2014 Couldn't Escape Slumping Game Sales," CNET, January 15, 2015. Http://www.cnet.com/news/for-video-game-industry-2014-couldnt-escape-slumping-software-sales/. Accessed October 8, 2015.

5 "More than half of those sales…" Allegra Frank, "Take a look at the average American gamer in new survey findings," Polygon, April 29, 2016. Http://www.polygon.com/2016/4/29/11539102/gaming-stats-2016-esa-essential-facts. Accessed November 12, 2016.

5 "Witness the documented effect…" Clive Thompson, "The Minecraft Generation," *New York Times Magazine*, April 17, 2016.

6 "Or what in *Reality Is Broken*…" Jane McGonigal, *Reality is Broken: Why Games Make Us Better and How They Can Change the World* (New York: Penguin Books, 2011), 77.

6 "Formally speaking,…" Johan Huizinga, *Homo Ludens: A Study of the Play Element in Culture*, trans. is uncredited (Boston: Beacon Press, 1971), 20.

6 "culture arises in the form of play…" Ibid., 46.

6 "The sociologist Roger Caillois's…" Roger Caillois, *Man, Play and Games*, translated by Meyer Barash (Urbana, IL: University of Illinois Press, 2001), 7.

7 "In effect, play is essentially…" Ibid., 6.

7 "text-based games and current games…"Frank J. Lee, in discussion with the author, Drexel University, Philadelphia, PA, October 23, 2015.

10 "Margaret Atwood has written…" Margaret Atwood, forward to *Eve to Dawn: A History of Women in the World*, by

Marilyn French (New York: The Feminist Press, 2008), 40-41.

11 "If you accept the idea…" Warren Robinett, forward to *The Video Game Theory Reader*, edited by Mark Wolf and Bernard Perron, sent to author as Microsoft Word file.

1 – Epic Origins

14 "Now I am become Death…" James A. Hijiya, "The *Gita* of J. Robert Oppenheimer," Proceedings of the American Philosophical Society, vol. 144, no. 2, June 2000. Https://amphilsoc.org/sites/default/files/proceedings/Hijiya.pdf. Accessed November 30, 2015.

14 "Another witness to the detonation…" Institute of Nuclear Material Management News. "Safeguards Pioneer William A. Higinbotham Dies," May 4, 2016. Http://www.inmm.org/AM/Template.cfm?Section=40th_Years_of_JNMM&Template=/CM/ContentDisplay.cfm&ContentID=2637. Accessed November 29, 2015.

14 "In Italy, for thirty years…" John Gray, "A Point of View: Are Tyrants Good for Art?" BBC News, August 10, 2012. Http://www.bbc.com/news/magazine-19202527. Accessed December 2, 2015.

15 "A few years later…" Kristen J. Nyitray, "William A. Higinbotham: Scientist, Activist, and Computer Game Pioneer," *IEEE Annals of the History of Computing*, April-June 2011, excerpted at William A. Higinbotham Game Studies Collection, Stony Brook University. Http://www.stonybrook.edu/commcms/libspecial/videogames/whbio.html. Accessed October 2, 2016.

15 "Machines with interchangeable parts…" Vannevar Bush, "As We May Think," *The Atlantic*, July 1945. Http://www.theatlantic.com/magazine/archive/1945/07/as-we-may-think/303881. Accessed July 7, 2016.

15 "…thrown most violently off stride…" Ibid.

16 "…wanted to be involved in instruments…" William A. Higinbotham, quoted in Kristen J. Nyitray, "Biographical Sketch: William (Willy) A. Higinbotham," Stony Brook University,

April-June, 2011. Http://www.stonybrook.edu/commcms/lib special/videogames/whbio.html. Accessed June 6, 2016.

16 "...develop state-of-the-art..."Brookhaven National Laboratory, Instrumentation Division, "Video Tennis: A Reproduction of the World's First Video Game," pamphlet.

17 "By all accounts..." Ibid.

18 "I've always been interested..." Peter Z. Takacs, e-mail message to author, October 2, 2014.

18 "We've got to preserve..." Peter Z. Takacs in discussion with the author, Brookhaven National Laboratory, Upton, NY, October 2, 2014.

18 "...there was no information..." Raiford Guins, *Game After: A Cultural History of Video Game Afterlife* (Cambridge, MA: MIT Press, 2014), 270.

18 "Takacs and his team..." Ibid., 272.

19 "The game is currently..." Peter Z. Takacs, e-mail message to author, June 15, 2014.

22 "The interesting thing..."Peter Z. Takacs in discussion with the author, Brookhaven National Laboratory, Upton, NY, October 2, 2014.

24 "I was around..." Ibid.

24 "When I was a kid..."Ibid.

24 "...you could make the distinction..." Ibid.

25 "You have to be careful..." Ibid.

25 "How would you classify..." Ibid.

25 "My grandfather..." Ibid.

2 – Era of Innovation

27 "For one Russian man..." Robin McKey, "Sergei Korolov: The Rocket Genius behind Yuri Gagarin," *The Guardian*, March 12, 2011. Http://www.theguardian.com/science/2011/mar/13/yuri-gagarin-first-space-korolev. Accessed December 4, 2015.

27 "Tyuratam Missile Range..."Paul Rincon and Katia Moskvitch, "Profile: Yuri Gagarin," BBC News, April 4, 2011. Http://www.bbc.com/news/science-environment-12460720. Accessed December 8, 2015.

27 "...three press releases..."Encyclopedia Astronautica, "Vostok 1." http://www.astronautix.com/v/vostok1.html. Accessed December 8, 2015.

27 "The short and slightly built..." Ibid.

27 "At 23,000 feet..."Jeremy Norman, "Yuri Gargarin Becomes the First Human to Travel into Space and the First to Orbit the Earth (April 12, 1961)." Http://www.historyofinformation.com/expanded.php?id=3467. Accessed November 12, 2016.

28 "The space race..." Steve Russell, "A Conversation with John Romero and Steve Russell," YouTube video, 43:57, from a keynote delivered at IndieCade in 2012, posted by IndieCade, February 5, 2013. Https://www.youtube.com/watch?v=vHGTY4_TGy0, accessed December 8, 2015.

28 "The Russians had..." Mike Wall, "FAQ: Alan Shepard's Historic Flight as First American in Space," Space.com, May 4, 2011. Http://www.space.com/11562-nasa-american-spaceflight-alan-shepard-spaceflight-faq.html. Accessed November 12, 2016.

29 "In engineering..." Norbert Wiener, *Cybernetics: Or Control and Communication in the Animal and the Machine,* revised and expanded, (Cambridge: MIT Press, 1975), xii.

29 "...a competitive game..." Ibid., xiv.

29 "Housed in the basement..." Walter Isaacson, *The Innovators: How a Group of Hackers, Geniuses, and Geeks Created the Digital Revolution* (New York: Simon and Schuster, 2015), 202.

29 "...a clever modification..." "Hackers," The Tech Model Railroad Club of MIT, http://tmrc.mit.edu/hackers-ref.html. Accessed December 2, 2015.

29 "Born in 1937..." Moby Games, "Steve Russell," last updated May 8, 2014. Http://www.mobygames.com/developer/sheet/view/developerId,596093. Accessed June 7, 2016.

29 "...he is also known for writing the first..." Computer Nostalgia. "Computer History: Tracing the History of the Computer – Steve "Slug" Russell." http://www.computernostalgia.net/articles/steveRussell.htm. Accessed June 7, 2016.

30 "He has claimed..." Computer Nostalgia. "Computer History: Tracing the History of the Computer – Steve "Slug" Rus-

sell." http://www.computernostalgia.net/articles/steveRussell
.htm. Accessed June 7, 2016.

30　"...the biggest computer available..." Russell, "Conversation."

30　"The lab work was funded by the Pentagon." Hamza Shaban,
"Playing War: How the Military Uses Video Games," *The Atlan-
tic*, October 10, 2013. Http://www.theatlantic.com/technology
/archive/2013/10/playing-war-how-the-military-uses-video
-games/280486. Accessed June 21, 2016.

30　"In September 1961..." Walter Isaacson, *The Innovators:
How A Group of Hackers, Geniuses, and Geeks Created the
Digital Revolution* (New York: Simon and Schuster, 2014),
203.

30　"...the PDP-1 represented..." Computer History Museum.
"DEC PDP-1 Collection." http://www.computerhistory.org
/collections/decpdp-1/. Accessed December 1, 2015.

31　"...only three universities..." Stephen L. Kent, *The Ultimate
History of Video Games* (New York: Three Rivers, 2001), 17.

31　"...was only the size..." Russell, "Conversation"

31　"...elbows got very tired..." Steve Russell, quoted in Kent,
Ultimate History, 19.

32　"On one site..." Masswerk Media Environments. "Space-
war!" http://www.masswerk.at/spacewar. Accessed December
2, 2015.

32　"The early versions include..." J.M. Graetz, "The Origin of
Spacewar," reprinted from Creative Computing, August 1981.
Wheels.org. Http://www.wheels.org/spacewar/creative/Space
warOrigin.html. Accessed December 3, 2015.

32　"A 2015 kitchen-sink hack..." Masswerk Media Environ-
ments. "Spacewar!" Http://www.masswerk.at/spacewar. Ac-
cessed November 12, 2016.

32　"...tiny dot whose quick..." Rainer Maria Rilke, "From the
Notebooks: III (Capri, January-February 1907)," *The Inner
Sky: Poems, Notes, Dreams*, translated by Damion Searles
(Boston: David Godine, 2010), 111.

33　"...the 360 offered..." IBM. "Chronological History of IBM:
1960s." http://www-03.ibm.com/ibm/history/history/decade
_1960.html. Accessed December 8, 2015.

33 "In 1969..." IBM. "Chronological History of IBM: 1969." http://www-03.ibm.com/ibm/history/history/year_1969.html. Accessed December 8, 2015.

33 "We attribute the word 'eureka'..." David Biello, "Fact or Fiction?: Archimedes Coined the Term 'Eureka!' in the Bath," *Scientific American*, December 8, 2006. Http://www.scientific american.com/article/fact-or-fiction-archimede. Accessed December 8, 2015.

34 "...leapt out of the vessel..." Marcus Vitruvius Pollio. "De Architectura, Book IX." http://penelope.uchicago.edu/Thayer /E/Roman/Texts/Vitruvius/9*.html#Intro.9. Accessed December 8, 2015.

34 "Born into a Jewish family..." Douglas Martin, "Ralph H. Baer, Inventor of First System for Home Video, Is Dead at 92," *New York Times*, December 7, 2014. Http://www.nytimes .com/2014/12/08/business/ralph-h-baer-dies-inventor-of-odyssey -first-system-for-home-video-games.html?_r=0. Accessed November 30, 2015.

34 "In 1938..." Benj Edwards, "The Right to Baer Games – An Interview with Ralph Baer, the Father of Video Games," Gamasutra, March 23, 2007. Http://www.gamasutra.com/view /feature/130108/the_right_to_baer_games__an_.php. Accessed December 6, 2015.

34 "I was damn lucky..." Benj Edwards, "The Right to Baer Games – An Interview with Ralph Baer, the Father of Video Games," Gamasutra, March 23, 2007. Http://www.gamasutra .com/view/feature/130108/the_right_to_baer_games__an_ .php. Accessed December 6, 2015.

34 "During World War II..." Martin, "Ralph H. Baer."

34 "Baer spent his first..." Kent, *Ultimate History*, 22.

35 "I'm sitting on a curb..." Ralph Baer, interview by Gardner Hendrie, "Oral History of Ralph Baer," October 12, 2006 and November 27, 2006, Computer History Museum. Http:// archive.computerhistory.org/resources/text/Oral_History /Baer_Ralph_1/Baer_Ralph_1and2.2006.102657972_final .pdf. Accessed December 8, 2015.

35 "A few days later..." Ibid.

35 "The very first thing..." Ibid.

35 "Due to the amount..." Mark Langshaw, "Magnavox Odyssey Retrospective: How Console Gaming was Born," Digital Spy, December 13, 2014. Http://www.digitalspy.com/gaming /retro-corner/feature/a616235/magnavox-odyssey-retrospective -how-console-gaming-was-born. Accessed December 12, 2015.

36 "That first commercial..." Online Odyssey Museum, "The extra games of -72." Http://www.magnavox-odyssey.com/1972 %20games.htm. Accessed November 12, 2016.

36 "Each game came..." Ian Bogost, e-mail message to author, November 14, 2016.

36 "Oddly, the Odyssey..." Martin, "Ralph H. Baer."

36 "While the available peripherals..."Langshaw, "Magnavox Odyssey Retrospective."

36 "In the first year alone..." Martin, "Ralph H. Baer."

37 "In September 1971..."Walter Isaacson, *The Innovators: How a Group of Hackers, Geniuses, and Geeks Created the Digital Revolution* (New York: Simon and Schuster, 2015), 209

37 "At a time when many..." Stanford University Infolab. "The Galaxy Game." http://infolab.stanford.edu/pub/voy/museum /galaxy.html. Accessed December 9, 2015.

37 "By way of comparison..." Kurt Ernst, "The AMC Gremlin X: Because Different is Good," Hemmings Daily, June 25, 2014. Http://blog.hemmings.com/index.php/2014/06/25/the-amc -gremlin-x-because-different-is-good. Accessed December 9, 2015.

37 "The equipment was simply..." "The Galaxy Game."

37 "...Steve Russell was like..." Steve Bushnell, quoted in Isaacson, *The Innovators*, 207.

37 "For the display..." Kent, *Ultimate History*, 31-32.

38 "...called a 'totally bastardized version'..." Bill Pitts, quoted in Isaacson, *The Innovators*, 209.

3 – Atari

40 "Nolan Bushnell..." Stephen L. Kent, *The Ultimate History of Video Games* (New York: Three Rivers, 2001), 35.

40 "The name they chose..." Kent, *Ultimate History*, 35.

40 "She remained with Atari..." Stephen L. Kent, *The Ultimate History of Video Games* (New York: Three Rivers, 2001) 39.

40 "...$2 billion a year..." Ibid, 38-39.

40 "The second employee hired..." Ibid.

41 "I had no aspiration of..." Allan Alcorn, quoted in Cam Shea, "Al Alcorn Interview," IGN, March 10, 2008. Http://www.ign.com/articles/2008/03/11/al-alcorn-interview?page=2. Accessed December 12, 2015.

41 "It was only meant..." Allan Alcorn, quoted in Kent, *Ultimate History*, 40-41.

42 "I just tried to make the game..." Allan Alcorn, quoted in Cam Shea, "Al Alcorn Interview."

42 "The frequencies were..." Ole Caprani, "The PONG Game," Computer Science Department, Aarhus University, September 27, 2014. Http://cs.au.dk/~dsound/DigitalAudio.dir/Greenfoot/Pong.dir/Pong.html. Accessed December 12, 2015.

43 "Avoid missing ball..." Kent, *Ultimate History*, 42.

44 "The agreement also made Atari..." Ibid., 47.

44 "Realistic Sounds of Ball..." Atari Corporation, Pong advertisement. Http://www.ign.com/articles/2008/03/11/al-alcorn-interview?page=2. Accessed December 12, 2015.

45 "Some of them reportedly..." Kent, *Ultimate History,* 51.

45 "During the winter of 1977..." Ibid., 52.

45 "They eventually removed..." International Arcade Museum, "Gotcha" http://www.arcade-museum.com/game_detail.php?game_id=7985. Accessed December 15, 2015.

45 "Advertisements for *Gotcha*..." Arcade Flyer Archive, "Gotcha." http://flyers.arcade-museum.com/?page=thumbs&db=videodb&id=461. Accessed December 15, 2015.

45 "...I love to screw..." Kent, *Ultimate History*, 110.

46 "It went on to sell 150,000..." Ibid., 87.

46 "...new user-interface device..." Ibid., 107.

48 "...the world of the epic..." M. M. Bakhtin, "Epic and Novel: Toward a Methodology for the Study of the Novel," *The Dialogic Imagination: Four Essays*, edited by Michael Holquist, translated by Caryl Emerson and Michael Holquist (Austin: University of Texas Press, 1981), 13.

48 "...walled off absolutely..." Ibid., 15.

49 "...it didn't seem that bad..." Dona Bailey, quoted in Barbara Ortutay, "Iconic Atari Turns 40, Tries to Stay Relevant," Yahoo! News, June 29, 2012. Http://news.yahoo.com/iconic -atari-turns-40-tries-stay-relevant-211822140--finance.html. Accessed January 26, 2016.

49 "It was the first game made..." Colin Campbell, "The Story of Yar's Revenge Is a Journey Back to a Lost World of Video Games," Polygon, March 9, 2015. Http://www.polygon.com /2015/3/9/8163747/yars-revenge-is-a-journey-back-to-a-lost -world-of-video-games. Accessed January 26, 2016.

49 "The things you struggled with..." Warren Robinett, in discussion with the author via Skype, January 25, 2016.

50 "A spring 2014 expedition..." Adario Strange, "Legend Confirmed: Atari 2600 'E.T.' Game Discovered at New Mexico Dig," Mashable, April 26, 2014. Http://mashable.com/2014 /04/26/legend-confirmed-atari-2600-e-t-game-discovered-at -new-mexico-dig. Accessed January 26, 2016.

50 "...one of the most playable..." Craig Holyoak, "Here Are ColecoVision's Jewels," Deseret News, May 30, 1984. Https:// news.google.com/newspapers?id=PqZNAAAAIBAJ&sjid =D4MDAAAAIBAJ&pg=7081%2C6575510. Accessed October 8, 2016.

50 "The government of West Germany..." Jim Sampson, "German Crackdown on Videos, Game: Federal Control Office Eyes Violence, Pornography." Billboard. 24 Aug. 1985. Https://books.google.com/books?id=2iQEAAAAMBAJ&p- g=PT81&dq=river+raid+Activision+west+germany&hl=en& sa=X&ved=0ahUKEwidgIyzksjKAhVLcT4KHRKkAkQQ6A- EIHDAA#v=onepage&q=river%20raid%20Activision%20 west%20germany&f=false. Accessed October 8, 2016.

50 "The 1982 cartridge Berserk..." Tom Hirschfeld, How to Master Home Video Games (New York: Bantam Books, 1982), 196.

51 "Do all these forces and energies..." Walpola Rahula, What the Buddha Taught (New York: Grove Press, 1974), 33.

4 – Call to Adventure

53 "...work of an artist..." Kenneth Clark, *What Is a Masterpiece?* (New York: Thames and Hudson, 1979), 44.

54 "Mr. Melville has to thank..." Henry F Chorley, *London Athenaeum,* October 25, 1851. Melville.org. Http://www.melville.org/hmmoby.htm#lospec. Accessed January 28, 2016.

54 "Recent evidence indicates..." John Dorsey, "The van Gogh Legend—A Different Picture the Story That the Artist Sold Just One Painting in His Lifetime Endures. In Fact, He Sold at Least Two," *Baltimore Sun,* October 25, 1998. Http://articles.baltimoresun.com/1998-10-25/features/1998298006_1_gogh-red-vineyard-painting. Accessed January 28, 2016.

54 "I think we can..." Clark, *What Is a Masterpiece?*, 43-44.

54 "...a masterpiece must use..."Ibid.

55 "The fact is that each writer..." Jorge Luis Borges, "Kafka and His Precursors," *Selected Non-fictions,* edited and translated by Eliot Weinberger (New York: Penguin Books, 2000), 365.

55 "In the early 1970s..." Colossal Cave Adventure Page, "A History of 'Adventure,'" rickadams.org. Http://rickadams.org/adventure/a_history.html. Accessed 24 October 2015.

56 "Suddenly, I got involved in a divorce..." Ibid.

56 "That program turned out to be..." National Park Service, "Mammoth Cave." http://www.nps.gov/maca/index.htm. Accessed 24 October 2015.

56 "Let us now with whatever levers..." Herman Melville, *Moby-Dick* (New York: W.W. Norton Critical Edition, second edition, 2002), 264.

56 "Crowther programmed the original..." "A History of 'Adventure.'"

57 "Woods contacted Crowther..." Ibid.

57 "If players collected every..." Ibid.

57 "If you are using the Bob Supnik..." codescott123, Colossal Cave Adventure forum. Http://forums.delphiforums.com/xyzzy/messages/?msg=463.1. Accessed 24 Oct. 2015.

58 "...an interactive textual simulation..."Dennis G. Jerz, "Somewhere Nearby is Colossal Cave: Examining Will

Crowther's Original 'Adventure' in Code and in Kentucky, Digital Humanties Quarterly, vol. 1, no. 2 (2007). Http://www .digitalhumanities.org/dhq/vol/001/2/000009/000009.html. Accessed 24 Oct. 2015.

58 "Please wait while..." *Colossal Cave Adventure*. William Crowther and Don Woods, et al. 1976-. Video Game. Windows DOS.

58 "Welcome to Adventure!! ..." Ibid.

58 "Somewhere nearby.." Ibid.

59 "* GOOD LUCK!" Ibid.

59 "You are standing at..." Ibid.

60 "You are inside a building..." Ibid.

60 "...frozen rivers of..." Ibid.

60 "...huge green fierce snake..." Ibid.

61 "... cheating as a means of winning..." Huizinga, *Homo Ludens*, 52.

62 "The more cartoony..." Scott McCloud, *Understanding Comics: The Invisible Art* (Northampton, MA: Kitchen Sink Press, 1993), 31.

62 "I called the square..." Warren Robinett, in discussion with the author via Skype, January 25, 2016.

62 "I decided to make it a square..." Ibid.

62 "So I drew this little square..." Ibid.

63 "Willy Crowther basically invented..." Ibid.

63 "I made a pilgrimage..." Ibid.

63 "He decided to create..." Warren Robinett, quoted on The Jaded Gamer, via Internet Archive Wayback Machine. Http:// web.archive.org/web/20070927005831/http://www.dadgum .com/halcyon/BOOK/ROBINETT.HTM. Accessed December 16, 2015.

63 "...rendering a large virtual space..." Nick Monfort and Ian Bogost, *Racing the Beam: The Atari Video Computer System* (Cambridge, MA: MIT Press, 2009), 46.

63 "I thought I was going to Vietnam..." Warren Robinett, in discussion with the author via Skype, January 25, 2016.

64 "...nothing to write home about..." Ibid.

64 "Memory was expensive." Ibid.

64 "...in 1978, Intel's 16-bit..." John Sheesley, "Intel's 8086 Passes the Big 3-0," TechRepublic, June 16, 2008. Http://www.techrepublic.com/blog/classics-rock/intels-8086-passes-the-big-3-0. Accessed August 2, 2016.

65 "...How are you going to get..."Warren Robinett, in discussion with the author via Skype, January 25, 2016.

65 "He was pissed..." Ibid.

65 "I told the people at Atari..." Ibid.

66 "...because it was different." Ibid.

66 "I remember quite a few times..." Ibid.

66 "In a way, those four notes..." Ibid.

67 "Maybe there was some other way..." Ibid.

67 "But pardon, gentles all..." William Shakespeare, "The Life of King Henry the Fifth," *The Complete Works of Shakespeare,* fourth edition, edited by David Bevington (New York: Harper Collins, 1992), 853.

68 "An evil magician has stolen..." "Adventure," Atari Game Program Instructions (1979).

69 "I decided to give you..." Warren Robinett, in discussion with the author via Skype, January 25, 2016.

69 "I made a breakthrough..." Ibid.

69 "Each video game back in the late '70s..." Ibid.

70 "Well, I wanted to get credit..." Ibid.

70 "I don't like being pushed around..." Ibid.

70 "It was my attempt at irony..." Warren Robinett, forward to *The Video Game Theory Reader*, edited by Mark Wolf and Bernard Perron, sent to author as Microsoft Word file.

71 "Descend with bat and sword..." Tom Hirschfeld, *How to Master Home Video Games*. (New York: Bantam Books, 1982), 183.

71 "Mr. Robinett has placed..." Hirschfeld, *How to Master Home Video Games*, 183-184.

71 "If all goes well, The Man..." "Adventure (Atari 2600) Finding the Hidden Easter Egg," YouTube video, 10:18, posted by EastCoast Destruction BMX, February 19, 2011. Https://www.youtube.com/watch?v=YS-HYWRdb2g. Accessed December 16, 2015.

71 "I called it my signature…" Warren Robinett, in discussion with the author via Skype, January 25, 2016.

71 "I was kind of demoralized…" Ibid.

71 "He and the other three founders…" Kent, *Ultimate History*, 197.

71 "Later he designed one…" Warren Robinett, "Warren Robinett's Home Page." http://www.warrenrobinett.com. Accessed December 16, 2015.

71 "I didn't continue to make…" Warren Robinett, in discussion with the author via Skype, January 25, 2016.

72 "…changed [his] whole life…" Ernest Cline, e-mail message to author, February 1, 2016.

72 "It's about the implementation…" Warren Robinett, in discussion with the author via Skype, January 25, 2016.

72 "…there is not only skill…" Robinett, forward to *Video Game Theory Reader*.

72 "It was the first graphical…" Fatsquatch, "Of Dragons and Easter Eggs: A Chat With Warren Robinett," The Jaded Gamer, May 13, 2013. Http://tjg.joeysit.com/of-dragons-and-easter-eggs-a-chat-with-warren-robinett. Accessed January 30, 2016.

72 "But I want to do it…" Warren Robinett, in discussion with the author via Skype, January 25, 2016.

5 – Arcade Projects

74 "At low tide like this…" Elizabeth Bishop, "The Bight," *The Complete Poems: 1927-1979* (New York: Farrar, Straus and Giroux, 1983), 60.

75 "…everybody and his brother…" Laura June, "For Amusement Only: The Life and Death of the American Arcade," The Verge, January 16, 2013. Http://www.theverge.com/2013/1/16/3740422/the-life-and-death-of-the-american-arcade-for-amusement-only. Accessed October 8, 2016.

76 "…annual gross of $7 billion…" Ibid.

77 "Maybe boy stories…" Toru Iwatani, quoted in Chris Morris, "Five Things You Never Knew about Pac-Man," CNBC, March 3, 2011. Http://www.cnbc.com/id/41888021. Accessed January 19, 2016.

77 "So the verb 'eat'…" Toru Iwatani, quoted in Chris Morris, "Five Things You Never Knew about Pac-Man," CNBC, March 3, 2011. Http://www.cnbc.com/id/41888021. Accessed January 19, 2016.

77 "…sound of Pac-Man's insatiable…" Mark Bould, Andrew M. Butler, Adam Roberts and Sherryl Vint, editors, *The Routledge Companion to Science Fiction* (New York: Routledge, 2009). https://books.google.com/books?id=aD-PAgAAQBAJ &pg=PT626&lpg=PT626&dq=pac-man+fever+ted+nugent &source=bl&ots=VuUJl2Osrm&sig=_ADVXvkOH5fKQA-uC0Mc-6a4H_Rc&hl=en&sa=X&ved=0ahUKEwi1_7S4xbb-KAhXI2T4KHaWiAIQQ6AEISzAL#v=snippet&q=pac-man &f=false. Accessed January 19, 2016.

78 "There's not much entertainment…" Toru Iwatani, quoted in Michael Mateas, "Expressive AI: Games and Artificial Intelligence," Georgia Institute of Technology. Http://homes.lmc .gatech.edu/~mateas/publications/MateasDIGRA2003.pdf. Accessed January 19, 2016.

78 "I wanted each ghostly enemy…" Ibid.

81 "…Ms. Pac-Man was not only…" Anita Sarkeesian, "Ms. Male Character—Tropes vs Woman," Feminist Frequency, video, 25:01, posted November 18, 2013. Http://feministfrequency .com/2013/11/18/ms-male-character-tropes-vs-women. Accessed January 19, 2016.

83 "Unable to secure the licensing rights…" Travis Fahs, "The Secret History of *Donkey Kong*," Gamasutra, July 6, 2011. Http://www.gamasutra.com/view/feature/134790/the_secret _history_of_donkey_kong. Accessed October 2, 2016.

83 "Nobody ever threw barrels at me…" Shigeru Miyamoto, quoted in Seth Porges, "Exclusive Interview with Nintendo Gaming Mastermind Shigeru Miyamoto," *Popular Mechanics*, December 17, 2009. Http://www.popularmechanics.com/culture /gaming/a4690/4334387. Accessed February 6, 2016.

85 "*Mario Bros.* (not *Super*)…" Ian Bogost, e-mail message to author, February 3, 2016.

86 "Everyone is afraid of falling…" Shigeru Miyamoto, "Q&A: Shigeru Miyamoto on the Origins of Nintendo's Famous

Characters," NPR, June 19, 2015. Http://www.npr.org/sections /alltechconsidered/2015/06/19/415568892/q-a-shigeru-miya moto-on-the-origins-of-nintendos-famous-characters. Accessed January 25, 2016.

86 "My vision of Mario…" Ibid..

87 "This includes the changes…" Walter Benjamin, "The Work of Art in the Age of Mechanical Reproduction," *Illuminations: Essays and Reflections*, translated by Harry Zohn (New York, Schocken: 2007), 220.

6 – The First Auteur

89 "We just gradually convince ourselves…" Shigeru Miyamoto, quoted in Carolyn Sayre, "10 Questions for Shigeru Miyamoto," *Time*, July 19, 2007. Http://content.time.com/time /magazine/article/0,9171,1645158,00.html. Accessed February 2, 2016.

90 "…Creative Fellow." Nintendo Co., Ltd., "Notice Regarding Personnel Change of a Representative Director and Role Changes of Directors," September 14, 2015. Https://www .nintendo.co.jp/ir/pdf/2015/150914e.pdf. Accessed October 1, 2016.

90 "One day, when he was seven…" Nick Paumgarten, "Master of Play: The Many Worlds of a Video-game Artist," *The New Yorker*, December 20, 2010. Http://www.newyorker.com /magazine/2010/12/20/master-of-play. Accessed February 2, 2016.

90 "Over the summer…" Ibid.

90 "…had magical meaning…" Helen Gardner, *Art through the Ages*, eighth edition, edited by Horst de la Croix and Richard G. Tansey (San Diego: Harcourt Brace Jovanovich, 1986), 28.

90 "All the beasts thus represented…" James George Frazer, *The Golden Bough. Volume I: The Magic Art and the Evolution of Kings*, third edition, vol. 1 (New York: St. Martin's Press, 1966), 87.

91 "We had gone on this hiking trip…" Miyamoto, "Q&A: Shigeru Miyamoto."

91 "Nintendo traces its origins…" Kent, *Ultimate History*, xi.

92 "He changed the name to Nintendo..." "The Lucky Birth," N-Sider, September 12, 2003. Http://www.n-sider.com/content view.php?contentid=34. Accessed June 10, 2016.

92 "For the first time, citizens heard..." Victor Sebestyen, *1946: The Making of the Modern World* (New York: Pantheon, 2014), 354.

92 "...endure the unendurable..." John W. Dower, "Embracing Defeat: Japan in the Wake of World War II," excerpted in the *New York Times*, 1999. Https://www.nytimes.com/books /first/d/dower-defeat.html. Accessed August 3, 2016.

92 "Miyamoto was born amid..." Nick Paumgarten, "Master of Play: The Many Worlds of a Video-game Artist," *The New Yorker*, December 20, 2010. Http://www.newyorker.com /magazine/2010/12/20/master-of-play. Accessed November 14, 2016.

92 "He earned a degree in industrial design..." Ibid.

92 "His early projects at Nintendo involved..." Travis Fahs, "The Secret History of *Donkey Kong*," Gamasutra, July 6, 2011. Http://www.gamasutra.com/view/feature/134790/the_secret _history_of_donkey_kong. Accessed November 14, 2016.

92 "Before I saw it..." Miyamoto, "10 Questions."

93 "Nintendo would go on to sell..." Don Reisinger, "Nintendo Shocks Classic Gamers with NES Relaunch, *Fortune*, July 14, 2016. Http://fortune.com/2016/07/14/nintendo-nes-classic. Accessed October 8, 2016.

93 "...to where we were creating worlds..." Miyamoto, "Q&A: Shigeru Miyamoto."

97 "I thought it was really fucking..." Warren Robinett, in discussion with the author via Skype, January 25, 2016.

97 "I didn't want the game to drop out..." Ibid.

98 "MASTER USING IT..." *The Legend of Zelda*. Nintendo. Video game. 1986.

98 "One thing I'm not really good at..." Miyamoto, "Exclusive Interview."

98 "THANKS LINK..." *The Legend of Zelda*.

99 "The system sold over 49 million..." "Consolidated Sales Transition by Region," WebCite, cached February 14, 2010.

Http://www.webcitation.org/5nXieXX2B. Accessed October 1, 2016.

7 – The Renaissance

103 "This penetration of the panel surface…" Gardner, *Art through the Ages,* 556.

104 "…Nintendo has made innovative…" Adam Theriault, e-mail message to author, February 29, 2016.

105 "The more fingers you can engage…" Ibid.

106 "This is a fateful story of those…" *Chrono Trigger* booklet. Accessed via PlayStation network.

107 "Computer games had employed 3D imaging…" Ultimate History of Video Games!. "Spasim." Http://ultimatehistory videogames.jimdo.com/spasim-plato. Accessed November 14, 2016.

108 "To date over 11 million copies…" Spencer, "Final Fantasy VII Has Sold Over 11 Million Unites Worldwide." Http://www.siliconera.com/2015/08/19/final-fantasy-vii-has-sold-over-11-million-units-worldwide. Accessed November 14, 2016.

109 "…easily the most interesting…" Ron Dulin, "Final Fantasy VII Review," GameSpot, July 7, 1998. Http://www.gamespot.com/reviews/final-fantasy-vii-review/1900-2536027. Accessed June 11, 2016.

109 "…3D game for the PlayStation was Masaya Matsuura's *Vib-ribbon*…" Paola Antonelli, "Video Games: 14 in the Collection, for Starters," Museum of Modern Art, November 29, 2012. Https://www.moma.org/explore/inside_out/2012/11/29/video-games-14-in-the-collection-for-starters. Accessed November 14, 2016.

111 "The jump to 3D and more computing power…" Adam Theriault, Facebook Messenger message to author, February 15, 2016.

111 "…a set of training wheels…" Ibid.

111 "The thing that people often seem…" Ibid.

112 "In order to show those 3-D…" Miyamoto, "Q&A: Shigeru Miyamoto."

113 "It dawned on me that…" Ibid.

113 "So we came up with this idea…" Ibid.

113 "We thought he was the perfect character…" Ibid.

113 "…closed a millennium of Medieval art…" Gardner, *Art through the Ages*, 553.

113 "…this foot-plant animation…" Steve Swink, *Game Feel: A Game Designer's Guide to Virtual Sensation* (Burlington, MA: Morgan Kaufmann Publishers, 2009), 248.

114 "The multi-purpose analog button…" Adam Theriault, Facebook message to author. September 22, 2016.

114 "Ten years after its launch, the original PlayStation…" Alex Matsuo, "10 Most Popular Game Consoles of All Time," The Richest, February 22, 2014. Http://www.therichest.com /rich-list/most-popular/10-most-popular-game-consoles-of -all-time. Accessed August 4, 2016.

114 "The PS2, released in 2000…" Ibid.

115 "…Sony has already sold over 35 million copies…" Mark Walton, "EA Lets Slip Lifetime Xbox One and PS4 Consoles Sales," Ars Technica, January 29, 2016. Http://arstechnica .com/gaming/2016/01/ea-lets-slip-lifetime-xbox-one-and-ps4 -consoles-sales. Accessed August 4, 2016.

8 – Dialing Up

120 "…[his] characters are galley-slaves…" Vladimir Nabokov, "The Art of Fiction No. 40," *The Paris Review*, summer-fall 1967. Http://www.theparisreview.org/interviews/4310/the-art -of-fiction-no-40-vladimir-nabokov. Accessed November 10, 2015.

120 "A good game attracts you…" Tom Bissell, *Extra Lives: Why Video Games Matter* (New York: Vintage, 2010), 93.

120 "Vishnu, for instance…" *Oxford English Dictionary*, "Avatar," accessed June 12, 2016.

121 "Molyneux's most famous titles are…" Laura Kate Dale, "Peter Molyneux Interview: 'It's Over, I Will Not Speak to the Press Again,'" *The Guardian*, February 13, 2015. Http://www .theguardian.com/technology/2015/feb/13/peter-molyneux -game-designer-interview-godus. Accessed November 10, 2015.

121 "A blue-faced god appeared…" *Populous*. Video game. De-signed by Peter Molyneaux. Bullfrog Productions, 1989. Ac-cessed via GOG.com network, November 2015.

121 "…the development team for *World of Warcraft*…"Jason Sch-reier, "Blizzard Talks *World of Warcraft* Legacy Servers and More," Kotaku, June 10, 2016. Http://kotaku.com/blizzard -talks-world-of-warcraft-legacy-servers-and-mor-1781753 136. Accessed June 11, 2016.

122 "Elivi—now a professional flutist…" Elivi Varga, in discus-sion with the author, November 12, 2015.

123 "…one of the worst movie-based…"Brad Hicks, "Total Recall (NES)," SwankWorld. Http://www.swankworld.com/Games /retro/nes/ totalrecall/review.htm. Accessed June 11, 2016.

124 "God is dead…" Friedrich Nietzsche, *The Gay Science with a Prelude in Rhymes and an Appendix of Songs*, translated by Walter Kaufman (New York: Vintage, 1974), 181.

125 "Wer, wenn ich schriee…" Rainer Maria Rilke, "The First El-egy," translated by the author from *The Selected Poetry of Rainer Maria Rilke*, bilingual edition, edited and translated by Stephen Mitchell (New York: Vintage International, 1989), 150.

125 "All three thinkers sought to…" F. Thomas Trotter, "Varia-tions on the 'Death of God' Theme in Recent Theology," *The Meaning of the Death of God: Protestant, Jewish and Catho-lic Scholars Explore Atheistic Theology*, edited by Bernard Murchland (New York: Vintage Books, 1967), 17-18.

126 "She stood among the swaying crowd…" James Joyce, "Eve-line," *Dubliners* (New York: Gramercy Books, 1992), 30.

127 "…in a video game, the player…" Jason Rohrer, in discussion with the author via Skype, June 17, 2015.

127 "…even though the player's making…" Tim Schafer, in discus-sion with the author via Skype, June 11, 2015.

9 – An American Master

129 "Schafer was born in Sonoma…" Eric Wittmershaus, "With 'Brütal Legend, Sonoma native Tim Schafer crafts one-f-a-kind world for gamers," *Press Democrat*, October 8, 2009.

http://www.pressdemocrat.com/news/2271243-181/with
-brtal-legend-sonoma-native. Accessed November 14, 2016.

129 "...at the height of the summer of love" IGN, "Tim Schafer."
Http://www.ign.com/stars/timschafer. Accessed November 14,
2016.

130 "I think that games can be enriching..." Ibid.

130 "I was like, What's happening?..." Tim Schafer, "'I Don't
Know If a Duck Is Going to Swallow Me Whole.' The Tim
Schafer Interview," U.S. Gamer, December 30, 2015. Http://
www.usgamer.net/articles/Tim_Schafer_Interview. Accessed
March 11, 2016.

130 "I don't know if a duck..." Ibid.

131 "That's how I got into games..." Tim Schafer, in discussion
with the author via Skype, 11 June 2015.

131 "I loved Lucasfilm..." Schafer, "'I Don't Know.'"

131 "...action game that was widely..." Ibid.

132 "In addition to Sandy's boyfriend Dave..." "Let's Play Maniac
Mansion (Full Playthrough)," YouTube video, 54:12, posted by
Let's Play With Brigands, December 5, 2012. Https://www.you
tube.com/watch?v=L7oUArcVis0. Accessed March 12, 2016.

133 "So we were all watching..." Schafer, "'I Don't Know.'"

133 "Writing for video games..." Alex Irvine, e-mail message to
author, March 22, 2016.

134 "...in play we may move below..." Huizinga, *Homo Ludens*, 19.

134 "...the stupidest name..." *The Secret of Monkey Island*. Dou-
ble Fine. Video game. 1990.

134 "I've always wanted to bring in..." Tim Schafer, in discussion
with the author via Skype, 11 June 2015.

135 "Whenever I smell asphalt..." *Full Throttle*. Double Fine.
Video game. 1995.

136 "I feel that taking care of the creative..." Tim Schafer, in dis-
cussion with the author via Skype, 11 June 2015.

136 "...a story set in the land..." Ibid.

136 "...very heavily inspired by film..." Ibid.

137 "The idea of creative ownership..." Schafer, "'I Don't Know.'"

138 "...the ultimate battlefield..." *Psychonauts*. Double Fine.
Video game. 2005.

138 "...psychic soldiers..." Ibid.

138 "...highly-classified, remote government..." Ibid.

138 "Schafer once explained that..." Schafer, "'I Don't Know.'"

138 "I had started playing *Mario 64*..." Tim Schafer, in discussion with the author via Skype, 11 June 2015.

138 "I really wanted to make a game..." Schafer, "'I Don't Know.'"

138 "This fit in with a lot of other stuff..." Ibid.

138 "It was a whole new way..." Ibid.

139 "It's hard to think of too many..." Kristan Reed, "Psychonauts: For the Love of God, Just Buy It," Eurogamer, February 13, 2006. Http://www.eurogamer.net/articles/r_psychonauts_pc. Accessed 14 June 2016.

139 "It's as if critics the world over..." Ibid.

139 "I had wanted to do an RTS..." Schafer, "'I Don't Know.'"

139 "I'll show it to you..." *Brütal Legend*. Double Fine. Video game. 2009.

139 "The kids who work here don't know..." Ibid.

139 "What I hold in my hand..." Ibid.

140 "You see heavy metal singers..." Schafer, "'I Don't Know.'"

141 "Welcome! Don't let my sultry..." *The Cave*. Double Fine. Video game. 2014.

142 "Welcome to the Cave..." Ibid.

142 "It's a story of seven people..." Ibid.

143 "We are now approaching the misty..." Ibid.

143 "Welcome, young apprentice..." Ibid.

143 "That was quite a climb..." Ibid.

144 "Our enlightenment-seeking trio..." Ibid.

144 "...take you on an emotional journey..." Tim Schafer, in discussion with the author via Skype, 11 June 2015.

144 "...lets you experience things..." Ibid.

144 "There's people like me..." Ibid.

10 – World of Warcraft

147 "He headonned and killed..." Denis Johnson, "Car Crash While Hitchhiking," *Jesus' Son* (New York: Farrar, Straus and Giroux, 2009), 3.

148 "Spending forty hours or more…" Daniel Lisi, *World of Warcraft* (Los Angeles: Boss Fight Books, 2016), 81.
149 "All that is said about Zen…" Christmas Humphreys, *Studies in the Middle Way* (Wheaton, IL: The Theosophical Publishing House, 1984), 129.
149 "Zen, being direct experience…" Ibid.
149 "The word eustress originates with…" Jane McGonigal, *Reality is Broken: Why Games Make Us Better and How They Can Change the World* (New York: Penguin, 2011), 32.
150 "…the player experience design expert Nicole Lazzaro…" Nicole Lazzaro, "The 4 Keys 2 Fun," nicolelazzaro.com, accessed April 4, 2016, http://www.nicolelazzaro.com/the4-keys-to-fun.
150 "…coined the term *flow*…" *Mihaly* Csikszentmihalyi, *Flow: The Psychology of Optimal Experience* (New York: Harper Perennial, 2008), xi.
150 "…we have all experienced times…" Ibid., 3.
151 "…when they forget themselves altogether…" Walpola Rahula, *What the Buddha Taught* (New York: Grove, 1979), 72.
152 "…California-based company Blizzard Entertainment…" Blizzard Entertainment, "Classic Games, "Warcraft: Orcs & Humans," Http://us.blizzard.com/en-us/company/about/profile.html. Accessed November 14, 2016.
152 "…released in 1994 for MS-DOS." Blizzard Entertainment, "Company Profile." http://us.blizzard.com/en-us/games/legacy. Accessed November 14, 2016.
152 "…2016 movie that cost $160 million…" "Warcraft," Box Office Mojo, accessed June 17, 2016. Http://www.boxofficemojo.com/movies/?id=warcraft.htm.
152 "As far as game designers go…" Rob Pardo, in discussion with the author via Skype, June 9, 2015.
152 "You start with nothing…" Ibid.
153 "So you can see basically an entirely different game…" Ibid.
153 "…brought in more than $1 billion…"Andy Chalk, "League of Legends Has Made Almost $1 Billion in Microtransactions," PC Gamer, October 23, 2014. Http://www.pcgamer.com/league-of-legends-has-made-almost-1-billion-in-microtransactions. 26 March 26, 2016.

154 "...it doesn't make much sense to compare..." Ian Bogost, e-mail message to author, February 24, 2016.

155 "All addictions have a behavioral component..." Clayton R. Cook, e-mail message to author, June 15, 2016.

156 "In 2012, twenty-three-year-old Chen Rong-Yu..." Simon Parkin, *Death by Video Game: Danger, Prestige, and Obsession on the Virtual Frontline* (New York: Melville House, 2016), 3-5; Simon Parkin, *Death by Video Game: Danger, Prestige, and Obsession on the Virtual Frontline* (New York: Melville House, 2016), 4-5

156 "[H]onestly anyone will do..." "An EPIC Mount! (Warcraft Players Look inside) – w4m" craigslist advertisement, April 8, 2007. Http://www.craigslist.org/about/best/nyc/308349637 .html. Accessed June 16, 2016.

156 "They had played *World of Warcraft* so obsessively..." Rick Rojas, "Couple Allegedly Locked Up Girls and Played Video Games," *Los Angeles Times*, May 31, 2016. Http://articles .latimes.com/2013/may/31/local/la-me-ln-oc-couple-accused -of-locking-girls-in-filthy-home-as-they-played-videogames -20130531. Accessed June 16, 2016.

156 "...covered in mold and cobwebs..." Kennedy Ryan, "O.C. Couple Obsessed with 'World of Warcraft' Sentenced to Prison for Extreme Child Neglect," KTLA, August 12, 2014. Http://ktla.com/2014/08/12/couple-obsessed-with-world-of -warcraft-sentenced-to-prison-for-child-neglect. Accessed June 16, 2016.

157 "The names of Breivik's characters included..." Jason Schreier, "The Life of a Mass Murderer in World of Warcraft," Kotaku, April 20, 2012. Http://www.kotaku.com.au/2012/04 /the-life-of-a-mass-murderer-in-world-of-warcraft. Accessed April 25, 2016.

157 "A number of comments he posted..." Anders Behring Breivik, a.k.a. Conservative, "Lemassive, internet famous," web forum, battle.net, May 2, 2011. Http://eu.battle.net/wow/en /forum/topic/1622897808#6. Accessed April 25, 2016.

157 "...when we first started we were starting..." Shigeru Miyamoto, "Q&A: Shigeru Miyamoto On The Origins of Ninten-

do's Famous Characters," NPR, June 19, 2015. Http://www
.npr.org/sections/alltechconsidered/2015/06/19/415568892
/q-a-shigeru-miyamoto-on-the-origins-of-nintendos-famous
-characters. Accessed January 25, 2016.

157 "After all, the obsession/addiction factor..." Martin Amis,
quoted in Simon Parkin, *Death by Video Game: Danger, Prestige, and Obsession on the Virtual Frontline* (New York: Melville House, 2016), 13.

158 "The tricky part is the video game designers..." Clayton R.
Cook, e-mail message to author, June 15, 2016.

158 "I think that might be where a lot..." Adam Saltsman, in discussion with the author via Skype, August 3, 2015.

159 "...12 million monthly subscribers." Matt Peckham, "The Inexorable Decline of World of Warcraft," *Time*, May 9, 2013.
Http://techland.time.com/2013/05/09/the-inexorable-decline
-of-world-of-warcraft. Accessed April 4, 2016.

159 "...that number had dropped to 5.5 million." Ben Skipper,
"World of Warcraft Subscribers Hit 5.5 million, Lowest Number for 10 Years," International Business Times. November 3,
2015. Http://www.ibtimes.co.uk/world-warcraft-subscribers
-hit-5-5-million-lowest-numbers-10-years-1527035. Accessed
April 4, 2016.

160 "Now you're at level 5!..." Jason Rohrer, in discussion with
the author via Skype, 17 June 2015.

160 "The game is sort of trumping up..." Ibid.

161 "...35% of the *WoW* population..." Lisi, *World of Warcraft*,
48.

161 "...post-racialism is apparently..." Gene Demby, "What
World Of Warcraft Can Tell Us About Race In Real Life,"
NPR Code Switch blog, March 8, 2014. Http://www.npr.org
/sections/codeswitch/2014/03/08/287368917/what-world-of
-warcraft-can-teach-us-about-race-irl. Accessed November 14,
2016.

162 "Where you pass..." *World of Warcraft*. Blizzard. Video game.
2004-present.

162 "Life isn't about finding yourself..." *World of Warcraft*. Blizzard. Video game. 2004-present.

163 "I feel like the story is always…" Rob Pardo, in discussion with the author via Skype, 9 June 2015.

164 "As long as you live…" Rahula, *What the Buddha Taught*, 72.

164 "Real life is the present moment…" Ibid.

11 – Trigger Warnings

165 "…as many as 18 million people…" Peter Van Allen, "Franklin Mills Mall Lines up as Major Tourist Destination," *Philadelphia Business Journal*, August 7, 2006. Http://www.bizjournals.com/philadelphia/stories/2006/08/07/story4.html. Accessed June 21, 2016.

165 "…in 2009, the United States government…" John Hurdle, "U.S. Army Recruiting at the Mall with Videogames," Reuters, January 9, 2009. Http://www.reuters.com/article/us-usa-army-recruiting-idUSTRE50819H20090110. Accessed June 21, 2016.

165 "…33 Franklin Mills shoppers…" Ibid.

165 "…there's sort of a core idea…" Warren Robinett, in discussion with the author via Skype, January 25, 2016.

166 "…a Texas-based firearms manufacturer…" Daniel Xu, "Video: The Nintendo Glock Zapper in Action," Outdoorhub, March 16, 2016. Http://www.outdoorhub.com/news/2016/03/16/video-nintendo-glock-action. Accessed April 22, 2016.

166 "…over 125 million people…" Dean Takahashi, "Call of Duty: Advance Warfare by the (big) numbers, VentureBeat, November 24, 2014. Http://venturebeat.com/2014/11/24/call-of-duty-advanced-warfare-by-the-big-numbers. Accessed November 15, 2016.

166 "…surpassed $10 billion…" Paul Tassi, "Activision Smokescreens 'Call of Duty: Advanced Warfare' Sale, Continuing a Trend," *Forbes*, November 20, 2014. Http://www.forbes.com/sites/insertcoin/2014/11/20/activision-smokescreens-call-of-duty-advanced-warfare-sales-continuing-a-trend. Accessed October 8, 2015.

167 "At 2 p.m. on December 10, 1993…" T.C., "The meaning of 'Doom,'" *The Economist*, December 10, 2013. Http://www.economist.com/blogs/babbage/2013/12/video-games. Accessed November 15, 2016.

167 "...which promptly crashed..." Ewan Aiton, "Doom: A Bloody History," TeamRock, May 19, 2016. Http://teamrock .com/game/2016-05-19/doom-a-bloody-history-1. Accessed November 15, 2016.

167 "Using AOL and other commercial networks..." Klint Finley, "The Average Webpage Is Now the Size of the Original *Doom*," *Wired*, April 23, 2016. Http://www.wired.com/2016 /04/average-webpage-now-size-original-doom/. Accessed April 25, 2016.

167 "...took up to four hours..." "The History of: Doom," Now Gamer, January 27, 2009. Http://www.nowgamer.com/the -history-of-doom. Accessed April 25, 2016.

167 "..., a typical webpage in 2016..." Finley, "The Average Webpage."

167 "...re-assessed what your objective was..." John Romero, quoted in "5 Years of Doom," DoomWorld. Http://5years.doomworld. com/interviews/johnromero. Accessed June 21, 2016.

168 "He practiced his assault in so-called God mode..." "Did Harris Preview Massacre on 'Doom?'" [sic quotation marks] *Denver Post*, May 4, 2009. Http://extras.denverpost.com /news/shot0504f.htm. Accessed April 25, 2016.

168 "Her career began at age fifteen..." Simon Parkin, *Death by Video Game: Danger, Prestige, and Obsession on the Virtual Frontline* (New York: Melville House, 2016), 210.

168 "...For John Romero..." Brenda Romero, e-mail message to author, May 11, 2016.

168 "None had an ideal upbringing..." Ibid.

169 "The day before *DOOM* was released..." Ibid.

171 "Everything you're about to see..." Jason Jones, quoted in "Steve Jobs Introducing Halo," YouTube video, 3:38, posted June 16, 2008 by SummitOperations. Https://www.youtube .com/watch?v=Tzrme9yWens. Accessed April 25, 2016.

171 "Jobs, it has been reported..." Rob Crossley, "Steve Jobs 'Raged at Microsoft' over Game Studio Sale," Develop, October 26, 2010. Http://www.develop-online.net/news/steve-jobs -raged-at-microsoft-over-game-studio-sale/0108013. Accessed April 29, 2016.

171 "The series has sold 65 million…" Eddie Makuch, "Halo Series Reaches 65 Million Units Sold," GameSpot, July 13, 2015. Http://www.gamespot.com/articles/halo-series-reaches-65-million-units-sold/1100-6428844. Accessed November 15, 2016.

171 "…grossed $3 billion." Samit Sarkar, "Halo franchise tallies 46 million copies sold, almost $3 billion total revenue," Polygon, October 31, 2012. Http://www.polygon.com/2012/10/31/3581904/halo-franchise-lifetime-sales-revenue. Accessed November 15, 2016.

172 "As Master Chief…" Halo homepage. Https://www.halowaypoint.com/en-us/games. Accessed April 20, 2016.

172 "High-tech, gendered imaginations…" Donna. J. Haraway, "The Cyborg Manifesto," *Manifestly Haraway* (Minneapolis: U Minnesota Press, 2016), 42-43.

174 "Beginning a new game gave me the option of starting…" *Spore.* Electronic Arts. Video game. 2008.

174 "Kent Jolly had created soundtracks…" "Spore (Windows)" credits, Moby Games. Http://www.mobygames.com/game/windows/spore_/credits. Accessed November 16, 2015.

175 "Throughout Spore, the choices you make…" *Spore.* Electronic Arts. Video game. 2008.

176 "…created human beings…" Pope Francis, quoted in Ishaan Tharoor, "Pope Francis says evolution is real and God is no wizard," Washington Post, October 28, 2014. Https://www.washingtonpost.com/news/worldviews/wp/2014/10/28/pope-francis-backs-theory-of-evolution-says-god-is-no-wizard. Accessed November 15, 2016.

176 "Evolution in nature is not inconsistent…" Ibid.

177 "*Halo* has a kind of reassurance…" Brian Evenson, e-mail message to author, April 24, 2016.

177 "…limited enthusiasm…" Ibid.

177 "The closer the FPS gets to feeling like…" Ibid.

178 "Having known someone who was essentially…" Ibid.

178 "…martial patrimony." Tom Bissell, *Extra Lives: Why Video Games Matter* (New York: Vintage, 2011), 132.

178 "Today, the American military uses…" Hamza Shaban, "Playing War: How the Military Uses Video Games," *The Atlantic,*

October 10, 2013. Http://www.theatlantic.com/technology
/archive/2013/10/playing-war-how-the-military-uses-video
-games/280486. Accessed June 21, 2016.

178 "Play a few rounds of target practice..." U.S. Army. "Down-
loads > Games." http://www.goarmy.com/downloads/games
.html. Accessed June 21, 2016.

178 "Game developers have long..." Shaban, "Playing War."

178 "...the symbiotic relationship..." Marcus Schulzke, "Rethink-
ing Military Gaming: America's Army and Its Critics," *Games
and Culture* 8, March 2013. Http://gac.sagepub.com.goucher
.idm.oclc.org/content/8/2/ 59.full.pdf+html. Accessed via SAGE
June 21, 2016.

179 "That partnership entered..." Ibid.

179 "...over twenty-five iterations of that game..." Ibid.

179 "it is operated by an Xbox controller." Jordan Golson, "Ar-
my's New Laser Cannon Blasts Drones out of the Sky, Even in
Fog," *Wired*, September 5, 2014. Http://www.wired.com/2014
/09/armys-new-laser-cannon-blasts-drones-out-of-the-sky
-even-in-fog. Accessed April 28, 2016.

179 "...propaganda in some form or other..." George Orwell, "The
Frontiers of Art and Propaganda," *My Country Right or Left*
1940-1943, *Essays, Journalism & Letters, Vol. 2*, edited by Sonia
Orwell and Ian Angus (Boston: David R. Godine, 2000), 126.

179 "...idea of exploring in the shadow..." Tim Schafer, in discus-
sion with the author via Skype, June 11, 2015.

180 "And just like sometimes my daughter..." Ibid.

12 – Exile and the Kingdom

182 "Those who come to our borders..." Benjamin R. Teitelbaum,
"Sweden's Self-inflicted Nightmare," op-ed, *New York Times*,
November 13, 2015. Http://www.nytimes.com/2015/11/14
/opinion/swedens-self-inflicted-nightmare.html. Accessed Jan-
uary 11, 2016.

183 "The airport has also..." Karla Cripps, "Swedish Airports Use
Retro Video Games to Collect Spare Currency," CNN, March
24, 2015. http://www.cnn.com/2015/03/24/travel/sweden-spare
-currency-arcade. Accessed January 11, 2016.

183 "It is the unhealable rift forced..." Edward W. Said, "Reflections on Exile," *Reflections on Exile: And Other Essays* (Cambridge, MA: Harvard University Press, 2000), 173.

183 "...had won a number of Developers Choice..." Chris Suellentrop, "Journey, an Indie Video Game, Wins Top Prizes," New York Times blog, March 28, 2013. Http://artsbeat.blogs .nytimes.com/2013/03/28/journey-an-indie-video-game-wins -top-prizes. Accessed January 11, 2016.

183 "...that stretch what people think..."Tim Schafer, in discussion with the author via Skype, 11 June 2015.

183 "The goal is to get to the mountaintop..." "Journey." thatgamecompany. Http://thatgamecompany.com/games/journey. Accessed October 2, 2016.

186 "...One cannot read a book..." Vladimir Nabokov, quoted in Nathaniel Stein, "Are Rereadings Better Readings?" *The New Yorker*, November 1, 2011. Http://www.newyorker.com/books /page-turner/are-rereadings-better-readings. Accessed January 14, 2016.

187 "TAP THE PATH..." *Monument Valley*. Ustwo. Video game. 2014.

187 "...HOLD AND ROTATE..." Ibid.

187 "...IDA EMBARKS..." Ibid.

187 "How far have you wandered..." Ibid.

188 "This was the valley of men..." Ibid.

188 "And in one sense..." Frantz Fanon, *Black Skin, White Masks*, translated by Charles Lam Markman (New York: Grove, 1967), 120.

190 "Language is a very poor..." Jenova Chen, in discussion with the author via Skype, January 15, 2016.

190 "I often felt it's difficult..." Ibid.

190 "...identities are actually barriers..." Ibid.

192 "At the time, the PlayStation Network..." Sony PlayStation, "PlayStation Global." https://www.playstation.com/country-selector. Accessed October 1, 2016.

192 "[A] very large mass of writers..." Edward W. Said, *Orientalism* (New York: Vintage, 1994), 3-4.

193 "...achievements of the exile..." Said, "Reflections on Exile," 173.

193 "...I felt the connections of people..." Jenova Chen, in discussion with the author via Skype, January 15, 2016.

13 – New Auteurs

195 "...to further enjoyment and appreciation..." "About the Stoogeum," stoogeum.com. Http://stoogeum.com/about. Accessed August 17, 2016.

196 "The initial games at MoMA..." Paola Antonelli, "Video Games: 14 in the Collection, for Starters," Museum of Modern Art, November 29, 2012. Http://www.moma.org/explore /inside_out/2012/11/29/video-games-14-in-the-collection-for -starters. Accessed 14 October 2015.

197 "...Custom video game software..." Long March: Restart. (New York: Museum of Modern Art.) Museum exhibit label, visited April 8, 2016.

198 "...Throw soda." Ibid.

198 "The game seemingly took place..." Ibid.

198 "Because of the vast space..." Feng Mengbo, quoted in Katelyn Sandfort, "New Acquisition: Feng Mengbo's *Long March: Restart*," Museum of Modern Art, February 4, 2010. Http://www .moma.org/explore/inside_out/2010/02/04/new-acquisition -feng-mengbos-long-march-restart. Accessed April 7, 2016.

201 "*Canabalt* doesn't have..." Adam Saltsman, in discussion with the author via Skype, August 3, 2015.

201 "Everything that's on the end of the spectrum..." Ibid.

202 "It was among the first video..." Paola Antonelli, "Video Games: 14 in the Collection, for Starters," Museum of Modern Art, November 29, 2012. Https://www.moma.org/explore/ inside_out/2012/11/29/video-games-14-in-the-collection-for- starters. Accessed November 15, 2016.

202 "...a 2016 solo exhibition..." Davis Museum at Wellesley College, "The Game Worlds of Jason Rohrer: Feb 10 2016 – Jun 26 2016." Https://www.wellesley.edu/davismuseum/whats -on/current/node/79126. Accessed November 15, 2016.

202 "...A tiny bit of background..." Jason Rohrer, "What I Was Trying to Do with *Passage*," personal blog. Http://hcsoftware .sourceforge.net/passage/statement.html. Accessed April 12, 2016.

202 "...memento mori game." Ibid.

202 "Once you meet up with a partner..." Jason Rohrer, in discussion with the author via Skype, June 17, 2015.

202 "The simplicity of the space..." John Sharp, *Works of Game: On the Aesthetics of Games and Art* (Cambridge, MA: MIT Press, 2015), 58.

203 "I'm just struggling with my feelings..." Jason Rohrer, in discussion with the author via Skype, June 17, 2015.

203 "...marvel at how small..." Ibid.

203 "Once you're down through..." Ibid.

204 "...takes this whole manifold..." Ibid.

204 "When we were in New Mexico..." Ibid.

204 "I don't have an answer..." Ibid.

205 "...being able to be that powerful..." Ibid.

206 "I want death to be death..." Ibid.

206 "...to try to love the questions..." Rainer Maria Rilke, *Letters to a Young Poet*, translated by M.D. Herter Norton (New York: Norton, 1993), 35.

206 "...makes you think about something..." Jason Rohrer, in discussion with the author via Skype, June 17, 2015.

206 "...so beautiful and wise..." Robert Stone, "The Loser's Loser," *New York Review of Books*, June 22, 1995. Http:// www.nybooks.com/articles/1995/06/22/the-losers-loser. Accessed 11 April 2016.

207 "...a game to soothe..." Gravity Ghost. Http://gravityghost. com. Accessed 18 April 2016.

207 "...there's no killing..." Ibid.

207 "I knew I wanted to have..." Erin Robinson Swink, in conversation with the author via Skype, February 18, 2016.

208 "Where are you going?" *Gravity Ghost*. Ivy Games. Video game. 2015.

208 "But it's a very unusual game..." Erin Robinson Swink, in conversation with the author via Skype, February 18, 2016.

209 "I always liked ghost stories…" Ibid.

209 "That's what we hear about…" Ibid.

209 "I learned that one of the things…" Ibid.

14 – The Art Question

211 "…a thinker who communicated…" James Harkness, "Translator's Introduction," Michel Foucault, *This Is Not a Pipe* (Berkeley: U California Press, 1983), 2.

212 "Are religion, or sports…" Adam Saltsman, e-mail message to author, October 15, 2015.

212 "I feel like in any of the debates…" Rob Pardo, in conversation with the author via Skype, June 9, 2015.

212 "In a lot of ways…" Ibid.

212 "…Most video games would…" Ibid.

212 "I don't consider it particularly…" Ibid.

212 "I don't generally like arguing…" Erin Robinson Swink, in conversation with the author via Skype, February 18, 2016.

212 "To me, it's like asking…" Erin Robinson Swink, e-mail message to author, March 1, 2016.

212 "Video games can never…" Roger Ebert, "Video Games Can Never Be Art," blog post, April 16, 2010. Http://www.roger ebert.com/rogers-journal/video-games-can-never-be-art. Accessed October 13, 2015.

213 "Let me just say…" Ibid.

213 "One obvious difference…" Ibid.

213 "Zzzzzz. Oh, sorry…" Double Fine Productions, "Frequently Asked Questions." Http://www.doublefine.com/about. Accessed January 30, 2015.

213 "…are a particularly argumentative bunch…" Tom Bissell, *Extra Lives: Why Video Games Matter* (New York: Vintage, 2010), xiv.

213 "…all men enjoy works…" Aristotle, "Poetics," *Selected Works*, third edition, translated by Hippocrates G. Apostle and Lloyd P. Gerson (Grinnell, IA: Peripatetic Press, 1991), 650.

214 "…although we are pained…" Ibid.

214 "For anything so o'erdone…" William Shakespeare, "Hamlet, Prince of Denmark," *The Complete Works of Shakespeare*,

fourth edition, edited by David Bevington (New York: Harper Collins, 1992), 1088-1089.

214 "The idea of a conservative artwork..." Theodore W Adorno, *Aesthetic Theory,* translated by Robert Hullot-Kentor (Minneapolis, MN: Minnesota University Press, 1997), 177.

214 "...cloud of bureaucracies..." Dave Hickey, "After the Great Tsunami: On Beauty and the Therapeutic Institution," *The Invisible Dragon: Essays on Beauty*, revised and expanded (Chicago: U Chicago Press, 2012), 53.

214 "...art-world tribe..." Grayson Perry, *Playing to the Gallery: Helping Contemporary Art in Its Struggle to be Understood* (New York: Penguin Books, 2015), 39.

215 "...describe those who decide what is art..." Grayson Perry, *Playing to the Gallery: Helping Contemporary Art In Its Struggle to be Understood* (New York: Penguin Books, 2015), 39.

215 "...a loose confederation of museums..." Dave Hickey, "After the Great Tsunami: On Beauty and the Therapeutic Institution," *The Invisible Dragon: Essays on Beauty*, revised and expanded (Chicago: U Chicago Press, 2012), 53.

215 "One might call it an 'academy,'..." Hickey, "After the Great Tsunami," 53.

215 "...quite middlebrow." Perry, *Playing to the Gallery,* 39.

216 "...dissonance between an intellectual..." Ibid., 43.

216 "After all, if Duchamp..." Ibid., 58.

216 "Duchamp's aesthetic display..." David Foster Wallace, "E Unibus Pluram: Television and U.S. Fiction," *A Supposedly Fun Thing I'll Never Do Again: Essays and Arguments* (New York: Little, Brown, 1997), 42.

216 "...based on a simple idea..." New York University. The Tisch School of Arts. Game Center. "About." http://gamecenter.nyu.edu/about. Accessed May 13, 2015.

216 "Video games are thereby afforded..." New York University. The Tisch School of Arts. Game Center. "About." http://gamecenter.nyu.edu/about. Accessed May 13, 2015.

216 "...the definitive textbook..." New York University. The Tisch School of Arts. Game Center. "Eric Zimmerman." Http://

gamecenter.nyu.edu/faculty/eric-zimmerman. Accessed May 14, 2015.

217 "...whether games are art is simply..." Eric Zimmerman. "Games, Stay Away from Art. Please," Polygon, September 10, 2014. Http://www.polygon.com/2014/9/10/6101639/games-art. Accessed January 29, 2015.

217 "Marcel Duchamp put a toilet..." Ibid.

217 "That's the point of Duchamp's readymade..." Ibid.

218 "In the insider world..." Ibid.

218 "...indie developer Brianna Wu..." Dennis Scimeca, "Indie developer mocks GamerGate, chased from home with rape and death threats," The Daily Dot, October 13, 2014. Http://www.dailydot.com/parsec/brianna-we-gamergate-threats. Accessed November 15, 2016.

219 "Anita Sarkeesian of the Feminist Frequency..." Caitlin Dewey, "The Only Guide to Gamergate You Will Ever Need," *Washington Post*, October 14, 2014. Https://www.washingtonpost.com/news/the-intersect/wp/2014/10/14/the-only-guide-to-gamergate-you-will-ever-need-to-read. Accessed June 24, 2016.

219 "The Gamergate hashtag..." Simon Parkin, *Death by Video Game: Danger, Prestige, and Obsession on the Virtual Frontline* (New York: Melville House, 2016), 97.

219 "It's the difference between the historical..." Caitlin Dewey, "The Only Guide to Gamergate You Will Ever Need," *Washington Post*, October 14, 2014. Https://www.washingtonpost.com/news/the-intersect/wp/2014/10/14/the-only-guide-to-gamergate-you-will-ever-need-to-read. Accessed June 24, 2016.

15 – Restart

221 "...*Tetris* is the bestselling video game..." "The 10 Best-selling Video Games of All Time," Connectedly. Http://www.connectedly.com/10-best-selling-video-games-all-time#slide11. Accessed June 27, 2016.

222 "...those *Tetris* shapes illuminated..." SCA Group. Http://www.sca.com. Accessed October 7, 2015.

223 "...created a similarly sized game of *Pong*..." Britt Faulstick, "Pong on Cira Centre Sets Guinness World Record," Drexel-NOW, November 18, 2013. Http://drexel.edu/now/archive /2013/November/Cira-Pong-Guinness. Accessed November 15, 2016.

223 "...four years and ten months..." Frank J. Lee, in discussion with the author, Drexel University, Philadelphia, PA, October 23, 2015.

223 "If the refresh rate was one..." Ibid.

224 "Then they acquired the software..." John Paul Titlow, "How a Drexel Professor Created the World's Biggest Game of Tetris," *Fast Company*, April 9, 2014. Http://www.fastcodesign .com/3028784/how-a-drexel-professor-created-the-worlds -biggest-game-of-tetris. Accessed October 6, 2015.

224 "Thankfully, we were able to improvise..." Frank J. Lee, in discussion with the author, Drexel University, Philadelphia, PA, October 23, 2015.

224 "...Nintendo recently sold..." Mat Paget, "Nintendo Isn't the Majority Owner of a Pro Baseball Team Anymore," GameSpot, August 19, 2016. Http://www.gamespot.com/articles /nintendo-isnt-the-majority-owner-of-a-pro-baseball/1100 -6442839. Accessed September 24, 2016.

224 "In 2014, Amazon purchased..." Douglas Macmillan and Greg Bensinger, "Amazon to Buy Video Site Twitch for $970 Million," Wall Street Journal, August 26, 2014. Http://www .wsj.com/articles/amazon-to-buy-video-site-twitch-for-more -than-1-billion-1408988885. Accessed November 15, 2016.

225 "The top *League of Legends*..." Kevin Knocke, "Why Prize Pools Don't Matter In Esports Anymore," IGN, August 9, 2016. Http://www.ign.com/articles/2016/08/09/why-prize -pools-dont-matter-in-esports-anymore. Accessed November 15, 2016.

225 "The 2014 *League of Legends* championship..." Paul Tassi, "40,000 Korean Fans Watch SSW Win 2014 'League of Legends' World Championship, *Forbes*, October 19, 2014. Http:// www.forbes.com/sites/insertcoin/2014/10/19/40000-live

-korean-fans-watch-ssw-win-2014-league-of-legends-world
-championship/#6198a50b5a6d. Accessed 15 Aug. 2016.

225 "In 2015, three North American teams..." Paul Tassi, "Monstrous Viewership Numbers Show 'League of Legends' Is Still eSports King," Forbes, December 11, 2015. Http://www .forbes.com/sites/insertcoin/2015/12/11/monstrous-viewer ship-numbers-show-league-of-legends-is-still-esports-king /#5e20f2784021. Accessed November 15, 2016.

225 "...higher average of 14.7 million viewers..."Max Rieper, "Royals/Mets Gets Highest World Series TV Ratings in Six Years," SB Nation Royals Review, November 5, 2015. Http:// www.royalsreview.com/2015/11/5/9675778/royals-mets-gets -highest-world-series-tv-ratings-in-six-years. Accessed August 15, 2016.

225 "SK Telecom TI repeated as champions..." Leo Howell, "2016 League of Legends Worlds prize pool at $5.07M with fan contributions," ESPN, October 29, 2016. http://www.espn.com /esports/story/_/id/17919126/2016-league-legends-worlds -prize-pool-507m-fan-contributions. Accessed November 15, 2016.

225 "It became more and more popular..." Rob Pardo, in discussion with the author via Skype, June 9, 2015.

226 "Over 100 million people play..." Riot Games. "Our Games." http://www.riotgames.com/our-games. Accessed June 28, 2016.

226 "Sport answers this question..." Roland Barthes, *What Is Sport?*, translated by Richard Howard (advance uncorrected proof, New Haven, CT: Yale University Press, 2007), 58.

226 "...In sport, man experiences..." Ibid., 61.

227 "...was created by Markus Persson in 2011..." Clive Thompson, "The Minecraft Generation: How a Clunky Swedish Computer Game is Teaching Hundreds of Millions of Children to Master the Digital World," *New York Times Magazine*, April 17, 2016, 64.

227 "...100 million players worldwide." Ibid.

228 "So that's pretty cool..." Adam Saltsman, in discussion with the author via Skype, August 3, 2015.

229 "*Minecraft* pushed the boundaries..." Warren Robinett, in discussion with the author via Skype, January 25, 2016.

231 "Games are the ultimate interactive..." Brenda Romero, e-mail message to author, May 11, 2016.

INDEX

ANGELICA BAUTISTA

Andrew Ervin is the author of *Burning Down George Orwell's House* and *Extraordinary Renditions*. He has written essays and reviews for the *New York Times Book Review*, *Washington Post*, *San Francisco Chronicle*, *Salon*, and others. He writes the Geek Reads column for Electric Literature and teaches part time at Temple University, and lives with his wife in Philadelphia, Pennsylvania.